ART AND TIME IN MEXICO

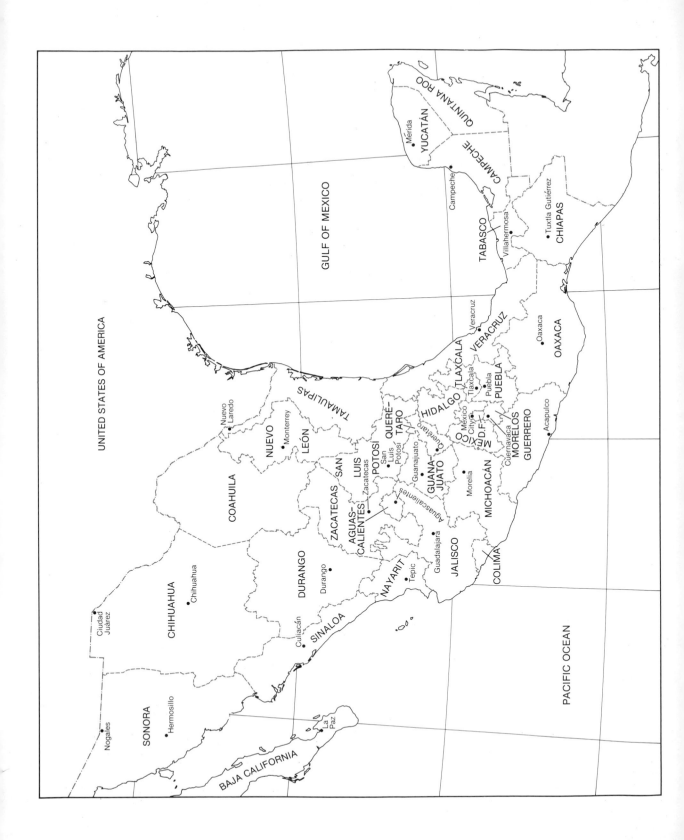

ART
AND TIME IN
MEXICO

Architecture and Sculpture
in Colonial Mexico

Text by Elizabeth Wilder Weismann
Photographs by Judith Hancock Sandoval

Foreword by Sidney D. Markman

Icon Editions
An Imprint of HarperCollins *Publishers*

HarperCollins books may be purchased for educational, business, or sales promotional use. For information please write: Special Markets Department, HarperCollins Publishers, Inc., 10 East 53rd Street, New York, NY 10022.

This Icon paperback edition published 1995.

Designed by C. Linda Dingler
Map of Mexico on page ii by Andrew Tomko

Library of Congress Cataloging-in-Publication Data

Weismann, Elizabeth Wilder, 1908–
 Art and time in Mexico.

 (Icon editions)
 Bibligraphy: p.
 Includes index.
 1. Art, Mexican. 2. Art, Colonial—Mexico.
 I. Sandoval, Judith Hancock de. II. Title
 N6553.W44 1985
 709´.72 84-48202

ISBN 0-06-430143-5 (pbk.)
95 96 97 98 99 CW 10 9 8 7 6 5 4 3 2 1

CONTENTS

LIST OF ILLUSTRATIONS

vii

LIST OF ILLUSTRATIONS

LIST OF ILLUSTRATIONS

ix

ACKNOWLEDGMENTS

We would like to express our gratitude to Julio Gutiérrez Trujillo of El Centro de Estudios de Historia de México Condumex, which owns the Hancock Sandoval Photographic Archive, and to Juan Luis Mutiozabal, Director, for generous and invaluable assistance in the preparation of this book.

We would also like to thank the following organizations and individuals for their many kindnesses and contributions: Aeromexico; The American Geographical Society; Archivo del Arzobispado, Durango, Dgo.; Archivo del Arzobispado, Guadalajara, Jal.; Archivo del Estado de Zacatecas, Zac.; Archivo General de Indias, Seville; Archivo Histórico del Estado de Jalisco; Archivo General de la Nación; Arizona State Museum, University of Arizona; Avery Library, Columbia University; Biblioteca Nacional de México; Biblioteca Pública del Estado de Jalisco; Biblioteca Pública del Estado de Zacatecas; El Colegio de México; Dirección Generál de Estudios del Territorio Nacionál (DETENAL); The Fogg Art Museum, Harvard University; Geneaological Library, The Church of Jesus Christ of Latter-day Saints; Goddard Institute for Space Studies, Columbia University; Hill and Knowlton, Inc.; Instituto de Investigaciones Estéticas, Universidad Nacional Autonoma de México; Instituto Nacional de Antropología e Historia; Mexican Government Tourist Office; Ministry of Tourism of Mexico; National Endowment for the Humanities; the National Gallery of Art; New York Public Library; Organization of American States, Plan UNESCO, Oaxaca; Secretaría de Agricultura y Ganadería; Southwest Cultural Resources Center, Albuquerque; University of Texas at Austin, The Nettie Lee Benson Collection; Ludwig J. Vogelstein Foundation.

Jerome Alexander, Silvino Aguilar Anguiano, Richard Ahlborn, Francisco José Álvarez y Lezama, Luis Alvarez Uriquiza, Gordon Ames, Robert O. Anderson, Manuel Barbachano Ponce, Ward J. Barrett, Erasmo Barroso Real, Nettie Lee Benson, Ignacio Bernal, José Bonilla Robles, Frederico Bribiesca, Guillermo Brockmann, Barry Broden, J.

ACKNOWLEDGMENTS

Anthony Burton, Israel Cabazos, Francisco Cabrera Gómez, Constance Cambria, Cass Canfield, Jr., Jaime Carranza G., Luis Carrillo Paredes, Carlos Castelán Flores, Carmen Castañeda, Sebastián Castro, Javier Castro Mantecón, Efrain Castro Morales, Carlos Chanfon Olmos, Jerry Coiner, William Colon, Herman Conrad, Joaquin Cortina Goribay, Barbara Croissant, Anthony Crosby, Teresa Davalos de Luft, Juan Antonio Diaz, Frederick Dockstader, Roman Draznowski, Armando Duvalier, James Ebert, Mario Elizondo, Berta Enciso de Gallardo, Carlos Equiarte, Alfonso Escárcega, Cuauhtemoc Esparza Sanchez, Roberto Felix Espinosa, Eduardo Flores Ruiz, Enrique Florescano, Pedro Franco, Beatriz de la Fuente, Hector Gallardo, José Ignacio Gallegos, Porfirio García de León, Eugenio García Romero, Sandra Vale García, Enrique Garibar del Rio, Peter Gerhard, Andrea Gibbs, José Gómez Sicre, Manuel Gonzalez Galván, Julio Gutiérrez Trujillo, Laura Gutiérrez-Witts, Charles H. Harris, Austin Hoover, Eugenio del Hoyo, J. Jesús Huerta, David Jones, Elisabeth Kelemen, Pál Kelemen, Richard Kimball, Mark Kontos, Robert Lee, Riva Livingston, Thomas Livingston, Ernesto Loera, Eucario López, Miguel López Lecube, Carlos E. Loumiet, Enrique Luft, Thomas Lyons, Salvador Maciel Pullido, José Luis Magaña, Javier Malagón, Enrique Manero Peón, Sidney Marleman, Grace M. Mayer, C. Miller McCarthy, Robert B. McNee, Philip Marcus, Jorge Medellín, Luis M. Mendez L., Eduardo Menéndez Acosta, Eugenia Meyer, Francisco Miranda, Agnes Mongan, Mariano Monterrosa, Robert J. Mullen, Josefina Muriel de la Torre, Armando Nicoláu, Eugenio Noriega Robles, Luis Ocampo, Edmundo O'Gorman, Jorge Olvera, María del Carmen Olvera, Luis Ortíz Macedo, Amaya Lizarraga de Pablos, José Padilla Sánchez, Fernando Pámanes Escobedo, Ruth Philbrick, Miklos Pinther, Adolph Placzek, Antonio Pompa y Pompa, Philip W. Powell, Susan Ann Protter, Jacinto Quirarte, José Rebollar Chavez, Cuauhtemoc de Regil, Roberto Reveles, Francisco Rincon Gallardo, Jaime Rincon Gallardo, Helene E. Roberts, José Rodriguez Elias, Louis R. Sadler, José A. Saenz, Douglas Reyes Sandoval, Luis Alberto Savala, Alan Sawyer, Frederico Sescosse, J. Jesús Sotelo, Christina Stebelski, Alejandro Topete del Valle, Juan Toscano G. de Quevedo, Cristina Treviño Urquijo, Ángelo A. de Tuddo, Luis Tur, Douglas Turnbaugh, Elisa Vargas Lugo de Bosch, Dudley M. Varner, J. Alberto Villasana L., Merle G. Wachter, Alexander von Wuthenau, Maria Cantinelli von Wuthenau.

We also extend our thanks to the many members of the clergy and private citizens of Mexico, whose assistance and hospitality were essential.

And, last, posthumous thanks to Alfredo Barrera Vásquez, Manuel Castillo Negrete, Alessandro Contini-Bonacossi, Justino Fernández, and Francisco de la Maza—distinguished scholars whose help and encouragement will long be remembered.

FOREWORD

About a decade has passed since this book, *Art and Time in Mexico*, first came to light. During the interim, a new relationship—commercial and materialistic, it is true—has been forged between the United States and Mexico. It is fitting, therefore, that this valuable book replete with insights into the unfolding of the history of Mexico should be made available to a new generation of readers for whom it will open a door, or perhaps only a small window, to an understanding of the hearts and minds of our neighbors through an appreciation of the work of their hands, the art and architecture of colonial Mexico.

The architectural monuments fronting the Plaza of the Three Cultures—*Plaza de las Tres Culturas*—in Mexico City summarize Mexico's culture and history: the indigenous native American Indian culture, extending back for millennia before the Spanish Conquest; the colonial, which developed during the three centuries between the Conquest and the Independence from Spain in the early nineteenth century; and the third extending from the Independence until today. This book deals with the crucial period in the middle, the colonial, during which there emerged a new society and a new culture.

In Mexico City some forty years ago, one of that country's foremost art historians observed that he could not live anywhere but in Mexico. When asked why, he immediately responded that Mexico was a paradise, *un paraíso*, where all problems, be they political, social, economic, or whatever, were ultimately resolved on an aesthetic basis. Only now after once again reading the forthright and perceptive text of Elizabeth Wilder Weismann and lingering over the magnificent photographs of Judith Hancock Sandoval have I realized that the witty aphorism I heard so many years ago was not a poetic metaphor but a statement of fact.

Weismann and Sandoval treat the art and architectural monuments of colo-

nial Mexico as social documents that mirror the process of the creation and formation of Mexican society in the New World over the course of almost three hundred years. The art and architecture, the sticks and stones, so to speak, comprise the tangible, material, physical history of colonial Mexico. Among these visual documents are, for example, the cathedrals of Mexico City, Merida, Puebla, Guadalajara, and Zacatecas, the chapels of the Rosary in both Puebla and Oaxaca, the small-town polychromed facade of the church of San Francisco Acatepec, and the vast number of churches, fourteen thousand of which are said to have been built in the eighteenth century alone, as well as palatial houses, haciendas, plazas, bridges, and civic buildings, all constructed during the three centuries of the colonial period.

This is the Mexico to which the authors open up our minds and eyes.

SIDNEY DAVID MARKMAN
Professor of Art History and Archaeology, Emeritus
Duke University

PREFACE

Given the opportunity to work with this remarkable collection of some 34,000 photographs of Mexican art, I wanted, above all, to display its special character. This has to do with the scope of the collection, the villages seen, the kilometers covered, the amount of shoe leather and tire rubber and endurance and patience which went into it. Photographs were made in some twelve hundred places—cities, towns, and villages—in many of which a score of buildings were recorded. A number of these buildings were probably photographed for the first time, certainly for the first time documented and brought home to an available archive. It is a fact that many of them have never been published at all. It recalls that old use of the verb "discover," as "In the year 1487 three ships went out from Bristol to *discover* the Island of Brasil." The old buildings are there (like Brazil), all over the countryside, and all one need do is reveal them.

What we see in this collection is that Mexico is a country as richly set with architecture as an Elizabethan gown with pearls. Obviously they are not all jewels, but all have their places in the great network from which such buildings as the parish church of Taxco, San Agustín Acolman, the cathedral of Puebla, the Palacio del Gobierno in Guadalajara, or the *Casa de los Azulejos* in Mexico City stand out. Indeed one cannot understand the great monastery of central Mexico, or the cathedral in the provincial capital, without some acquaintance with the hundreds of village churches and the rugged frontier missions which ring them. To think of Mexican colonial architecture—whether churches, or houses, hospitals, or haciendas—as a scattering of remarkable buildings is to be astonished at the wrong thing. This was not an architecture of imperial display, marking the high points of the system, but the intimate expression of the life of New Spain. In the country around the monastery of Santo Domingo in Oaxaca

there lie some thirty-five other Dominican monasteries, with fifteen or so foundations of other Orders, and more than sixty humble parish churches—yet not so humble but that they hold gold altarpieces and *artesonado* ceilings, rococo organs, and baptismal fonts three hundred years old. To realize this is to appreciate how much the architecture of Mexico is endemic, pervasive, and deeply rooted in Mexican life. What is astonishing, indeed, is their extraordinary number—that and the number of places where the colonial furnishings are still treasured and used, and the colonial setting can still be savored.

In this situation it was tempting to leave out entirely the famous, the familiar and long-admired, and to make it a book of the humble architecture of Mexico. But that also would be false, like leaving out the tall trees in a forest study: we are concerned with an organic group, complicated and intensely interrelated, where even a lost building (like San José de los Naturales) has importance in its influence on other buildings. So, without forgetting the archetypes, I have simply tried to get in as many as possible of the faraway, unknown or unexplored, provincial, eccentric, or simply modest buildings. This has led me, somewhat unexpectedly, to some reappraisal of the character of architectural history. Less surprisingly, I have found myself choosing photographs which record what the Mexicans call the *conjunto* (an innocent tribute to the *Gestalt?*), because we are talking less about the progressive development of molding profiles than about the total culture. Because (to put it in terms of experience) though the building may be inconsiderable as architecture, or in the history of architecture, its impact may be immense in the context of the whole experience. That is why I like the Christmas Day at Capácuaro with its cold and brilliant light on the congregation, rather than a clearer view of the façade.

ELIZABETH WILDER WEISMANN

ART AND TIME IN MEXICO

In Mexico there is always a brooding sense of the past. Turn off the highway, and the rutted road leads you over humpbacked bridges, past the gates of old *haciendas*, through the villages where the church stands on the plaza as it always has. The high mesa blossoms pink with cosmos in late August, and far away on the edge of the hills shine the tile domes. Farther up in the hills are markets where not everyone speaks Spanish, where women are still wearing garments which they weave for themselves. You eat immemorial foods: tortillas, *atole*, chocolate with cinnamon. In Yucatán people still live in the thatched houses shown on the Maya building at Uxmal, and speak the same language, too. Even in the capital one can hardly forget that the Zócalo was always the plaza—and long before Cortés arrived—and that under the cathedral there is still some of the Aztec temple. Cortés' hospital is still there, near the spot where Montezuma greeted him; the girls' school founded by the pious Basques still rings with the schoolgirl voices. In the spring, poppies blossom as they always did at Santa Anita; at Halloween the country is festooned with marigolds, the *sempasuchitl*, flower sacred to the ancient dead. It is not merely that one recalls the past, nor the mere survival of buildings or institutions, not a matter of self-conscious observance of tradition, but something deeper and more penetrating. The past is still there, like the snowy volcanoes that seem a myth until suddenly they reveal themselves, sharp against the limpid sky.

In fact there has always been something strange about time in Mexico. Suppose we think of the Spanish conquest as the coming together of two histories, two cultures, each trailing back into the past, each built up of generation

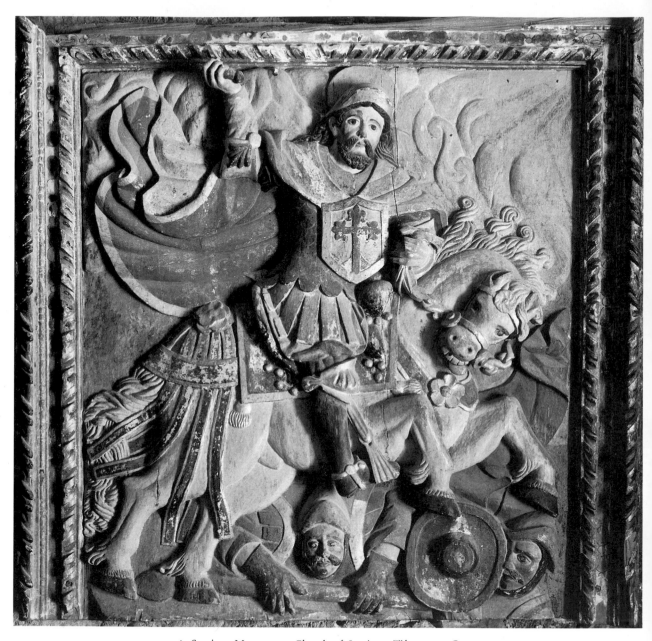

1. Santiago Matamoros. Church of Santiago. Tilantongo, Oaxaca.

after generation of historical sequences. The American heritage was complicated by an abundance of variants—many tribes, many rulers, many languages, a great diversity of levels of development, up to the relative complexity of the Aztec empire. There were people in Mexico in 1500 who could write and read their hieroglyphs; there were also people living without clothes in the jungle. The baggage of the Europeans was at once multiple and single. They were subjects of the Spanish king, of the Hapsburg empire, and of the Church of Rome. By the same token they might be, under Charles V, Flemings or Neapolitans or Dutchmen; within the Franciscan Order they were French or Italian or Austrian as well as Spanish. Also they had lived, as it were, through the Middle Ages, and the Dark Ages, and under Rome, and the Moors, and even in Greece—and just now, in the Renaissance. With them, the multiplicity was that of recorded civilizations, and the past was not necessarily buried as deep as one might expect.

Now it was the sixteenth century. The years of Mexico were henceforward to be bracketed firmly into European centuries, decades, months, and days. Warehouses full of documents were to be clearly dated—signed, witnessed, and sealed by notaries of the King—and most of them carefully filed and indexed. But there is still something ambiguous and shifting about the story. In 1519 soldiers with swords in their hands marched across the land, following the Hebrew Virgin on their banners, in the footsteps, as it were, of the Roman Empire. A saint on a white horse fought with them in their worst need. The very foot-soldiers wished to emulate "Caesar and Pompey and other Romans of that sort." The Aztec emperor thought Cortés might be the ruler-god Quetzalcoatl, who dated from the age of fable, and Bernal Díaz del Castillo wondered whether the Aztec capital Tenochtitlán might not belong in a medieval romance, such as *Amadis of Gaul*. In due sequence Christian missionaries advanced to set the cross in the plaza, as they had in eighth-century Ireland. The Bishop of Mexico translated Erasmian doctrine for Indian converts, the Bishop of Michoacán thought Thomas More's *Utopia* could be realized among his Indians. Fresh from the courts of Charles V or Clement VII, friars who had talked to Erasmus and seen the beginning of Baroque Rome built Gothic—or even Romanesque—vaults, or Moorish wooden ceilings over their mission churches in Indian market towns. What had happened to time, during that two-week trip from the capital? How far have we wandered from the sixteenth century of Bramante and Michelangelo and Titian, of Cervantes and Shakespeare?

So Mexico has always enjoyed a chronological anarchy. It is not only in the sixteenth century, in the shock of the Conquest, that time is evasive in Mexico. Right through the colonial period, problems of distance and communication translate into cultural lag and eclecticism. Immensity was the environment

of the New World—such distances, such emptiness, as no European had dreamed of. The mails were very slow; news of the Ultra-Baroque *estípite* came tardily to a town still building with hexagonal *mudéjar* columns. These were frontier conditions throughout the period of the viceroyalty. Even in an organization as absolute as the Spanish empire, the provinces were running on a very different clock from the capital, and from the Spanish peninsula.

One of the things we have to throw away as a result of these temporal peculiarities is the idea that *style* can be used to organize and explain art. When you begin to talk—in a situation at once provincial and primitive—of setting up an Early Christian mission, and you use amateur designers and builders who are more or less familiar with Classical, Romanesque, Gothic, Renaissance, Mudéjar, Isabeline, Manueline, and the earliest Baroque styles in half a dozen European countries—working with craftsmen trained in alien and exotic forms—it is obvious that the resulting artifact cannot be described by any one of these names. If it is to be called a style at all, it will have to dodge the issue by denying the great styles, by calling itself hybrid or mongrel or *mestizo*. For the concept of *style* is essentially one of purity (as in the case of race), and a proper style should change only progressively, in time. Even the "folk" styles are to be identified by their imperfect relationship to a strong chronological mainstream.

Thus it is difficult (and usually of little interest in itself) to designate the "style" of a Mexican building, or painting, or crucifix. That is, if it can be done easily, the object is apt to be uninteresting—a servile copy. Where else but in Mexico would the term *anástilo* have been seriously used—a category referred to as "without style," because it fits into none of the orthodox types? Is it not significant that the term *Churrigueresque*—used freely in Mexico for a particular and exuberant mode of the Baroque—has almost nothing specific to do with the art of the Churriguera brothers in Spain? (Manuel Toussaint confessed that he continued to use the word because it had a rich sound which seemed appropriate to the altarpieces.)

By the same token, it is difficult to date an unidentified example of art in Mexico by style alone—perhaps impossible, unless one knows its provenience. It can be true that the churchyard cross, now assumed to date from the sixteenth century, was so new in 1945 that it leaned against the churchyard wall, waiting to be set up; that the stucco ceiling of the church, popular in mood but evidently eighteenth-century in style, was re-made after a fire in 1938, no doubt by the same family of craftsmen who worked on the original. Small communities in out-of-the-way places build modest churches which are all but undatable—

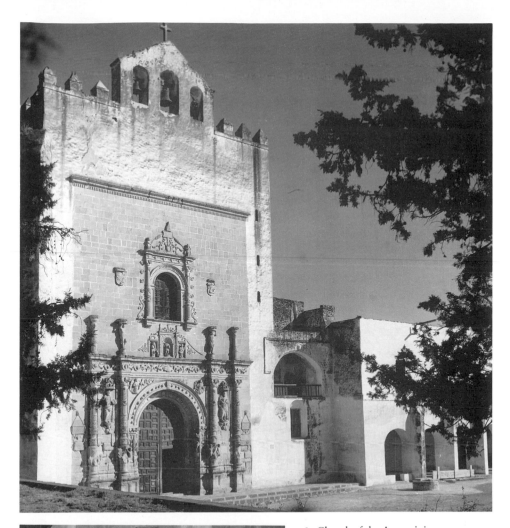

2. Church of the Augustinian monastery. Acolman, México.

3. Crucifix, parish church. Valle de Bravo, México.

perhaps eighteenth-century?—surely *Mexican* is all we can say. Old photographs are needed to convince us that the cloister, the *altarpiece,* the churchyard gate, is new, out of whole cloth, so to speak. This is not to say that the expert historian cannot distinguish the carving of 1960 from that of 1560—whether it be restoration or free invention within the tradition. But to an extraordinary degree everything that has ever gone on in Mexico is still possible, and by the same token the art of Mexico has been curiously uninhibited by that bondage to fashion which we magnify as style.

Master artists, with their masterpieces, are also hard to find in colonial Mexico. No Donatello emerges, no Verrocchio or Leonardo da Vinci, no Raphael, taking off from the teaching of a Perugino. But neither do artists of striking individuality appear in the Middle Ages, or in Egypt, or, for that matter, in preconquest American art. If we assume that there must always be individuals who catalyze the history of art, still, in medieval France for example, the individual artist remains invisible, his genius channeled into a common style, diffused over a whole church front. Furthermore, his accent is vernacular; he speaks the language of the people because he belongs to the people—not a unique genius, but an artist-craftsman sharing in a craft tradition.

Viceregal art, like medieval art, shares these qualities of popular art, or folk art—the impersonality or anonymity, the vernacular eloquence, the reliance on shared models and conventions, the backwardness in time. The artist, even when his name is known, seems not to have given himself airs, but to have remained in a relatively humble position. There were some respectable painters in New Spain who signed their pictures, and many of them were immigrants from Europe. They represent the provincial elite; beyond them are the mural decorators of the sixteenth century or the genuine folk painters of the seventeenth and eighteenth centuries, turning out their portraits and saints.

There were gifted wood-carvers, whose names we know from contracts for the gilded and painted *retables;* but not one whiff of personal style emerges from those group projects to identify the names. The line between carpentry and sculpture was very tenuous, and the wood-carver may have turned out a saint with no more ado than a column. From time to time a brilliant name will flash into Mexico—like Jerónimo de Balbás, who came from Seville bringing with him the *estípite,* which he thoroughly demonstrated and glorified in the splendor of the *Altar de los Reyes* of the cathedral of Mexico. But this retable behind the high altar is very different from Michelangelo's *Last Judgment:* the role of Balbás (apart from the "plan" and "explanation" he gave the cathedral chapter) is obscure, and

the carving itself remains essentially impersonal.

Oddly enough, it is in architecture, that most impersonal and communal of the arts, that one comes nearest to savoring artistic individuality. In a small sixteenth-century monastery—like Epazoyucan—one may sense a personality at work, in the manipulation of traditional plan and forms, in the special treasures, even though this Augustinian designer has no name.

And there are a few Baroque churches—Santa Prisca in Taxco, San Cayetano de la Valenciana outside Guanajuato, for example—which are clearly the integrated invention of a single artist. We even know more names of architects—in the sense of attaching them to a considerable oeuvre—than we do of sculptors. In the eighteenth century the buildings of Lorenzo Rodríguez and of Francisco Guerrero y Torres describe genuine architectural personalities, like architects in Rome or Madrid. It is only fair to add that a number of buildings in Mexico which convey this feeling of personality are, instead, the result not only of many designers and many hands, but of great sweeps of time. Many of the parish churches in Mexico have this quality. A good example is the sanctuary of Ocotlán in Tlaxcala: begun in the late seventeenth century, it was still being decorated a hundred years later; more was added in the nineteenth century; and the whole thing refurbished in the twentieth. One is tempted to say in such a case that the "artist" is the *genius loci,* and that the perdurance in time of so specific a taste shows exactly what we mean about Mexican chronology.

The suggestion that colonial art in Mexico has this popular aspect is by no means derogatory. The popular is often the vital, and Mexico is a fine place to demonstrate this. Compare the dullness of most "correct" colonial painting with the piquancy of a popular altarpiece, the devout drama of an ex-voto on tin. Through this folk quality—a kind of local taste, and a feeling for form which overrode provincial servility—invention did function during the colonial period. An inexact copy is not necessarily inferior (as witness El Greco's variations on Tintoretto). The changes rung on the imported *metropolitan* models were not necessarily coarsening, not necessarily decay. The difference might be growth, evolution, exuberance.

An excellent example of the mutant local product equaling (if not surpassing) its model is the facade sculpture of the Augustinian church at Cuitzeo in Guanajuato. Here it is not difficult for the purist to point out exactly where the design of the facade has been misunderstood and has fallen away from the comparative purity of the Plateresque model at Acolman. But in the sculpture itself, both in the new motifs adapted to the Plateresque framework and in the style and elegance of the cutting, there is an individuality and an authority which cannot be demeaned by any label or its lack.

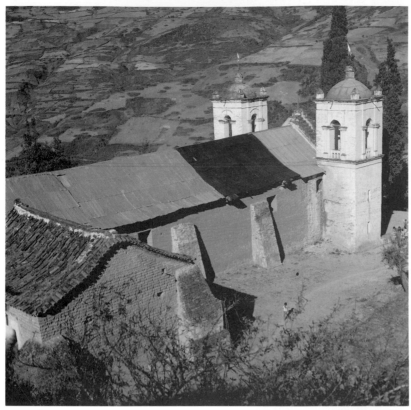

4. Church of San Juan Evangelista. Analco, Oax-
 aca.

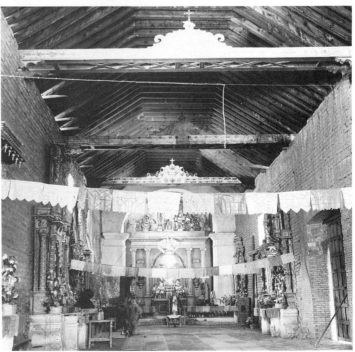

5. Nave, Church of San Juan Evangelista. Analco,
 Oaxaca.

In the last decade Latin American colonial architecture has often been disparaged as imitative and provincial, but this criticism seems rather at odds with the assumption that a style like the Baroque is diffused precisely by the imitation of ideal models. If New Spain was without geniuses, it was also free of academies and their stultifying perfectionism. Within the idiom of the model provided, spontaneity could flourish.

What is wanted, in looking at this colonial art of Mexico, is some sort of innocence of the presuppositions of European art history. Chronology, the sequence of styles (and their purity), the notion of individual self-expression, all function somewhat differently in the Western Hemisphere. Terms like "provincial," "*retardataire*," "hybrid," "incorrect," varied by "derivative," and "inept" get us nowhere. What is wanted is an interested—indeed, a passionate—scrutiny of the objects of art themselves. We cannot avoid the flow of time, the expansion of European culture over the land, the obscure growth of Mexican society and its institutions, or the fluctuations of material fortune to which art is so sensitive. We must note the transitions from certain forms to other forms, that tendency to mutation which is one of the things that shows art to be alive. But let us *look* at the church, the painting, the altarpiece—just look—without at once worrying about the framework of periods and styles, or the lack of examples suitable for labeling with European terms.

So we return to what the anthropologists call the artifact. When we speak of an artifact, we mean anything that man makes: tools, for instance, and all objects of use, as well as *objets d'art*. How illuminating to think of a whole frontier mission, with all its furniture, as an artifact: the complicated, articulated solution to a need, just as an arrowhead is a simple answer to a simple problem. Patiently attended, the missionary complex will yield all sorts of information. We can learn about ritual, and administration, about the friar's life, his homeland and training, belief and hopes, about the number and character and needs of his congregation. A vault of Gothic ribbing over the altar means that a European has been here. The great painted and gilded retable tells us that he was Spanish. When you see Renaissance grotesque friezes, you can surmise: the sixteenth century? Looking closer, you find Aztec tiger-knights painted among the scrollery—and it is clear that the painters themselves were *Indians*, and working in that first part of the sixteenth century when they still remembered the old days and were encouraged to do so. So the artifact is like a man-made geology that will explain itself by showing what has happened in the past.

"In 1525, they built the church of San Francisco in Mexico City; it is small, and the chancel has a vault made by a mason from Castile. The Indians marveled to see the vaulting, believing that when the scaffolding was taken away,

the whole thing would certainly fall; and they were afraid to walk under the vault, convinced that the stones would not for long stay up in the air by themselves. Since then the Indians have made two small vaulted chapels in the province of Tlaxcala." When we look (following Motolinía's direction) at such a small vaulted chapel in Tlaxcala, we look at the reality of Mexican history. The contrast between the daring principle of construction, and the clumsy ribs which a child might have rolled out of Plasticene—and which only partly realize their function in the true arch—tells the story.

This is the Spanish Conquest, which happened not once in 1521, but over and over. And perhaps not only in one direction, but back and forth: it was surely an Indian conquest of the Spaniards as they took up the eating of chocolate and tomatoes and tamales. Or, as the cut stone of the Aztec temple was reassembled on the old sort of paved plaza, into a Christian church this time, and the Indian musicians stood in the churchyard playing their ancient tunes on their Indian instruments (to a Virgin with a different name)—what was surrendering to what? Who was surrendering to whom?

Artifacts are the stuff of history. They not merely evoke history, they *are* history in visible form. They are the unique residue of history, the past surviving into the future, tangible, recalcitrant.

For all such meditations, Mexico is a superb arena. The total history of mankind is, as it were, exemplified there, illuminated, isolated. In the background are stone-age civilizations—a long, almost continuous record of development from the time of mastodons to monuments so splendid, so unpredictable, that they still surprise us. Just over the horizon are great migrations (like those of the Celts or the Scythians), and here, almost within touch, they are remembered through inherited narrative and recorded in picture-writing. Then comes the confrontation of Europe and America—the paradigm of culture-shock. Invasion and conquest, colonization, acculturation—it is an old story in the history of mankind. But here it is fully documented, told in the words of eye-witnesses (far more eloquent than Caesar), commented on by letter and petition, debated by lawyers and theologians, mourned by native voices, condemned by humanitarians, collected as anthropology, codified in laws and constitutions—and exemplified in the monuments. The history is long, engrossing, undeflected, as Mexico slowly emerges.

It was the viceregal period—from 1521 to 1821—which formed Mexico. In those centuries the future of the New World was cross-fertilized, incubated, fostered. Before Cortés, "Mexico" did not exist, nor did "Indians"; there was only land, over which various indigenous tribes—Aztecas, Mayas, Totonacas— speaking various languages, met in trade or in war. Cortés, for his part, brought

European soldiers—Spanish, Portuguese, Italians, Flemings, French, bound in a loose discipline. In the sixteenth century this immense campaign of acculturation, whether by conquest, by education or by conversion, was the daily preoccupation of all the participants.

Nomenclature has some role in this story. Who are the Indians? (The very name "Indians" was, of course, the original mistake of Christopher Columbus, who expected to find the people of India and was gratified to report that he had done so.) "Indians" are simply natives of the Western Hemisphere. "Mexicans" (although they had been given the name of a preconquest tribe) were simply more natives. A new name was needed for a new thing happening in the New World—neither the old preconquest thing nor the old European thing—and that is what can rightly be called *Mexican.*

The initial period of Spanish-Indian history in Mexico is so fascinating that we tend to linger over it and expand it far beyond its bounds. From the first moment (in 1519) when the ships with their great sails, like birds over the water, drew up to the shore of Veracruz (which did not yet know that it was Veracruz), and Montezuma's tax-collectors walked by—their hair elegantly dressed, carrying flowers and staffs, like figures on an archaic frieze—until the Spanish adventurers looked down on the Aztec capital, Tenochtitlán, floating on its lake "like the enchantments they tell of in the romance of Amadis" (as Bernal Díaz remembered it in his old age), the Conquest is sheer drama. If we tend to see it from the Spanish point of view, this is not only because the record is fuller on that side, but also because destiny was running that way. The Spaniards took the great city, and the country, and rebuilt it into New Spain. But for nearly half a century there was experiment and possibility—there was a chance that many good and new things might be salvaged from the Indian world.

In 1524 Tenochtitlán-Tlatelolco was being rebuilt on the island site, much on the same plan, as Mexico, the capital city. It seems to have been Cortés' choice (he had loved and admired the city he had destroyed), and he also considered saving at least one complete temple complex as a memorial, reluctantly dismissing the idea as too dangerous. But Europe was fascinated by the New World. As late as 1542 Viceroy Mendoza commissioned a report in glyphic writing as a gift for his emperor Charles V (from the Indian Francisco Gual-puyoguálcal). Botanists were sent out from Spain to collect and describe plants and their uses, and Indians also recorded their own botanical knowledge for the Spaniards. Great treasures of Indian art went back to Europe—of silver and gold and feathers and turquoise—to astonish such a man as Albrecht Dürer: "I saw

6. Fountain re-used as baptismal font, church of the Augustinian monastery. Yecapixtla, Morelos.

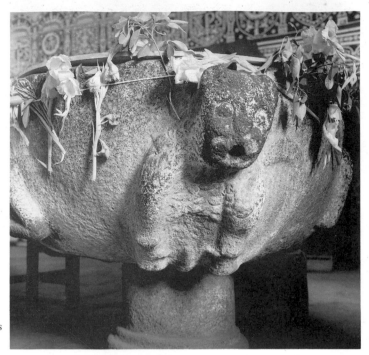

7. Facade, Church of San Juan on Christmas Day. Capácuaro, Michoacán.

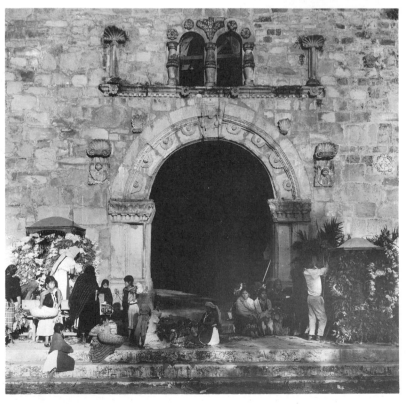

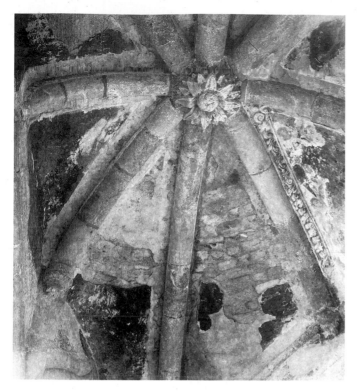

8. Vault, open chapel. Franciscan monastery. Tlaxcala, Tlaxcala.
9. Facade, Sanctuary of Nuestra Señora de Ocotlán. Tlaxcala, Tlaxcala.
10. Date stone (1589: 5-house; 1591: 7 reed), church of the Franciscan monastery. Tecamachalco, Puebla.

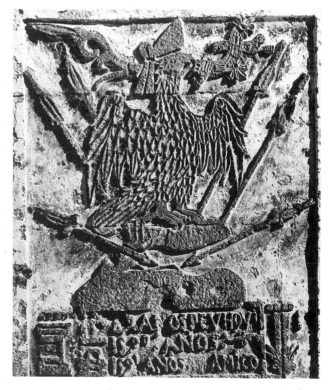

the things which were brought to the King . . . a sun entirely of gold, a whole fathom broad; likewise a moon entirely of silver, just as big. . . . I have never in all my life seen anything which so rejoiced my heart as these things. . . ."

In Mexico the same Indian craftsmen amazed the Spaniards by the dexterity with which they shifted to European models. There was considerable mating and some intermarrying; some mestizo sons of Spaniards became civil servants and friars. Indian society retained its organization, to a greater or less extent in different places: in general the nobles continued to be responsible for their people locally, to collect taxes (as they had for their Aztec rulers), and to supply bands of laborers for official activities, as they had always done. And although the missionaries were obliged to destroy the pagan temples and their graven images, some of the Franciscans, with the help of their Indian pupils, were recording everything they could discover about the Satanic devices of the Indian civilization—in order, as they said, to put Christians on their guard—or (as we should put it) trying to collect the anthropological data on Indian culture before it was too late.

It is worth noticing how many of the concepts and the experiments, not merely of imperialism but of political and social theory, were wrought in the debates of imperial Spain. From the very first days after Columbus' return, when Ferdinand and Isabella faced the problem of what to do with their discovery, the Spanish kept putting questions to themselves, with real concern and considerable gusto. Were they justified in seizing this new land? What were the rights of the natives? What sort of immigrants should be allowed to go to the New World? What sort of government should be set up in the Indies? Who should be sent to convert the Indians?

It is true that their opinions often clash with ours (undesirable settlers were the children and grandchildren of Lutherans, Jews, and Muslims; admissible, condemned murderers), but their concern cannot be faulted. Especially admirable was their willingness to see this as a new situation, for which no traditional solutions existed. Especially strange to us is their willingness to accept the decision of any duly constituted authority, such as the papacy. Thus Alexander VI allotted most of the Western Hemisphere to Spain, and declared that conquest would be justified by bringing the savage inhabitants into the fold of Christianity. But in fact it *was* an unprecedented situation, and, although we may find it ludicrous today, the debate at the University of Salamanca in 1517, which established that Indians were rational beings and possessed of souls, should be applauded for its open-mindedness.

Already in 1508 the papacy had delivered the control of the colonial church into the hands of the Spanish monarchs. Now, listening to Cortés, Charles

V appointed the Mendicant Orders to the task of conversion—Franciscans, Dominicans, and Augustinians. The Indians, said the emperor, were "to be instructed, and to live, in our holy Catholic faith as Christians, for their salvation, which is our principal wish and intention." Also in the laws of Burgos (1512) and in the New Laws (1542) the throne worked scrupulously to define the rights and describe the civil status of Indians as well as Spaniards. When all of this effort proved imperfect, they listened to the dissenting voices, as in the criticisms of Zurita, or the great debate between Ginés de Sepúlveda and Fray Bartolomé de las Casas. Of course nothing at all like perfection was ever achieved, but there did continue under the empire a slow maturing of the idea of human justice. It was in reference to Spanish America that Paul II in 1537 enunciated the cardinal ethnic proposition. With all the prestige of Peter's throne, he declared that Indians were indeed human beings, whose human rights must be respected; he specified that they could not be deprived of liberty or property, and went on to extend this to "all other nations which in the future may come to the knowledge of Christians." However some people might behave to other people in the centuries to come, man's humanity was never again brought into question.

We recognize in these preoccupations, these declarations and regulations, the concerns of modern man. Granted that it proved impossible to transform life, the impulse was there. The fault was not in their intention but in their understanding; their solutions did not work, their problems went unsolved because they were too complex for a plaster of simplistic good intention. "We desire," wrote Charles V, "that the Indians be treated as our vassals of the Crown of Castile, since they are so. . . ." But it was not as easy as the Holy Roman Emperor assumed.

It was an extraordinary situation in the Americas in the early sixteenth century, and the missionary friars were extraordinary men. The Franciscans, who came first—three in 1523, including Pedro de Gante, twelve in 1524, and Juan de Zumárraga as first bishop of Mexico in 1527—were men singularly conscious of their apostolic mission. (Not by chance had twelve been chosen.) Soon such Franciscans as Motolinía and Martín de Valencia were matched by Augustinians, like Alonso de la Vera Cruz, and then by Domingo de Betanzos and Bartolomé de las Casas among the Dominicans. Devout Christians suspected that God the Father, looking down on Earth, had seen that things were ready for the deliverance of the Indian peoples, and said: "Let America be discovered!"

When the moment came, Spain had a spiritual elite, ready to become a spiritual army for the salvation of the New World. The wave of reform which

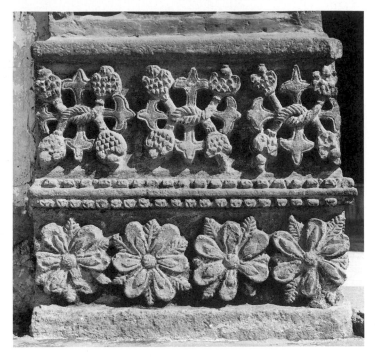

11. Detail, portal. Church of Santiago.
Angahuan, Michoacán.

13. Jamb, portal of Cabildo (Government Palace). Tlaxcala,
Tlaxcala.

12. Jamb, portal. Church of Santiago. Angahuan, Michoacán.

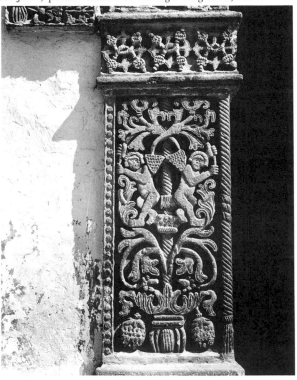

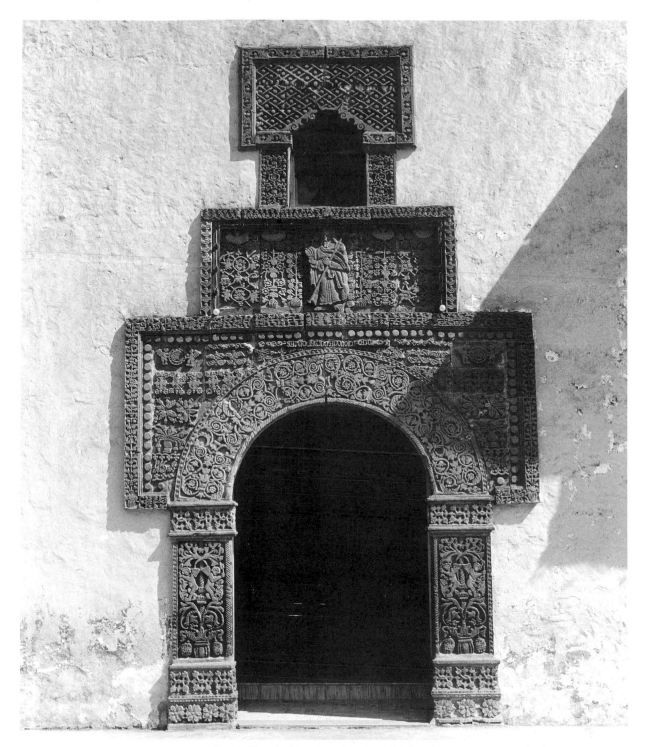

14. Portal, Church of Santiago. Angahuan, Michoacán.

had produced the Protestant schisms in the north had shown in Spain in a group of enlightened churchmen, foremost among them Cardinal Ximénez de Cisneros, Archbishop of Toledo and Primate of Spain. The Mendicant Orders, and especially the Franciscans, had rededicated themselves to a simple and pure Christianity. When Cortés suggested that only Mendicants should be sent to New Spain, they were ready for the task.

It is worth noting, as we look into the past, that the friars of this first wave were far from being narrow missionaries. Like Cisneros and Erasmus, many of them were intellectuals, men from the universities among them. Many of them were of good family, in a time when only that class had much freedom of choice. And they were of various nationalities, like the Church of Rome itself.

They were first and foremost Christians, and they never doubted that conversion with baptism was the first incomparable good which they could bring to the Indians, but they also shared an intellectual curiosity and a large view of their mission to a whole nation which reminds us that we are speaking of the Renaissance. This missionary campaign was to prove not the least interesting experiment of an experimental century.

The presence of the Mendicants was, in fact, the sign that a real effort was being made, officially, to find an ideal Christian solution to an unprecedented situation. For a little while, certain of these friars and other churchmen, in company with an exceptional leader like Cortés and a group of civil servants who were interested in the idea of justice, with some noblemen, and even some kings and an emperor, were actually projecting a new kind of Christian society—free, Utopian—for the New World.

Now we can understand the monastery buildings, immense, austere, dominating the landscape with their air of authority. They are the outposts of Christian civilization across the land. In New Spain the importance of the Christian church was not only religious—or only in the medieval sense, in which all of life is within religion, or in the sociological sense, in which the church is the vehicle of the culture: in becoming Christians, the natives of New Spain became also the heirs of European civilization. The Church was the gate through which the Indians, and all those to be born Mexicans (of whatever parentage), could enter the Western European world. It was in sober fact an organ of the government, which financed it, approved its plans, and appointed its clergy. Certainly it was the European element that lay deepest, and spread most widely, in Mexican life, and the one which must take the major credit for what was, on the whole, a peaceful conquest.

Mexico had been a theocracy under Montezuma, and for a while it functioned in rather the same way under the Christians. The temples and the

pyramids, pulled down, furnished stone for the churches, which were occasionally built on the very location, and always inherited the civic functions of the temple precinct. New deities (in an entirely new style) moved in beside the old ones; it is dubious whether the sixteenth-century Aztec differentiated very delicately between the Company of the Saints and polytheism. New feast days, sacred to these new gods, coincided in a remarkable way with old sacred times—at harvest, at planting time, or at the solstice. The daily ritual of the Christian year, focused on the monastery church in its great churchyard, had to fill the gap left by the disappearance of Aztec or Mayan ceremonial society.

But the friars did more than baptize and preach. They learned Indian languages and wrote dictionaries and devotional books; they set up schools for noble Indian children—to train a Christian elite for the next generation—and schools for craftsmen and musicians. They advised on agriculture and cattle raising; they collected libraries and set up printing presses; they ran hospitals. No one should imagine that these buildings of the sixteenth century were large and imposing and richly furnished by chance, nor that they represent nothing more than Roman Catholic ostentation. These buildings were the vehicle and the expression of colonization, the tangible exemplars of cultural as well as religious indoctrination. One might paraphrase Hernando de Talavera: *Architecture* is the tool of Empire.

In another way it is impossible to understand—or even to believe— these frontier monasteries. How could a handful of Franciscans, however dedicated, achieve such a work in less than a century? In 1524 "there was not a church built in all this realm"; but "there are now about forty houses, in this year of 1536," Motolinía reported. By 1538 there were also eight Dominican monasteries; by 1559 there were forty Augustinian houses. How could such a small number of friars—certainly under 2,000 in 1590—found, build, and man these missions, spread over the whole country from Zacatecas in the north to Chiapas in the south? By then there were over three hundred of them, and a good proportion were extensive, well-built architectural complexes.

The century of the Conquest and the great conversion provides the most heroic of Mexican architecture. It is true that stone could be quarried freely from the pagan buildings, or anywhere else, and that there was an almost inexhaustible supply of free labor. But these laborers were, at first, untrained in European methods, unused to the tools, and completely ignorant of the premises of European architecture. There seem to have been few professional architects in the colony; a surveyor, like Alonso García Bravo, might fill the gap, or a Spanish construction worker, like Juan de Entrambasaguas, whose first payment was for quarrying stone. No doubt the company of the friars included experienced

builders, but they are, as it were, invisible. It is true that building projects would automatically become schools where Indians learned to do things in the Spanish way—as in Motolinía's story of the vaulting of San Francisco—but who was to teach them? Motolinía says that it was "a master from Castile" who built that vault, and one can only surmise that there must have been also a number of such invisible Spanish artisans in New Spain by mid-century.

But even with every concession to probability, calling on every imaginary possibility, the number and size of these ancient buildings must continue to amaze. They do not represent the probable, or even the possible: they represent a dynamic vision, and their unlikeliness is an important characteristic. A great many of them are still standing—abandoned, converted, rebuilt, or in ruins, they stand like majestic natural landmarks in the countryside, the mountain peaks of viceregal history.

One of the delights of the sixteenth century in Mexico is this quality of the unexpected. You drive over the brow of the hill, and there in the valley, rising above the one-story town, looms the massive bulk of the monastery, with its crenellated roof lines and its bell tower—as totally improbable as a galleon on a village pond. The situation which produced them was unorthodox enough, with its small band of enthusiasts (fully authorized, however) and its mass of natives, with its contrast between the stores of raw material and raw labor and the scarcity of experts to use them. So, in one building, one may savor an uninformed but resolute solution to some problem of construction, in another, the innocent mixing of proper "styles" from Spain, or novel and peculiar decoration, or an unnerving echo from the distant past—Byzantium, perhaps—as a similar situation calls up a similar result. In the circumstances, their faults become their charm. And just when one has accepted and begun to expect such homemade delights, there is a further surprise: one looks up to see an impeccable cloister, a facade designed and carved not only with elegance, but with a fastidious Renaissance propriety.

The elements of the unpredictable are so manifold that the game is not to trace them down, but to give them free play. We should not worry about the correctness or propriety of each item, or about identifying its style, or tracing its prototype, or think about genius or about canons of taste. Think rather about men's memories of their youth—Castilian or Flemish or Aztec—think of drawings and plans brought to the colony and passed around like skirt patterns, of the jokes and puns of anonymous stonecutters, and the light-hearted way in which new and disparate items (mermaids? wodehouses? Tiger-Knights?) can be accommodated within the standard old Renaissance foliage.

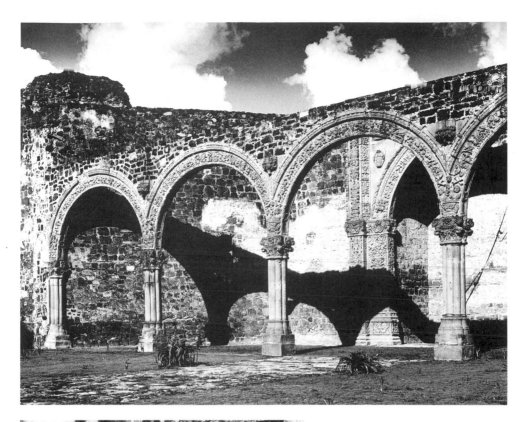

15. Open chapel, Franciscan monastery. Tlalmanalco, México.

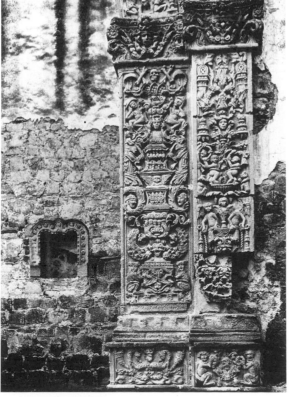

16. Pier, open chapel. Franciscan monastery. Tlalmanalco, México.

It is in this early period, partly through a positive interest on the part of the friars, partly through their neglect, that one finds a slight, but genuine Indian quality in architectural decoration. Only in decoration (which is without meaning), and rather more through the eye and hand of the artisan than in any direct presentation of motif or content, do we catch a flavor different, non-European, and specifically Indian.

The classic ideological problem of Latin American art—how much Indian residue is there in it?—is a question on which passions have run high. In consequence, the most delicate definition is required. Everything becomes simpler if in this respect we use "Indian" to mean *preconquest* Indian culture. Everything becomes clearer (when we are talking about art) if we insist on pointing to what we mean: it is no use talking about art unless you look at it, and unless you can show what you are talking about. When it is, then, claimed that a certain facade shows an Indian influence, one must ask: where in preconquest art do you find something like this? and how was it transmitted to this post-conquest artist—and when?

Plenty of problems remain. What does the phrase "preconquest art" refer to? Does it mean motifs and iconography only, or techniques and materials, or will it embrace also principles of design and aesthetic choice? *Which* preconquest art does it mean? for one must not forget that "Indian" is a convenience term to cover many and diverse cultures. Before you suggest this "influence" of Aztec taste on an Augustinian monastery, you had best know what you mean by Aztec taste, and how such an influence would be transmitted into the state of Hidalgo sixty years after the fall of Tenochtitlán.

The question of an Indian quality in viceregal art is many questions about many different situations. It has to be considered over and over—here in reference to the earliest colonial buildings, later in looking at full-blown Baroque. It is still around in the twentieth century, having suffered a self-conscious resurrection at the hands of the mural painters. But what is essential is to think of sculptors, both Indian and European, and the friars who directed the building of the monastic churches, and the engineers and architects who laid out towns, built aqueducts, and designed cathedrals, and the way artisans are trained, and various kinds of stone and wood, and old and new tools, and recipes for plaster, Moorish or Aztec—what is essential is to think of all such things as real, active elements in real situations.

One must step into the stream of time and try to estimate the meaning of a decade or a half-century in terms of human life (or human memory), for time is a tremendous factor here. The same chronology which proves so whimsical in terms of European fashion moves inexorably to sweep away the Indian heritage.

True that it does not move uniformly (any more than the geographical incidence of Indian culture is uniform); true that there are always capricious factors in anything human. But if we want to discuss an influence from preconquest culture in the last decades of the sixteenth century, we must try to face it as a real situation.

In 1585 there would be relatively few men living who remembered the Conquest (they tell us that in the sixteenth century very few people of any sort lived past fifty). The mature stonecutter is likely to be the *grandson* of the young stonecutter who had begun to work before 1520. Even if he is the son of that young Aztec stonecutter, he himself was born after the Conquest, and trained when his father had long modulated his craft to the requirements of the Spaniards. They now have new models, for working on new types of monuments, to satisfy new masters, and to achieve a new sort of security. It was a new world not only for the Europeans.

But not all of the old men had forgotten (one can protest), nor had they all died. Of course some had treasured—and passed along—traditional tricks and turns of their craft, as well as (perhaps tacit) habits of choice, rather than a conscious aesthetic. But to call the carving on the *posas* at Calpán *Indian* means something quite definite, namely, that we believe that whatever is different there (from the posas at Huejotzingo, let us say) has been caused by the positive intrusion of a different kind of sculpture, namely Indian—that is, preconquest Indian sculpture. If the posas were built around 1550, this is still a possibility: a young sculptor twenty years old in 1521 would now be only around fifty, and not necessarily dead. If in this period we can see anything like a vital tradition, it must mean that Indian workshops and Indian training existed quite apart from their Spanish employers, from the schools maintained by the friars to educate them in European ways, or the European artisans whom they assisted. In some informal sense, this would seem to have been true, at least for a time.

One can imagine a situation in which generation after generation of craftsmen learned their trade from their fathers, maintaining an art of which only they remembered the significance. But nothing like this appears to have happened in Mexico. Even before the end of the sixteenth century, to speak of an influence from preconquest art is dubious. (Probably we see more preconquest sculpture today than Indians did in sixteenth-century Mexico.)

Meanwhile, however, the situation was still mixed up and contradictory. It was still a time of conflict, and every positive statement can be matched by its contradiction. "Look!" we say, "Preconquest decorative carving is finished!" and then we see that there are a few Nahuatl inscriptions written in Roman letters, and other examples of using bits of preconquest culture as if it were equivalent

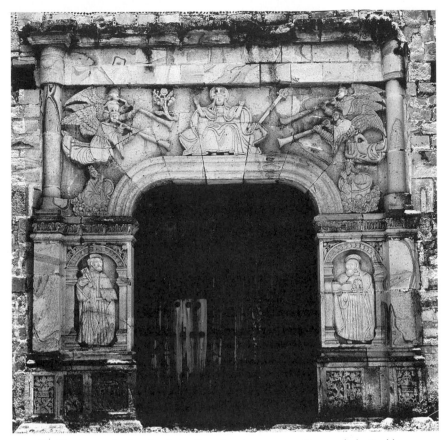

17. North portal, church of the Franciscan monastery. Huaquechula, Puebla.

18. Saint Peter. North portal, church of the
Franciscan monastery. Huaquechula, Puebla.

19. Churchyard cross, Church of Santiago. Atza-
coalco, D.F.

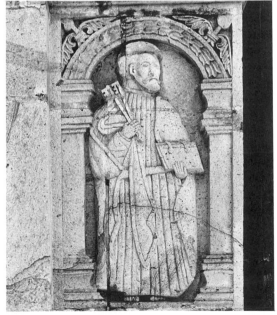

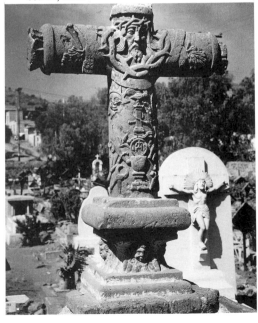

to the Christian. At Tecamachalco the dates are cut in both Arabic and Aztec reckoning, and on a baptismal font at Acatzingo the sculptor carved a rabbit that was a year-sign.

But these vestiges are very rare, and it should be observed that their rarity is not entirely the fault of the Christians: knowledge was too elite in the Aztec world, confined to too small a group, to survive the debacle in which that group lost their privileges. If all stonecutters had been conversant with glyphs, there might have been more such inscriptions.

This persistence of preconquest motifs under the Spanish empire is called *tequitqui.* The word is Nahuatl, used by the Aztecs to denote a vassal or one who pays tribute. The word "mudéjar" has the same meaning in Arabic: the art of the Moors under Spanish rule. This term recognizes that there was some interaction of the conquered culture in the work commissioned by the Christians, and very delightful it is. It also reminds us that the mingling of different cultures was an old story to the Europeans, and that a building like the mosque of Córdoba is a model of tolerance.

Much more numerous—and difficult to categorize—are examples of purely decorative carving, usually following familiar European patterns, but here skewed more or less toward unseen models in the sculptor's memory. A doorway might be framed—as on the old Cabildo at Tlaxcala or the church at Angahuan, or an arcade decorated, as in Tlalmanalco—by carving similar enough to European decoration to be inoffensive, and yet very different.

Sometimes one can project a lost model—St. Peter and St. Paul in the robes of Flemish burghers, for our tequitqui sculptor. The exotic quality of the reliefs on the north door at Huaquechula comes less from their clothing, however, than from the effort to render in low relief the two-dimensional model which, in turn, had tried to interpret round figures in flat perspectival illusion. It is fair to call this tequitqui (instead of poor drawing) because the symbolic, flat, two-level relief with tape-like edges resembles (in style) preconquest examples. Sometimes instead of reproducing the familiar Ionic or Corinthian capitals in a cloister—or instead of merely falling short in such an intention—the workman designed a quite novel capital, so that one gets an impression of energy and invention, as if anything might happen.

Occasionally, from routine copying and the routine variations that come easily from the Indian hand, something extraordinary arises. Such is the facade of the Augustinian church at Cuitzeo; within the familiar Plateresque design that originated Acolman new motifs appear, and are rendered in a new kind of relief. The whole thing is very handsome; the emphasis and proportion of the model are not impaired, but the detail is free and yet authoritative. To say that this is

no longer a pure Plateresque is praise, for it does more than repeat the Plateresque vocabulary: it creates something original.

Great stone churchyard crosses were carved for the center of the churchyard of the sixteenth century, and they are genuinely Indian. To break up the story of the Crucifixion into glyph-like symbols—scattered evenly over the shaft like the glyphs on an Aztec tribute-roll, all in crisp, two-level carving, bulging like a pillow and under-cut for greater sharpness—while the cross transforms itself into an idol, of which Veronica's veil is the visage, and the foliated finials the extended hands—this is true tequitqui. In such examples one catches a glimpse of what was lost in Mexico: something growing from the two traditions and yet new—not revolutionary but exploratory, inventive—perhaps the same pristine thing that the first Franciscans had felt in the Indians, which gave them hope for the Earthly Paradise.

A few techniques and materials were also carried over from preconquest into colonial times—saints molded of a paste made from corn-pith, turquoise inlay used for altar ornaments, feather mosaic substituting for embroidery—but these are all lost arts. The mural painting which was the first decoration in the monasteries and their churches was probably as much Indian as it was Spanish; at least painted walls were a familiar usage in preconquest Mexico, which was hardly true in Spain in 1500. A way of making stucco pavement with a burnished glossy surface was taken over by the friars, so that sometimes one really cannot tell whether the patches of smooth red pavement are left over from the sixteenth-century monastery, or from the temple before it. Materials provided by the land—especially some unusual kinds of stone—are not precisely attributes of preconquest style; still, the translucent marble called *tecali,* the black volcanic glass, obsidian, and the rose-red porous volcanic stone named *tezontle* were all materials that the Indians had used. All were new to the Europeans, and their appearance—especially that of *tezontle*—qualifies the imported styles, setting a unique Mexican stamp on the Renaissance or Baroque buildings.

Even in the earliest days, one would hardly expect to find church buildings influenced by preconquest architecture. There really seemed to be nothing in the pagan sanctuary that could be converted to Christian use. A church is a spacious void to hold a congregation; the Aztec holy place was a small shrine raised on top of a pyramid, "a sort of grandly monumental abstract sculpture."

One Christian usage that developed in Mexico does show more than a reminiscence of Indian arrangements. This was the use of the churchyard as an open-air church—the sanctuary represented by a chapel open to the walled yard,

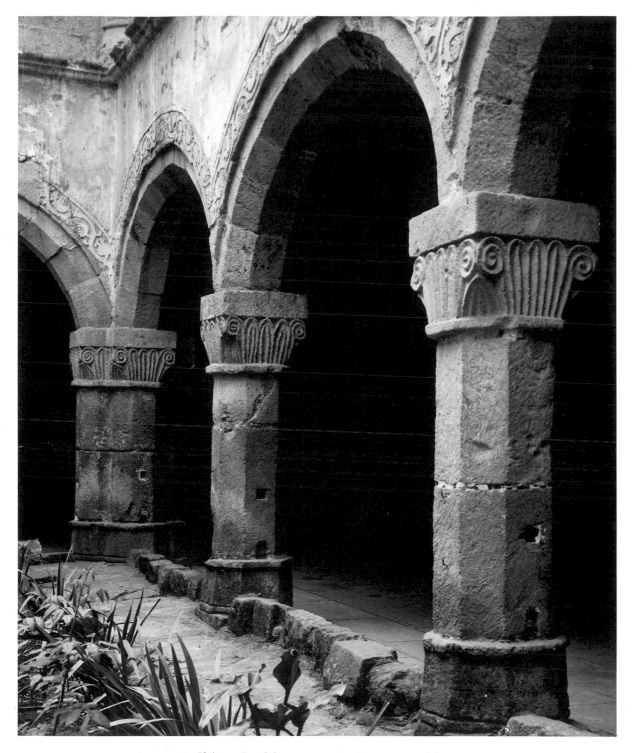

20. Cloister, Dominican monastery. Amecameca, México.

which served as its nave. The resemblance to the open-air temple precinct of the Indians, where they gathered to watch the ceremony of sacrifice, is obvious.

The reason for an open-air church is also obvious. In a country without churches (or architects, or crews of experienced builders) there were suddenly immense congregations to accommodate—the same congregations which had attended in the pyramid courtyard. One may question how deep, or how deeply understood, was the first conversion, but one cannot argue the fact: not thousands, but hundreds of thousands of Indians were baptized, ready for catechism and confirmation. Some of the Franciscan attempts to convey the pressure of mass conversion are almost ludicrous, as with the two missionaries at Xochimilco who baptized more than 15,000 people in one day by working in shifts, or in the complaint that "it happened many times that they could no longer raise their arms to perform that function, and even though they changed arms, both were worn out." All of this was, by definition, before churches were built—"en el campo (in the countryside)," as Brother Motolinía says.

That the Indian congregations continued outdoors even after the building of a church goes to show that the open-air worship had a special purpose. The first of the Indian chapels, San José de los Naturales (St. James of the Natives), which belonged to the Franciscan mission in the capital, was organized by Fray Pedro de Gante, one of the first three Franciscans who had come from Flanders in 1523. He learned Nahuatl, and published in Antwerp a catechism (Nahuatl written in Spanish phonetics), and he devised the plan of teaching the sons of the Indian nobles in order to spread Christianity throughout Indian society. One feels that it was not merely necessity, but a sympathy with Indian ways which invented the open chapel; parishioners also had special badges to show they belonged, and they performed plays at the major festivals of the Christian year. The open chapel was the first natural link between paganism and the new life.

That there were also open-air gathering places in Europe at pilgrimage sites, and that in the whole arrangement there is more than a reminiscence of the Muslim mosque with its courtyard does not at all invalidate the Indian precedent. It reminds us (as Bartolomé de las Casas put it) that "all the peoples of the world are men," that human solutions are apt to be similar everywhere. Architecturally, the open chapel is made up of European elements, like everything the Spaniards built (though the original San José, with its timber frame and thatched roof, would have been much more like an indigenous building). But the total plan of the churchyard, with its corner shrines, called *posas,* and its central cross, seems to have no larger precedent in the Old World. This was the one fresh invention of the missionary church in New Spain, an innovation in usage and in its architectural expression.

San José de los Naturales has long since disappeared, like the cultural situation which created it. An early variation, the Capilla Real at Cholula, can still be seen, as it was new-roofed with domes in the eighteenth century. So can scores of smaller open chapels of sixteenth-century construction, scattered over the country where the friars had been. Sometimes closed in now to make ordinary chapels, sometimes converted to the apses of later churches, as in Yucatán, sometimes standing abandoned or forgotten in their churchyards, they are the oldest buildings of New Spain. Some of the best of tequitqui decoration is to be found, as one might expect, in these churchyards which especially belonged to the Indians.

For the rest, the monasteries are comfortingly familiar. We can find our way at once in an unvisited monastery not only because we have been in other Mexican monasteries, but because the scheme is so right. And it is right not primarily because it cares for the Mexican situation, but because it is the end-product of a long evolution throughout all of Christendom. The traveler from Mexico will be at home also in English monasteries, and in Italy and in Jerusalem, as well as in Spain, and if he loses his way in the Escorial, that is simply because the Escorial was permitted to be eccentric.

"As for the building of monasteries, there have been great mistakes made." So the first viceroy, Antonio de Mendoza, warned his successor, Luis de Velasco, going on to say that he had agreed with the Franciscans and Augustinians on a modest sort of standard plan—"una manera de traza moderada"—which the Dominicans should also be urged to follow. No statement of this plan exists, so far as we know, but it is at once apparent to any visitor that it did exist. For all the variety of the Mexican foundations, the pattern is, at least in the great period and in central Mexico, almost unvaried. Like the New World urban plan, which was written into law (it seems) only after most of the cities had been laid out, the monastery plan must have come into being as common, if uncodified, knowledge. There seems little doubt that this happened in the colony itself. One should think of it not as the summing up of autocratic orders, but rather as the rule-of-thumb by which an unschooled builder figures out how to space the windows or how tall a chimney must be. The standard plan is, as it were, the Platonic simplification of the Christian missionary's life.

If this plan was partly folk tradition among the Orders, it was also another example of the Crown's mania for controlling every phase of life in the Spanish colonies. They might have done better to send more architects and fewer inspectors, to choose gifted workmen and give them more scope. As it was, all

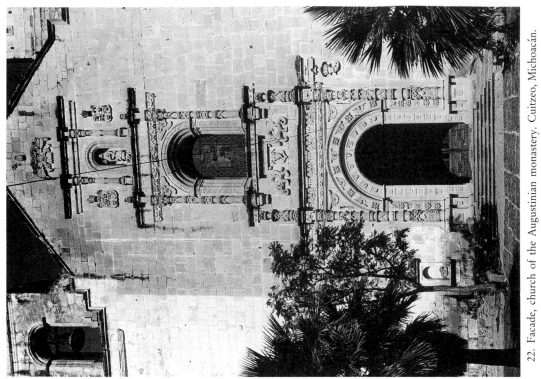

22. Facade, church of the Augustinian monastery. Cuitzeo, Michoacán.

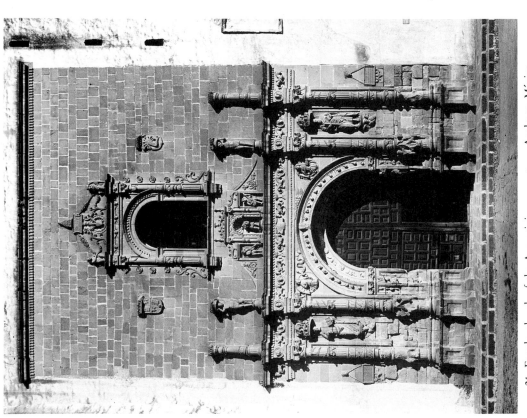

21. Facade, church of the Augustinian monastery. Acolman, México.

the early building was partly improvisation, and the amateur builders leaned strictly on their formula. At the beginning, while Indian workmen were being trained, everything was reduced to the simplest terms. Later this pragmatic simplicity was seen to merge into an aesthetic simplicity well suited to Mendicant philosophy. To plan and supervise these buildings was probably within the capacities of resourceful men, even without specialized skills (which we are never sure were not available within the Orders).

Although the monasteries were missionary projects, in the sixteenth century it was not generally a question of frontier conditions, of lack of labor or materials, for they were usually built in the centers of Indian life. The questions of size and design and character which arose were questions rather of the moral, or the expedient. In the first place, the Franciscans and Dominicans had taken vows of poverty. When circumstances made Franciscan residences necessary, St. Francis had provided for it in his testament: ". . . let them be poor, and used as if by pilgrims on this earth." In fact the Mexican Franciscans, early on, had drawn up a set of rules for what we might call the minimal monastery:

> The buildings which are built for the Friars' residence should be very humble indeed, conforming to the wish of our Father St. Francis: thus monasteries should be laid out to contain no more than six cells in the dormitory, eight feet wide and nine feet long, the dormitory corridor to be at the most five feet wide, and the cloister should have only one story, and be seven feet in width.

This formula had been approved by the Pope, Paul III, and it was probably used in laying out the first small, simple cloisters, before 1550. You can see one at Huexotla; as Father Mendieta added after quoting the order, "The house where I am writing this was built according to this rule."

Nonetheless, accusations of luxury, ostentation, and pomp were always being made against the friars. To people not in sympathy with their aims, every stone, every foot of decoration, every arch and vault was not merely wasted, but inflammatory. Many of the attacks came from Spaniards who believed that only they should be permitted to exploit native labor, who believed a large country house for a mine owner, for example, a far more suitable project than a large church for Indians. Envy and pride are also ingredients of the periodical attacks by bishops and parish priests. Undoubtedly there was some abuse in the monastic projects, as in all human enterprises; the amount of legislation in the rest of the century suggests indeed that the friars were under constant temptation to excess and eccentricity.

There were plenty of arguments on the other side, however, in favor of a reasonable luxury or a modest ostentation in the House of God. The friars pointed out at the beginning that Christianity had to compete with the remembered splendor of the heathen temples and their ritual: the church too must be large, imposing, and splendid. "It was necessary," the Franciscans explained, "to ornament and make a display in the churches, in order to elevate the Indians' souls and to move them toward the things of God, because their very nature, which is remiss and forgetful of inner things, needs to be helped by the outward aspect." In this they were following Augustine of Hippo, who had remarked that "Our soul riseth ... unto thee, helped upward by the things thou hast made." The Dominicans, who in the early years were often rebuked for their "impertinence" in building, had been advised to avoid "curiosities and paintings"; soon, however, painting, sculpture and ornament, if "useful for the service of God," were admitted. Most intransigent were the Augustinians; they had not taken a vow of poverty, and when questioned replied proudly that they had, indeed, built splendid churches, and furnished them lavishly, as was their wont.

The question hinges on whether the monastery was "more sumptuous than the village could stand," as Bishop Zumárraga complained to the emperor about Ocuituco. It was whether Fray Juan de Utrera was building "not according to the requirements of the place, but to those of his art" at Ucareo. Was it false pride? Was the cost to the Indian community disproportionate? On this we have the opinion of Alonso de Zurita, who was neither a churchman nor a resident of New Spain, but an observant Spanish traveler and a jurist interested in justice—that is, as impartial a man as could be found:

> Now, many Spaniards ... claim that the Indians worked harder in the days when they were heathen than they do now.... I shall show that ... in their commonwealths ... the building of temples and of the houses of nobles and of public works was always a community enterprise, and many people worked together with much merriment.... In this same way, with much rejoicing and merriment and without undue labor, they have built the churches and monasteries of their towns. These are not so sumptuous as some people have said, but accord with what is necessary and suitable, with moderation in everything.

Indeed, for all the complaints and legislation, the friars did on the whole build "plain, solid, and without any novelty." The lavishness was principally of size—of space—and of dignity. Even the altarpieces that began to appear at the end of

the century showed the same qualities of restraint and nobility; the extravagant and showy belong to the later centuries.

"In the churches so many, and such immense altarpieces . . . ," muses Grijalva, the Augustinian historian; ". . . so that the marvelous beauty of the Church Militant may shine out in the diversity of ornament," the Third Church Council explains. Already by 1528, according to Motolinía, the Franciscans "began everywhere to embellish their churches and to make altarpieces and ornaments . . . and since up to now [c. 1540] they have had no beaten gold on the retables—which are not few—they have given the images diadems of leaves of gold."

He tells also how Fray Pedro de Gante established a school of arts and crafts in the Indian chapel of San José, to provide such essential ornaments for the early churches. There was a serious need for images: Cortés seems to have traveled with a trunkful, for they are always reporting that "he explained the principles of our Holy Faith, and left them a figure of Our Lady." (Half a dozen little Virgins of wood—beginning with the Virgen de los Remedios—are still known as Virgen de Cortés, or La Conquistadora, and may indeed be such.) As early as 1512 the Laws of Burgos had required that anyone given an *encomienda* of Indians must provide a church for them, with a bell and "images of Our Lady." So it was prudent of Fray Pedro to try to supply this demand, and besides, as Viceroy Mendoza pointed out, the Indian artisans would also earn a living, and form a stabilizing elite among the Indian laborers.

A famous work of this Indian workshop was the altarpiece of San José de los Naturales (long since disappeared, like the chapel itself). According to the Indian chroniclers, it was inaugurated on Christmas Day, 1564, and it seems to have consisted of six large paintings, plus a predella, framed together.

It was just in time, as it turned out, that the Indian painter Marcos Cipac de Aquino (perhaps assisted by such other artists as Pedro Chocholaca and Francisco Xinmámal) set up this altarpiece, because in 1566 an enterprising Flemish retable maker was to arrive in New Spain with the third viceroy. Before this there had been a choice of imported images and paintings, or the work of supervised Indians; now there would also be the work of European craftsmen.

Here we are face to face with a real conflict between European and Indian. The Indians had been surprisingly agile in transferring their skills to European tools and techniques. "Now they make as good images as any in Flanders," Motolinía says bluntly. "According to my judgment," cries old Bernal Díaz, "that famous painter of ancient times, the renowned Apelles, or the modern ones

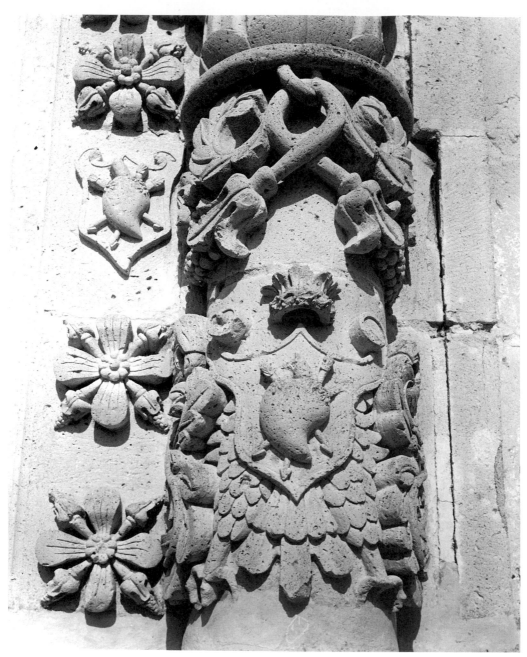

23. Column on facade, church of the Augustinian monastery. Cuitzeo, Michoacán.

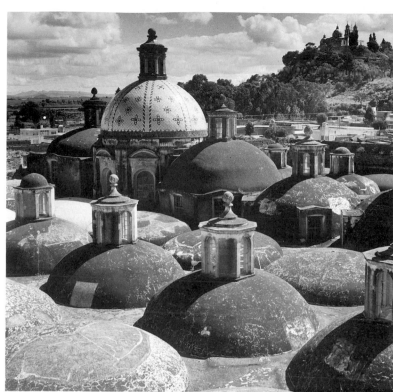

24. Domes, Capilla Real (open chapel),
 Franciscan monastery. Cholula, Puebla.

25. Capilla Real (open chapel), Franciscan
 monastery. Cholula, Puebla.

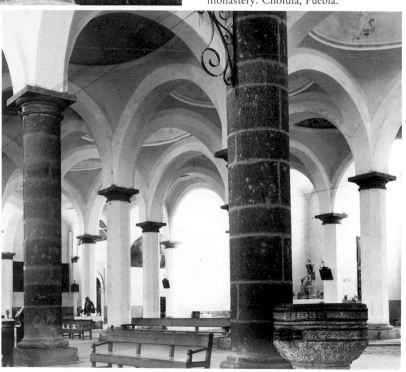

named Michael Angelo and Berruguete ... could not with their subtle pencils equal the works which are done by three Mexican artists." Be that as it may, it is undoubtedly true, as Mendieta puts it, that "practically all the good and skillful works which are made in all kinds of arts and crafts in this land of the Indies—at least in New Spain—it is the Indians who execute and make them." Even so, the Spaniards who were trying to get residences and government buildings constructed and decorated welcomed any European skilled labor that arrived. The friars might cautiously suggest that immigration be controlled, but one viceroy after another begged the Crown to send "good artisans," assuring them that there was no one in Mexico competent to build a cathedral, and so on. By mid-century one can name twenty to thirty experienced Europeans at work in Mexico City, and surmise the presence of a good many more who remain invisible.

When the bishop complained in 1556 that the Augustinians at Epazoyucán "are making a retable which will cost more than 6000 pesos ... for the back-country where there will never be more than two friars," we assume that the friars must have contracted with European artists, for no Indians would demand such a sum. Or when one looks at the facade of San Agustín Acolman, it is obvious that not only a European designer but European stonecutters worked there. However, one had better not feel too sure of anything. Until a few years ago the painter Juan Gerson, who was mentioned in the annals of Tecamachalco as at work in their church in 1562, was assumed to be a Fleming, not only from his name, but also from the Italian-Flemish character of the paintings on the choir vault. Now new documents have left no doubt that Juan Gerson was a native of Tecamachalco, an Indian, named for a famous French theologian. "On the said day [of 1592] license was also given to Don Juan Gerson, Indian noble of Tecamachalco, to ride on horseback with saddle and bridle ... and also (dressing, as he does, in Spanish clothes) to wear sword and dagger...." What this means to us is that the Indians were indeed transforming themselves into European artists, and valued members of the community. What it meant to the European artists who traveled to Mexico in expectation of a limitless market, we can guess. Henry Hawkes, an Englishman in New Spain in 1572, sums it up drily enough: "Indians will do worke so good cheape that poore young men that goe out of Spaine to get their living, are not set on worke."

It was an interesting challenge, to which the Europeans were able to bring no more than their old clichés: their superiority, their innate privilege, and the use of privilege to control (and suppress) a glut in the labor market. Instead of the Mendicant hope and experiment—instead of looking for new methods of training and employing willing craftsmen—they fell back on medieval usage and

exclusion: they founded guilds. They were forced to this, they claimed, by a more brazen medievalism: in 1550 the First Church Council had taken upon itself to supervise artists. Granted that their supervision would have been primarily doctrinal (to assure that the painters did not represent heresy), there was also a clause vesting in the bishops the right to evaluate paintings and determine prices, and that was going too far. The Guild of Painters and Gilders was approved in 1557. Now they had their monopoly: they had the sole right to define the standards of the craft, to train painters and then examine them and admit them as Masters into the guild, and thus to control the number and quality of practicing artists. In 1568 a guild of "Carpinters, Woodcutters, Joiners, and Viol-Makers" in turn submitted their ordinances for approval.

In approving the guild charters, the viceroy recognized the traditional monopoly of the Spanish master craftsmen. Then he turned around and recognized the natural right of the Indian workers "freely to use their craft," and even while approving the regulations, stipulated: "nor are any of these to be understood to apply to the natives of this country." One may ask how closely a guild could hope to control a country where the viceroy himself exempted the greater part of the practicing artisans. Nothing in colonial Mexico is a better example of the confusion (acculturation) that dominated the situation of Indian craftsmen.

But it is not really clear what the policy was, and even less clear what actually happened. Thus the 1557 Ordinances of Gilders and Painters stipulated: "That no Painter can receive an apprentice who is not Spanish," but also "That no Indian can sell the said items of painting or sculpture unless he has been examined, knowing the art to perfection," which certainly implies that he *might* be examined. The guilds in turn protected the Indians from exploitation by prohibiting the Masters to hire them or to sell their work; yet the Spanish artists needed the Indians as assistants. This second half of the century was a period of readjustments, and may well have been in continual change. What is evident is that the facts of labor and art in New Spain were very inadequately reflected in the official statements. Thus the 1570 Ordinances of Gilders stipulate "That no one who is not a Master should gild any . . . object whatsoever," while in 1585 "Marcos de San Pedro, Indian, gilder" contracted to gild the large altarpiece at Huejotzingo for Simón Pereyns, Master of Painting, whose guild prohibited his working with or hiring anyone "not properly examined." Perhaps everything had changed in the intervening fifteen years. Certainly the whole rigamarole was hopelessly irrelevant to the real situation, a good example of what happens when conflicting attitudes run side by side. But in this gap between what regulations described and what the individual actually did, the Indian workman never stopped working.

After the sixteenth century, with its special character and special hopes, had foundered (a couple of decades before 1600), there followed a century of uncertainty in New Spain. Perhaps no one had been quite sure what had been in mind; now everyone knew that there had been no realistic plan at all. There had been too many projects, too many conflicting enthusiasms, but no viable economic or social program to contain them. Now that was all over; the exciting days of the military and spiritual conquest were old men's tales.

When we say that the sixteenth century died prematurely between 1570 and 1580, we can point to a set of specific changes. The Indian population was drastically reduced by a series of epidemics. Spanish settlers were coming in ever larger numbers, not only soldiers and adventurers now, but artisans, merchants, priests and nuns, and even farmers. The haphazard economic arrangements by which mines and trade and the fleet were operated—primarily for the profit of the Spanish throne—began to break down. And the special dispensation entrusting the Christian welfare of New Spain to the Mendicant Orders was terminated. From our vantage point we can see that what happened in the Western Hemisphere was part of world events—related to the accession of Philip II, for example, and of Queen Elizabeth in England, to the activities of English and Dutch privateers, and to the Council of Trent. But in another sense it was all very particular, very Mexican, and like nothing else in the world.

For instance, the whole history of the Americas was affected by a special medical fact: the indigenous population had no immunity to common European diseases. Although the worst epidemic was still to come, by mid-century Indian deaths had already been shockingly high. The first epidemic of smallpox had killed Montezuma's heir, Cuitlahuac, and was a factor in the Spanish victory. In 1531 so simple a contagion as measles (it seems) had wiped out whole villages. An even worse epidemic—perhaps plague this time—fell in 1545. By the time the first viceroy, Luis de Velasco left, contemporaries were estimating the Indian population loss as between fifty percent (Zurita in 1555) and eighty-three percent (Mendieta in 1565). After the epidemic of 1576, the Indians of Xochimilco reported that from a population of 30,000 they were reduced to 7,000. Cuzcatlán, once a city of 40,000, had dropped to 460 tax-payers; Tecali, Tecamachalco, Tepeaca had all diminished by ninety percent.

Such hideous mortality could not but affect the spirit of survivors. The Indian social structure was shaken—the old hereditary elite was often wiped out, and with it the possibility of building the colonial structure upon it. Besides, with the people died the memory of the ancient civilization; the plagues worked to reduce the Indians to the primitive slaves, without inheritance or tradition, that some of the Spaniards preferred.

26. Cloister, Franciscan monastery. Tlaquiltenango, Morelos.

In those years around 1600 the ratio of Indians to Europeans was shifting also because of increased immigration. In 1595 a letter to the King protested against "the damage and inconveniences which come of allowing so many people to come out to these parts . . . for hardly a fleet arrives which does not land more than eight hundred persons." While the number of Indians dropped sharply, and then slowly continued downward until the mid-seventeenth century, the number of Europeans was steadily increasing. It was because of these things that Mexico would in the end be a mestizo culture.

So, after the dramatic sixteenth century, one begins by describing the seventeenth in negatives. Indian society had broken down, and forever. The economic life of the new colony had collapsed, and no one knew what to do about it. Spaniards who had dreamed of a lordly life without labor or distress found themselves hard up: the fabulous supplies of free labor, free land, and free building materials were dwindling away. The Spanish Crown itself was hard up, and began to pinch off subsidies. Territory to conquer was already difficult to find. Everything was in short supply: food (because farmers were), manufactured goods from Spain, and skilled craftsmen to make up the lack.

"Although I once knew a time when the term *Indies* implied plenty of meat, and at moderate prices, all that is now over," the younger Velasco wrote to his successor. Worst of all, problems of labor, of efficiency and of transportation had caught up with the mines—"the Mynes fall dayly in decay," wrote Henry Hawkes. New methods were not to be put into practice until the end of the seventeenth century; as late as 1690 silver shipments were still below those of a century before. This was the century when good resolutions about the Indians were forgotten; the viceroys kept writing to Spain that they *must* be allowed to put Indians into the mines, since all the Negro slaves had died in the epidemics.

Now also the missionary campaign of the Mendicant friars, with their vision of the New Jerusalem, began to lose its authority. No doubt the friars themselves were showing disillusion; the pioneer missionaries were gone by now, and to the new friars (who could hardly be so dedicated a band) it must have seemed that the Indians did not measure up to the role described for them. More priests came with the increase of Spanish immigrants; they and their bishops protested the peculiar position of the Orders—independent of episcopal authority, assuming the prerogatives of parish priests, and all this contrary to the dictates of the Council of Trent. Mendieta, that eloquent Franciscan, had warned that most of the newly arriving priests were unequal to the vision: "For they neither understood the task of converting the Indians, nor cared for learning their language, and much less for the Indians themselves; they were disgusted by their nakedness and odor of poverty, and there were not lacking some who said that

long years of study were not meant to be wasted on a people so bestial and stupid as the Indians." Nonetheless, slowly, over a period of time, and with much wrangling and intermittent stays, it was agreed by those in authority that perhaps the friars were no longer necessary, and the secular clergy began to move in. Missionary monasteries became parish churches, and the Mendicants had their choice of congregating in some few central houses or pushing on to the frontier where missions were still needed.

This dispossession of the Mendicants effectively marks the end of the first era of the viceroyalty. It serves as a sliding boundary, and a real one, since wherever the mission church survived was still, in some sense, frontier. Around Puebla, the friars were supplanted in the 1640s, under Bishop Palafox; Querétaro was secularized in 1682. Places like Zacatecas and Chihuahua, Chiapas, and even Oaxaca, continued longer in the hands of the friars; the California missions were still being administered by the Franciscans when the Yankees arrived in 1848. Their departure always marked the change from a unique to a more orthodox arrangement; in the Valley of Mexico it describes the ending of the sixteenth-century dream.

In these years a spiritual shift seems to have closed the Spanish mind to experiment and inquiry, just as the ports of New Spain were closed to foreigners. The arrival of the Jesuits set the intellectual climate for the seventeenth century; the institution of the Holy Office of the Inquisition was its religious counterpart. For the first time the Indians could be tried for heresy (on the presumption that they were all instructed Christians). And this was the century that began with Kepler and Galileo, to culminate in Isaac Newton's wrecking of the foundations of medieval thought! But none of that disquiet and questioning penetrated to New Spain; it was kept unspotted, protected from the future and even from the present. No heresy or revolt made headway, no Protestants raised their voices, no dangerous books were read. The Spanish had always revered tradition—like a sacrament—and New Spain was maintained by real effort in a kind of neo-medieval trance. Very suggestive is the development of the hacienda—that revival of the feudal manor—and its dominance over rural Mexico until the twentieth century. The experimental schools for Indians gave way to Jesuit schools and the Royal and Pontifical University, as scholastic as any in the world. A seventeenth-century archbishop would hardly have thought of citing the *Utopia* or paraphrasing Erasmus, as Juan de Zumárraga had done.

Although everything was changing, and usually not for the better, life seems to have gone on in New Spain without much comment. An unusual number of catastrophes plagued the country—earthquakes, prolonged rains and floods, crop failures that led to famine and rioting, raids by English and French

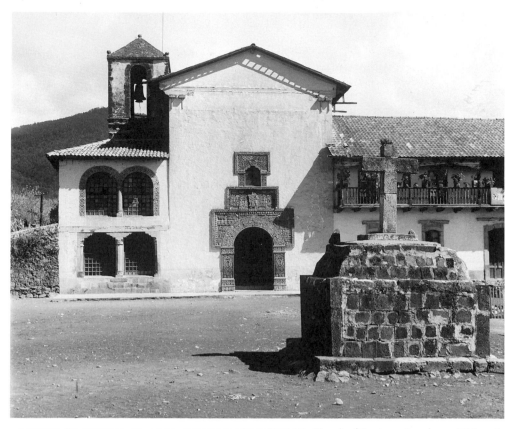

27. Church of Santiago. Angahuan, Michoacán.

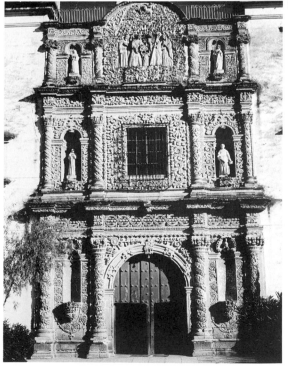

28. Parish church. Santa Anita, Jalisco.

pirates, even power struggles between the cathedral and the palace. But no one stood up in a pulpit and announced that the expunging of Indian culture was all but complete, and that the Indians' morale was irretrievably depressed. No one described the colony's economic situation as hopeless—underdeveloped, overextended, totally dedicated to the advantage of European Spain—though they noted, piecemeal, low revenues from mining, the suspension of public works, or the difficulty of buying eggs. Officially it was felt that with a few more regulations, more good Spanish residents, and a perfected bureaucracy, all would be in hand again. Meanwhile they must get on with building the appropriate cathedrals, provide the countryside with proper parish churches and priests, and see to the Viceregal Palace.

This history can be read in the architecture of the seventeenth century, if one looks at it acutely. On the negative side, no more of the large monastic complexes were built; or rather, they were built only on the periphery, in the sierra or on the frontier, still remote from the flood of Spanish immigrants.

In Mexico City, the central houses of the Orders were enlarged, their churches updated, rebuilt or refurbished. In provincial capitals also the Mendicant foundations changed character to fit their restricted activity. At the same time, other Orders were appearing in the country, building their mother-houses in the capital, to be followed by others farther afield. This began in the final quarter of the sixteenth century, with the Jesuits arriving in 1572, the Mercedarians in 1575, and the Barefoot Franciscans (known as Dieguiños) in 1579. In 1596 the Carmelite Order was licensed, and during the seventeenth century the Benedictines, the Bethlehemites and the Congregation of the Oratory of San Felipe Neri (called the Padres Felipensis) set up their houses in Mexico City.

Various groups of nuns also arrived, particularly the Franciscan sisters of Santa Clara (1579); by 1620 Vázquez de Espinosa reported sixteen convents in the capital. Many of these later groups were dedicated to some particular task, whether teaching or caring for the sick or sheltering travelers. For the rest, they differed from the original Mendicants because they served primarily the Spaniards; they settled in the Spanish cities, like Morelia or San Cristóbal, and they developed no special philosophy or procedure for the New World.

Most of the new building of the early seventeenth century is slighter, more sophisticated, and more up-to-date than earlier architecture. (Here we specifically exempt the frontier missions still building massive churches in a sixteenth-century mood, though with seventeenth-century detail.) If the presence of Jesuits and nuns of the Enseñanza indicates more Spanish population, their

buildings also evidence the presence of Spanish professionals and of Spanish-trained workmen. A Carmelite architect, Fray Andrés de San Miguel, would build their monastery of San Ángel outside the capital and the retreat of the Desierto de los Leones, and mark the houses of the Order with his personal style. Crews of skilled workmen seem to have worked for certain Orders, like the stucco workers who moved from Santo Domingo in Puebla down through Yanhuitlán and Etla into the Dominican monastery in Oaxaca. In the capital, the new church for the Franciscan foundation of Santiago Tlatelolco, finished in 1609, established the new model for the century: a church with a transept, and a dome at the crossing.

Hundreds of parish churches were founded, built, and furnished, as the priests took over from the friars. There was a double process of carving up the wide territories of the monasteries from which a number of friars had served the surrounding country, and of giving identity to new towns, both Indian and Spanish. Occasionally the *visita* chapels of the friars were already good stone buildings, like the parish church at Angahuan. Sometimes another century passed before they got around to replacing a temporary or inadequate church, but an astonishing number of the parish churches now standing seem to date from this period. As if to confirm the return to normalcy, they are quietly repetitious, with the small transepts and cupolas, the bell towers (one or two) on the facade, and the rather sober decoration of the facade itself. You can see a dozen of them right in the capital, and in the country you can hardly be out of sight of their pretty domes.

The decoration of these parish churches—and of the new monastic churches and the cathedrals as well—is a good index to their date. The facade reflects, with appropriate delay, what was happening in the metropolis. More monotonous, the seventeenth century was also more derivative or, at least, more correctly derived. No longer are we baffled by the indefinably pagan flavor of a carved doorway whose details all seem orthodox, but whose effect is exotic. There is no more tequitqui, because that special relationship of the Indian who remembers the old culture and the Spaniard who values it (or at least permits it) is over. The workmen are still predominantly Indians; but they are further and further removed from indigenous tradition. Nothing makes this clearer than a series of seventeenth-century portals: it is a cautious, correct group, perhaps a little self-conscious about speaking with the proper accent.

<center>⊰—⊱</center>

For art, the significant change as New Spain emerged from the sixteenth century was the arrival of the Baroque. It was this new mode in architecture—

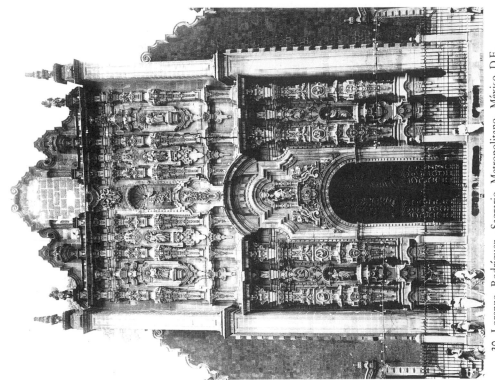

30. Lorenzo Rodríguez. Sagrario Metropolitano. México, D.F.

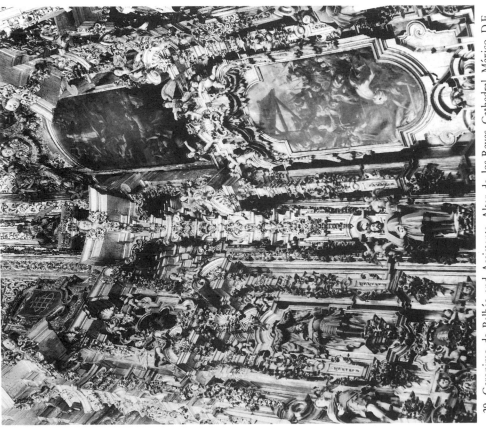

29. Geronimo de Balbás and Assistants. Altar de los Reyes. Cathedral, México, D.F.

the early sober Baroque of Juan de Herrera—which rescued the cathedrals from their medievalism and eventually carried them through to completion. Such facades, portals, and retables as the early part of the century produced followed the same example. From now on Mexico was given over to the continuing progression—the exploring, excursioning, inventing, varying of the Baroque— which we call a style, but which often seems more like a way of life, or perhaps like the cosmic forces among which one might try to make a life. The Baroque is not merely complicated, but manifold, contradictory; furthermore, one doesn't know what one is talking about. Earlier on, we protested that considerations of style should not be too much respected in Mexico; if we now agree that the Baroque must be coped with, perhaps that goes to prove that it is something more than a style.

The literature of international Baroque is (like the style) the most splendidly complex, confused, and contradictory imaginable. The term is applied to architecture—and to painting, sculpture, music, poetry, and human character. On the one hand, it is identified with a specific vocabulary of architectural decoration; on the other, it is extended to describe a mental attitude or an "*estado del espíritu.*" Sometimes it is identified geographically (Spanish Baroque), sometimes chronologically (seventeenth-century Baroque); sometimes it becomes a generic term, so that primitive art can have its baroque phase. Even if we take it in the simplest sense, as a historical style, there are still plenty of questions.

No one really knows where the word came from or what it was supposed to mean: it was intended to be insulting, but like slang it was at once trenchant and vague. Like "Gothic," Baroque referred to a falling away—a rebellion—from classical canons. It is plain that a Baroque designer (like a Victorian architect) was bored by the limited scope of the classical inheritance. Baroque is a style of invention and of excess. It seems, by this very quality, to elude a too exact definition: its destiny is to astonish, to break rules, and in so doing to create new canons of judgment. But is this not true of all art? To a Doric world, the Corinthian capital must have come as a great shock. The shock of the Baroque, however, came with the accumulation of eighteen or nineteen centuries of devices; perhaps to its anti-classical character should be added a bag of eclecticism garnered from the whole history of Western Europe. It is foolish to try to define this too specifically, and in the larger sense it seems that we are still not asking the right questions, for the term continues too inclusive and too contradictory.

Still we must use the term for the seventeenth and eighteenth centuries in Mexico. Something *did* occur in the stylistic history of Western Europe, some gathering up of old elements under a new impulse, which was peculiarly welcome

in Mexico. Perhaps one reason for its success was precisely that it was "impure," bizarre (even abusive of strict form), hybrid, and eclectic like Mexico itself.

There is really no point in measuring New World architecture against Baroque in Rome, to discover that it lacks spatial invention. It is even a waste of time to argue whether or not there is a "Mexican Baroque" or merely "Baroque in Mexico," or not even that. There *are* a number of captivating buildings, fantastic altarpieces, delicious domes and towers, houses with charming roof gardens, convents delightful down to the kitchens, school buildings of eccentric grandeur, and even cathedrals that qualify by metropolitan standards. Certainly they show the traits of style of the time, which was the period of the Baroque. There is no doubt that the Baroque modes had a sympathetic relationship to the Mexican mood. It would be foolish to deny that under this influence, and using its rhetoric, New Spain produced a fascinating body of art.

It has been claimed that Mexico embraced the Baroque style in the eighteenth century because Indians in preconquest times had preferred complexity of design. They say that the Churrigueresque altarpiece displays the same *horror vacui* as the Mayan temple, and that the Aztecs loved elaboration. Does this mean that aesthetic preference is a function of race: for example, that the color of a man's skin would predetermine whether he preferred spiral decoration? Or would it be a matter of geography? Was a preference for all-over pattern diffused like a miasma from the Mexican earth? All such notions are contrary to our understanding of the character of culture, of the history of a society, and of the nature of art.

The Indians of New Spain still spoke Indian languages in the eighteenth century, and they lived with many survivals from their ancestral culture. But these did not preserve Aztec or Mayan civilization or artifacts as they existed before the Europeans came; these were group memories or traditions transmitted into magic and folk art. Fray Juan de Torquemada, writing c. 1615, told how Archbishop García de Santa María mounted a campaign to destroy archaeological stones which people liked to use as cornerstones for their houses, commenting that "in his time it was already late for such scruples, for the Indians now alive not only do not revere these stones, but do not even notice them, or understand what they may have served for."

New Spain was beginning to take shape as something distinct from the Old World; Mexican-born Spaniards, and Indians, and mestizos were feeling their strength. There was energy and wealth to spare for building and decorating—and to this spirit the European Baroque styles, with their richness and grandiosity, offered an ideal vehicle.

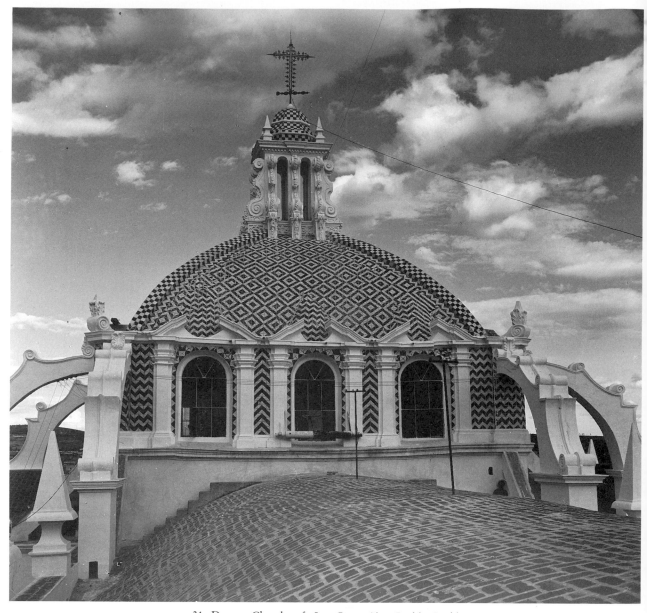

31. Dome, Church of La Compañia. Puebla, Puebla.

Baroque style arrived from Europe not only once, but in a succession of catalytic imports. One game is to analyze these events (several of which are quite specific in date), and to break up the flood of the Baroque into sub-styles and their examples. Thus certain elements can be traced to cathedral Baroque—like the domes which followed after Pedro García Ferrer built the first one (1640) on the Cathedral of Puebla. By 1680 there were thirty-six in Puebla alone. The next wave, which was felt around mid-seventeenth century, continues on into the 1730s, or even much later, here and there. One can generalize about this Baroque, pointing out attributes and components and tendencies that permit us to think of it apart—but the country is large, communication was still uncertain, individual builders were more or less skillful and informed, and, in short, the buildings and altarpieces refuse to fall into perfect classifications. Let us just say that there developed a richer style, marked by angular and polygonal forms, polychrome surfaces, heavy surface ornament that runs over everything like embroidery or vegetable growth, and, especially, the twisted column. Facades had a kind of severe opulence, clearly designed with plenty of columns and frames, and large didactic reliefs. The ultimate development of this rich but static ornament was the facade of the Cathedral of Zacatecas, dedicated in 1752.

The Ultra-Baroque style, which the Mexicans call Churrigueresque, was brought in by an extremely gifted designer from Seville, Jerónimo de Balbás, who demonstrated it on the Altar de los Reyes of the Cathedral of Mexico, between 1718 and 1737. This is the clearest date in the history of viceregal art, and one of the most dramatic events. The Altar de los Reyes is still Baroque, but a Baroque which has found its wings: every element of design is working against gravity, and with an instinct and coherency that can hardly be faulted. It is always hard to believe that this masterpiece was made with hands, and indeed it is easier to acquaint oneself with the elements of the idiom on the sister example, the Sagrario Metropolitano beside the cathedral. Here Lorenzo Rodríguez, another Andalusian, made two facades by hanging curtains of dark red tezontle from a broken Rococo edge (as it were) and setting before them altarpieces of gray *chiluca* stone. On the Sagrario one can see how it is put together—still with verticals and horizontals, bases and capitals and entablatures, but using a substitute for the shaft of the column, called an estípite. There is a good deal of foliage, busts and heads and putti, and pendant forms (*faldoncitos*) decorating everything and obscuring the form. Although too finical to describe in words, the estípite is instantly recognizable for what it is—the release of the column from its role of clarity and support.

Several things should be said about this Ultra-Baroque style. It is not the breaking down into anarchy of earlier Baroque systems ("carrying to extremes

the decadent expression of the Baroque"); it is both new and strict. You might as well say a fugue by Bach is anarchical; only a calculated discipline of extreme sensitivity could contain such richness of detail and such complexity. Purists are also upset by the shape of the estípite—"those upside-down columns with the capitals below and the bases above," a Neoclassicist complains. They call it "anti-architectural," by which they presumably mean anti-gravitational. They object that it is poorly engineered as a support, and works against solidity and security. In this observation they are of course quite right: the estípite is a great architectural device—possibly the greatest—for leaving the earth, a kind of rocket to levitate the spectator. What this style does, it would seem, is to express exactly what it sets out to do.

Jerónimo de Balbás' work seems to have played a double role. Besides introducing the estípite and inspiring its diffusion all over the country, the effect of the Altar de los Reyes was to emancipate Mexican designers, so that a number of Baroque varieties—not specifically derived from it—followed. Most important are the Rococo altarpieces of the Querétaro school, and the buildings of Francisco Guerrero y Torres, both dating from the last quarter of the eighteenth century.

This is what we mean by colonial art. Everything originated in the mother country: details, the way they were organized, the artists who manipulated them, all shipped out to the colony like the manufactured goods that came west in the fleet. At the same time, Rodríguez' Sagrario is a genuinely Mexican building—this use of a retable with estípites as a facade, the contrast of gray limestone and red tezontle, cannot be found anywhere else. In New Spain it has a long line of descendants. The many-colored glazed tiles of Puebla—the *azulejos*—are obviously of Peninsular origin, and there are Portuguese and Andalusian antecedents for using them in exterior decoration; but an entire facade of this material—the tiles made to order for cornices and capitals and columns—as in San Francisco Acatepec, is something special.

Or consider the facade of the school called Las Vizcaínas, that immensely extended, rich, solid building; it has such individuality that one's feeling for it is more like friendship than mere architectural approval. The use of tezontle and chiluca (rose-red and gray-white), the stately rhythm of pilasters and enormous windows skewered from base to cornice, and lightened by the gaiety of the procession of finials against the sky—all of this is made up from familiar usage. A building like the elegant Chapel of El Pocito, which encircles the miraculous well of the Virgin of Guadalupe, shows Guerrero y Torres, the architect, designing freely from a familiar inventory. With the contrasts of polychrome tile, rich red tezontle and gray stone trim, with the textures of glaze, of pumice, or of limestone embroidered in patterns of sun and shadow, with the spatial

contours of the circular plan and its three domes, and the ornamenting of the parapet against the sky, with the somewhat reserved trabeated portal, the fantastic lintel and the deliciously explosive star window, one finds packed into this little chapel the compacted sweets of the Baroque repertory. To pretend that things like twisted columns and estípites were not gifts from Europe would be quite unreasonable—after all, Spain had borrowed the twisted column from Italy and the Near East, but it is just as foolish to assume that nothing fresh or interesting can be done with a legacy.

In New Spain these variants of the Baroque dominate architectural design from mid-seventeenth until the very end of the eighteenth century, when Neoclassicism was officially imported to the viceroyalty. Chronologically, they are not mutually exclusive; the Solomonic column and the estípite was each dominant for about fifty years, but twisted columns never really went out, and estípites continued side by side with the Rococo. They are all parts of a variable, mutating, flowing movement which would be only misrepresented by any too precise classification. Estípites coincided—not, one feels, by chance—with the prosperity of the eighteenth century. Lavish and refulgent buildings were wanted, and the means were at hand for expressing and embodying lavishness and prodigality. Some new declaration of piety and faith was needed, and in its own transcendent way the Baroque altarpiece supplied it.

At the other end of the spectrum from proper cathedral Baroque, one finds the pot of gold: the polychrome and gilded retable—the vault-high altarpiece that transfigures the interior of the church. This is another thing that was by no means invented in New Spain, but which suited so well and was used so enthusiastically and so widely that it came to be a truly Mexican form.

Perhaps you have been riding all morning in a jeep. You come to a parish church, rising above the one-story village, facing the dusty plaza. The churchyard has a disheveled look, the stucco-covered facade is streaked by rain, bare except where some rudimentary decoration frames the door. Stepping inside, you blink for a minute in the darkness, and then—always suddenly, with a shock like an explosion—glory opens before your eyes. The whole chancel is filled with gold, glowing, exuberant gold, which seems to be in motion as one moves down the nave and the light finds it.

These retables are the essence of Mexican religious art. Only the fireworks of a major fiesta can rival them, and they share the dazzle and the movement and the capacity to absorb the spectator and exalt him. A church furnished with a full quota of such altarpieces, in the chancel, in the transepts, down the aisle,

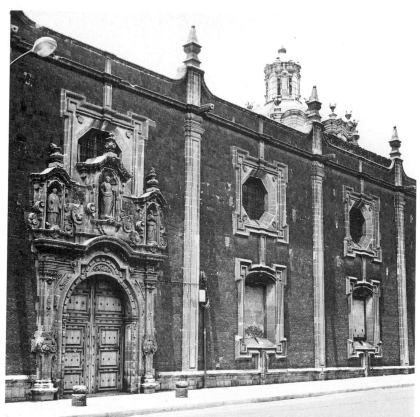

32. Portal of chapel, Colegio of San Ignacio
(Las Vizcaínas). México, D.F.

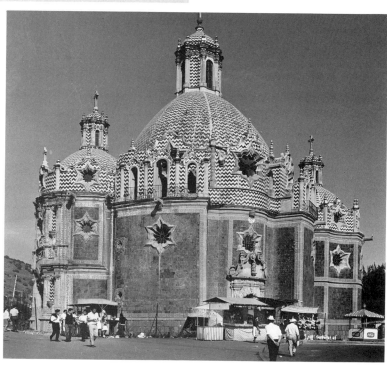

33. Francisco Guerrero y Torres. Chapel
of El Pocito. Villa Madero, D.F.

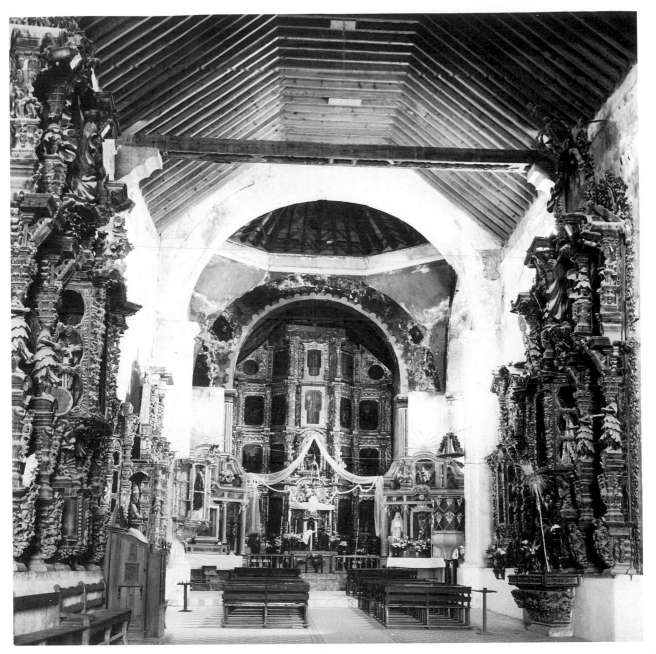

34. Nave, parish church. Calpulalpan, Oaxaca.

hardly needed elaboration of structure or plan. All that was needed was the wall on which they hang, and light to give them life.

The number of colonial period altarpieces at present existing *in situ* in the churches of Mexico is incredible. (We have photographs of some nine hundred, without at all presuming to be exhaustive.) Although changing taste had publicly denounced them before 1900, they have survived, some for nearly four hundred years. Some quality of absolute value—something rich and precious—has worked to preserve them. In very prosperous places, of course, old altarpieces were apt to be replaced or remodeled to fit changes in taste, as early as the seventeenth century. But for two centuries this was in the interest of transmuting an old one into an even richer and finer altarpiece. If a new and fashionable job was made for the chancel, the old model found a place along the nave, its sanctity unimpaired and its profile only slightly cut down. Even when they fell apart from neglect (as they do more and more in the heedless twentieth century) the pieces were salvaged, columns were worked into new shrines, the big narrative relief hung in the sacristy, while saints in good condition were set up on side altars. God the Father, from the top of the sixteenth-century retable, was very apt to survive, waist-deep in his lunette, raising his hand in blessing. These fragments were fortunately substantial enough to escape the cupidity of anti-quarians, who like things that will slip into an attaché case.

Only in the nineteenth century, under the stingy canons of Neoclassicism, was there any systematic destruction. (That was when they said the Altar de los Reyes of the Cathedral of Mexico was really good only for a bonfire.) The bogey of Good Taste made people feel embarrassed at such exuberance and passion, and they exchanged it for marble, real or painted, and other cold and antiseptic materials in pseudo-classical forms. But Neoclassicism was hardly a Mexican style; and the sheer numerical survival of the altarpieces attests to their continuing appeal to something very deep in the Mexican spirit.

It has been the custom, in studying retables, to classify them according to the sorts of columns that frame them. These are either Renaissance columns or twisted columns or estípites, which are referred respectively to the sixteenth, the seventeenth, and the eighteenth centuries, and designated as Renaissance, Baroque, or Ultra-Baroque (Churrigueresque). If you are interested primarily in classification, you can see immediately that the columns of the altarpiece at Amecameca are twisted with spiraling vines, and can declare that this is an example of seventeenth-century Baroque. Or at Tepotzotlán you will see the Churrigueresque order with its estípites, and drop that into the eighteenth-century slot. To these categories must be added a late Baroque called Rococo, which is likely to have no columns at all, such articulation having dissolved into contours and silhouettes. Rococo is

a specialty of the nuns' churches in Querétaro and belongs to the last twenty-five years of the eighteenth century.

When we have put together all the retables with twisted columns, and all those with estípites, it is doubtful what we have gained, however, aside from emphasizing that they have, on the one hand, twisted columns, and on the other, estípites, which one could see at the first glance. If this is the first step in looking closer, then it can be fruitful, for the first essential in understanding the retable is to study and understand the plan and the articulation and the parts of this complex organization. One needs to know it as the designer knew it, as he built it up, piece by piece, from the possibilities of moldings and shafts and capitals and bases and medallions and saints (standing or as busts), and finials and reliefs and putti and angels. One needs to sit for long periods in front of one altarpiece after another, reading them off like musical scores—seeing how a certain rhythm of saints and columns alternating across the lower story strikes its chord, or how folding the sections in and out like a screen gives vivacity, or building out at the top draws the spectator into its shelter. The aim of the retable is not to astonish us with skill and erudition, but to overwhelm us—to knock us out—and so to uplift and exalt us. But if one wishes to know how this is done, one must intermittently analyze instead of yielding to its charms. At the same time classification will become even less interesting, as one discovers the immense variety possible in this essentially conventional form—the almost individual personal quality of each of the great altarpieces.

Their diffusion through New Spain is another astonishing thing about the retables. How was it that such sophisticated and complicated objects could be transported into every corner of a generally unsettled and very extensive territory? One can find great examples of the art not only in the cathedrals and the large churches of prosperous cities, but in the monasteries of distant market towns, in sanctuaries hidden away in the mountains, and in the humblest village chapels. Yet this was the most European of viceregal arts, the one which never showed Indian influence, which gave way least to provincial and popular tastes. It was indeed this very conventionality—the codification of its parts—which worked to preserve the metropolitan sophisticated quality of the retable. When one has looked at hundreds of altarpieces, large and small, early and late, dispersed all over Middle America, one begins to see them as *assemblages,* made up of interchangeable parts, each different, each striking its own note, but always within the range of those familiar, perfected, and totally coordinated parts.

What is known about the retable workshops is compatible with this. They were mostly located in Mexico City. For the large Baroque altarpiece, craftsmen of all types were required. According to a master design, *entalladores* (wood-

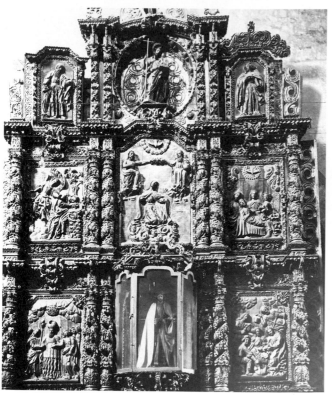

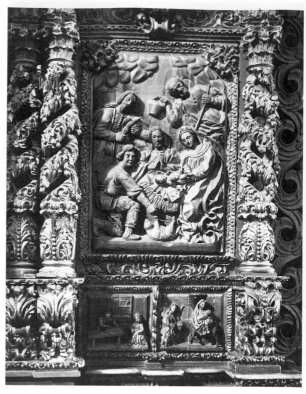

35. Altarpiece in nave, church of the Dominican monastery. Amecameca, México.

36. Adoration of the Magi. Altarpiece in nave, church of the Dominican monastery. Amecameca, México.

37. Pulpit, Church of the Convent of Santa Clara. Querétaro, Querétaro.

carvers) prepared the capitals and bases, moldings, frames, pedestals, dust-guards, twisted columns or estípites with all their details. Painters produced the canvases needed, sculptors, the panels in relief and the life-size statues of saints, whose robes were then brocaded with gold and color by an *estofador,* their faces and hands painted by an *encarnador.* This was all assembled and mounted by the *ensamblador* (the joiner), and finally gilded all over by a separate workshop. The medievalism of the guilds required this division of the crafts—no sculptor was permitted to paint, and so on—though (as in so much Mexican legislation) there is some doubt that it was strictly enforced. The top men were presumably Masters in their respective guilds, duly trained and examined.

Retables went out to the provinces in different ways. Often the contracted altarpiece was largely completed in the city and sent out in pieces with a crew to assemble and finish it (gilding was ordinarily done on the spot). At other times a crew would set up its workshop in the provincial town or monastery, and make the whole thing there. In the later eighteenth century there were important workshops in the provincial cities, and there also seem to have been traveling crews who moved from church to church—around Oaxaca, for instance. All of this is of importance, because the metropolitan, movable retable was the principal vehicle of style diffusion throughout Mexico in the seventeenth and eighteenth centuries.

We know more about retable workshops—who the principal artists were, what assistants they had, their materials and payments and perquisites—than all the rest of viceregal art put together. This is because the retable was made under contract; proper lawyers recorded every detail of the agreement and later filed the contracts away, safe in the Archivo de Notarios. A typical contract gives the date of writing and of promised completion, the names of the principals and the sums to be paid, and stipulates the particulars of size, design, style, and subject matter, materials and procedure. Here we learn that the wood must be cedar (against termites), and that there must be a resting period after being worked, before finishing and installing, for the wood to season. We learn how many girls will come daily to make tortillas, and how much hay the horses will be given, and what living quarters will be provided, and all the rest.

We discover how important style was, in a contract like that for the high altarpiece of Santo Domingo in Puebla. Written in 1688, it called for the recutting and bringing up to date of the old retable, with some twisted columns and the old saints carved over, presumably with more Baroque swing. (But it is a losing fight to be in the fashion; in the next century Echeverría y Veytia would dismiss this very altarpiece as "an old-fashioned gold retable.")

We learn that it was often stipulated who should give the libretto: "the

stories of the whole work are to be the choice of the Reverend Father, to choose what he wishes from Holy Scripture." Details like "six bases for the columns with six babies sculptured on them," "six Solomonic columns adorned with grapevines," or "estípites with their cubes and busts and little angels" show how closely the work was examined, although occasionally there was only a solemn stipulation that "the paintings, like the gilding, are to be among the most outstanding in this City," or that the artist is expected to do everything "according to his intelligence." It is clear that the whole intricate structure and its design, as well as the saints and their stories, were as familiar then as our daily newspaper is today.

Only the top men signed the contract or were designated by name. About the assistants—how many they were and exactly what they did, and how many of them were Indians—we can only surmise. The whole matter of the status of Indian artists is obscure in the period after 1600. It is clear that things were taking shape, more or less as they would function until the end of the viceroyalty, but exactly what the situation was at any given moment is not so clear. For one thing, documentation is chancy and incomplete. Also, what documentation we have is contradictory: labor legislation does not coincide with the evidence of contracts or of the monuments themselves. Thus after mid-century, although (as far as we know) guild regulations still excluded Indians from the rank of Master, notaries were filing papers of apprenticeship for "Esteban Martín, Indian." Salvador Ocampo took an Indian apprentice, and Agustín Román registered "the son of a *cacique* (a chief) as apprentice in wood-carving."

Tomás Juárez, one of the most eminent seventeenth-century sculptors in wood, is a case in point. He had successfully finished the retable of the new Augustinian church in Mexico City—a matter of fifteen months and 2,300 pesos for each of the three stories—and had already contracted to make the retable for the high altar of the Jesuit church of La Profesa, when he finally presented himself for examination as a cabinetmaker in 1697: "Thomas Xuarez, indio." How typical a case this was we really will not know until many more documents have been published, but it certainly demonstrates that a gifted Indian could make his way. It is not without meaning that Santiago Matamoros, the Moor-killing St. James on his white horse—had already changed sides; most of the representations of this subject in Mexican churches, whether on the facade or on retables, date from the seventeenth century.

If it is boring to classify Baroque monuments, it is just as tiresome to talk too much about them. No style that human beings have invented asks more

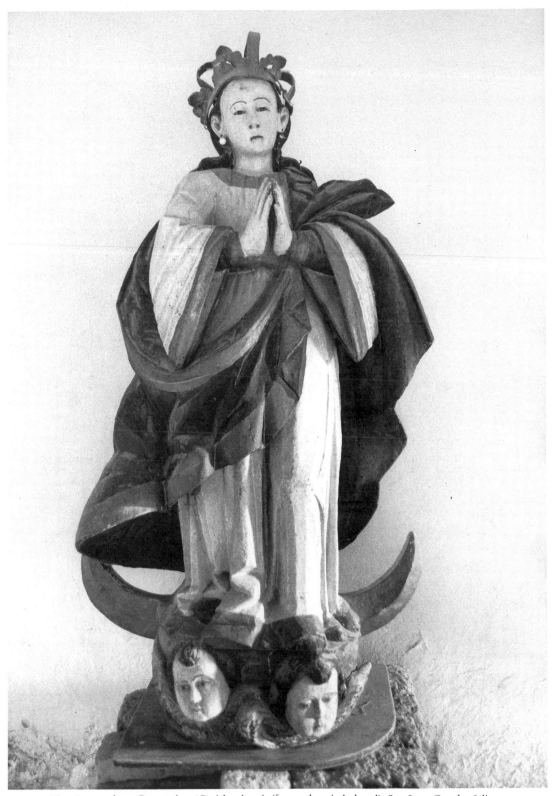

38. The Immaculate Conception. Parish church (former hospital chapel). San Juan Ocotán, Jalisco.

compellingly for direct surrender, without the intervention of reason. A Baroque church interior presses on you from every side—or should we say it welcomes you in?—for the sensation is not of being trapped, but released into some other reality quite unconnected with the world outside the church. For this the chancel has become a cave, all gold and color; for this the vaults are garnished and the nave lined with retables until you cannot see the wall. There is no doubt that the ideal is saturation, with every flat area converted into lively form, and nothing too static or solid. The shaft of the classical column is twisted irresponsibly, and then dissolved by its transformation into the estípite; the estípite in turn dissolves into Rococo silhouettes, and the plain walls of the standard church dissolve into a grotto of unearthly splendor. When this dream is realized, the criticism that Mexican Baroque architecture displays no mastery of space becomes meaningless: it is not space we have set our sights on, but infinity.

Baroque is always attentive to the total effect, and, by the same token, may be careless in its details. But the work of art we are concerned with is not the altarpiece—and much less any saint or painting incorporated into it. The work of art is the whole church, the cumulative effect of everything in it, and the effect all of these separate items have on each other. The Mexicans call this ensemble the conjunto, and it is worth noting that a rich Baroque conjunto will absorb almost anything. Starting with a hand-me-down Renaissance retable over the high altar, the congregation may have added a pair of fashionable altarpieces every half-century for two hundred years, and moved them about, and reassembled them, and installed old forgotten saints from the lumber room, and introduced new cults, and electricity, and added brocade dresses here and there, with artificial flowers and false pearls, as well as sheaves of real tuberoses in oil cans—and even Neoclassical niches—without impairing the Baroque ensemble.

One aim of Baroque design is to involve the spectator. The saints converse with communicating gestures; altarpieces reach out at the top, to draw you in and shelter you; and when all four walls of the sacristy are painted with dramatic events, you seem to be in a painted miracle yourself.

One should also note that the furnishings of the church were not (however it may seem) created by supernatural edict: they represent the participation of many individual worshipers, over long periods of time. This is another reason why it seems uninteresting (for anyone concerned with the significance of art rather than its classification) to labor at cataloguing the Baroque. Estípites and Solomonic columns, tile and stucco and tezontle all characterize the Mexican Baroque, but one comes to feel it more as a spirit than a checklist of stipulations: it is that conjunto which receives everything, welcomes everything, and transforms everything. Even aesthetic quality is secondary to this miracle. Even a very

isolated, very rough little church—like San Juan Evangelista Analco in the highlands of Oaxaca—shares in the spirit of Baroque munificence. The retables and decorated candles seem more rich and astonishing shown against the adobe walls; the chapel—with its turned grille and carved beams, and the gold altarpiece enshrined—like a genuine glimpse into Heaven.

Not that response to the Mexican Baroque ensemble is merely a surrender to the irrational. There is nothing like gold, but one can have too much of it. And it is possible, without being a puritan, to be tired out by gesticulating statues and totally busy walls. One can yearn for the bare, the flat, the empty, the abstinent—but not while one stands in a great Baroque room. This work of art, this total ensemble—all coherent, proportionate, harmonious—becomes an exemplar of the perfection we dream of. Stimulating and satisfying at once, it is a perfect world—a Paradise—in small. You will feel this in the chapel of El Santo Cristo at Tlacolula, in San Cayetano de la Valenciana outside Guanajuato, in the *camarines* (the dressing rooms) of the Virgin of Ocotlán, and of the Virgins of Loreto at Tepotzotlán and San Miguel Allende, in the Franciscan church at Tlaxcala, or the Dominican church at Oaxaca—even restored as it is—or Calpulalpam or Ixtlán de Juárez. Consider the Rosary Chapel of Santo Domingo in the City of Puebla: how exquisite its effect, how perfect the judgment that brought these elements together, where nothing seems missing, nothing out of place, nothing too much!

The most perfect ensemble of them all—the purest and the most complete—is still the parish church of Santa Prisca and San Sebastián in Taxco. Here everything was done within the lifetime of a single donor, and always with perfection: the setting on its hillside, facing the shadowed plaza, the apricot-pink stone, the facade with its saints framed between the elegant towers, the gaiety of walls and finials and dome and belfries against the sky—and the way fresh sunlight floods into the nave through an open door. Completely finished, with its organ, with the retable on the high altar, and two in the transepts, and three more on each side of the nave—all vibrant with red and gold and estípites—and the chapel, where deeper mysteries are sheltered in still more Rococo altarpieces, it is all of a piece. Like all of the Mexican interiors, it has its own individuality; in spite of the impersonality of the carving and the interchangeable parts of the design, in spite of the routine architectural box that holds them, each of these churches has what one can only call a personality.

The critics who say that Mexican Baroque is not architecture at all may have a point: often the builders were content to provide walls, windows and roof, leaving the rest to the decorators. Those who condemn it as anti-social and wasteful are dead wrong. This is an art of and for the people, open to all, aglow

for all, solacing all, and receiving the prayers and the tears, the candles and bouquets of all. The Neoclassicists were to find it vulgar; they had the notion that the elite must develop taste superior to ordinary humans, which could only be done by rejecting ordinary human delights. There is, indeed, something outrageously democratic about the Baroque interior, and this is partly why in Mexico the Baroque still has a popular quality. As for the people who say that the Baroque is showy, insincere, and neither devout nor religious—they have never stood in such a church.

Emerging from the Baroque chapel, we find that we are well on into the eighteenth century, and we are prepared to believe that it was the Golden Age of New Spain. Not the Earthly Paradise that had been attempted and abandoned in the sixteenth century, nor yet anything like the ideal republic of our dreams, with justice and equality and security for all. But the colony was rich, or at least comfortable, society was stable but open, and promising enough, the arts flourishing, opportunity unlimited—at least for some of the people. It seems to have been one of those periods when prosperity was so rampant that no one bothered about anything. Just as it was hard to say why the seventeenth century had gone into depression, there was a mystery about the well-being of the new century.

This eighteenth century was the last, waning summer of the Spanish Empire, though that was not apparent at once. It seemed that things had been patched up and were going ahead. Population had reached its smallest number around 1650, and was to grow steadily, both Indian and European, from then on. With more labor, they got the roads passable and the ranches working and the mines functioning again, so that production figures followed the population upward. In the last years of the century the viceroyalty of New Spain produced ten times as much gold and silver as all the rest of the world together. No wonder they could spare some for altarpieces!

So many people were getting rich that some further distinction had to be found, and the Crown invented the New World nobility. This required landed estates, but they were already there: the haciendas which had begun so inconspicuously as modest land-grants to old conquistadors. With a title one must have a mansion, and so the noble houses were built, the palaces which still astonish a traveler in Mexico City. The capital—always hailed as one of the beautiful cities of the world—became still more splendid. A new palace was built for the Viceroys, on the Zócalo where the Casas Viejas (Old Mansions) of Montezuma had stood. Across the square the cathedral (still lacking its towers

and dome) was being furnished with choir screen and organs, and the Altar del Perdón and Altar de los Reyes at either end of the nave. Fountains were embellished, churches and convents and hospitals and schools were founded, or were rebuilt, or given new modern facades and new sumptuous altarpieces. In the end there were 12,757 churches by actual inventory. Parks were laid out, and the new society drove about them in their carriages, and then on into the country, where they had picnics.

There was no war in Spanish America, in a century when Europe hardly paused to write peace treaties between campaigns. There was no religious conflict—there never had been any dissent in Mexico, because no dissenters were allowed there. There were no revolutionaries to break the peace, neither political professionals nor headstrong individuals attacking the homogeneous pattern of society. Or so we have been led to believe—but the picture is too unlike human nature as we know it. No new ideas, no disturbing books, no intemperate questions? To believe this would be to give entirely too much credit to the Royal Customs and to that monument of bureaucracy, the Holy Office of the Inquisition.

The laws said that no foreigners and no wicked books should be allowed into New Spain, and it is true that we feel the lack of the traveler's eye, in trying to imagine the eighteenth century—we know about most of it only in retrospect, from later visitors. But some observers did come, and on the most respectable business—official, be it noted—namely, a series of scientific missions. Such were Mutis, Sessé, and, in 1789, Malaspina, worthy predecessors to Count von Humboldt. What was more significant than the knowledge of new philosophy and new science, which was certainly talked about in the capital at the end of the century, was the very limited size of the elite who were in contact with such ideas.

In any case, Mexicans looked back from the nineteenth century (an independent republic now) and said that if you had not lived in the eighteenth century you would never know how delightful life could be. It was a sentiment widely expressed in the early nineteenth century; but what must not be forgotten is that it was the "Golden Age" in each country which led to the riots, the revolutions and the guillotine. It is true that in New Spain the growth of great fortunes had meant a greater gap between rich and poor, and that the beggars and paupers of Mexico City were as impressive as the noble houses. The Crown had not known how to prevent the concentration of wealth in a small class of landowners and mine owners. It was these people who described the Golden Age, and according to their tastes the theater, music, literature, painting, and above all architecture, flourished.

Through all of this the role of the Indian craftsmen remains as ambiguous

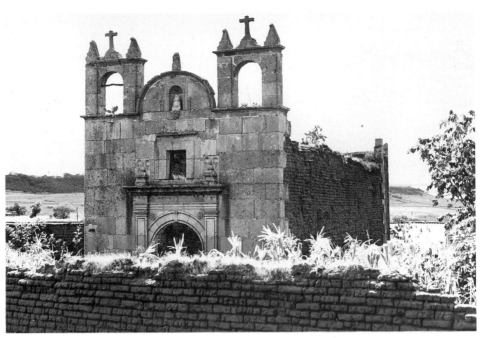

39. Hospital chapel. Santa María de La Paz (Ignacio Allende), Zacatecas.

40. Cloister, Augustinian monastery (Municipal Palace). Salamanca, Guanajuato.

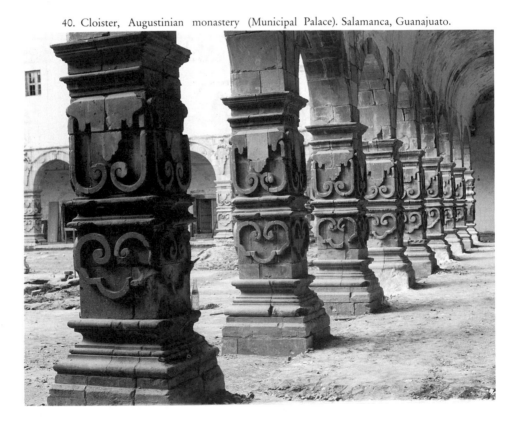

to classify as Baroque style. Probably it cannot be described as a single policy: practice differed in various crafts, and it was certainly different in rural life from the situation in the city. And although the workman is still identified as an Indian (e.g., in payments for work on the cathedral), there are signs that the distinction is shifting to class rather than race: Indians are the ones who wear sandals and *calzones* or *rebozos* (and dogs are trained to bark at people without shoes).

Among the well-known sculptors at the turn of the century we know several to have been "Indians": Pedro Patiño Ixtolinque (who had taken the name of his mother, a mestiza), and the Sandovals—Santiago Cristóbal, who is called "an Indian *cacique* from Tlatelolco," and his son Ignacio. At any rate, by 1800 the revival of Indian prestige in a romantic vein had already begun; two fellowships for Indians were established in the new Royal Academy of San Carlos.

It is probably unrealistic to try to describe the professional and social position of the Indian artist, because the fact is that New Spain was becoming a mestizo country. All we can talk about is what people thought—or believed, or wished to believe—about him. On the one hand, with Sandoval making saints for the cathedral towers and Ixtolinque as Director of the Academy, selected non-Spaniards were encouraged (as they always had been) to make their way in Spanish society. On the other hand, all the popular crafts were dismissed as "Indian stuff," and this included the anonymous wood-carvers and painters of the Baroque altarpieces.

To call all Baroque decoration Indian folk art, as the Academy liked to, shows sensibility to its quality, to the outpouring of the great range of work by trained craftsmen. The Neoclassicist wanted something correct, under control, which had been worked out in drawings for the sculptor to follow (precise details of classical design). But this does make it Indian—not in the old sense of original Indian cultural tradition. The "cultural tradition" had been suspended for two hundred years; the "Indian" element is parenthetical: this is an art of the people (and the people happen to be of Indian race).

Right to the end of the century Mexico continued an anachronism. In the most extraordinary way, New Spain in the eighteenth century was still a medieval society. It was in this century that the Franciscan monk, Fray Junípero Serra, revived the missions of California—a string of feudal monasteries on the medieval pattern—and Father Kino founded those of Arizona. While Jean-Jacques Rousseau and Voltaire were arguing for reason and nature, the Constitutional Assembly in Philadelphia resolutely disestablished religion in its new republic. In Mexico the fixed relationship of the classes, the paternalistic control of commerce, the

absolute authority of the Church—still the voice of the monarchy in moral and spiritual matters—and above all the ignorance of other ways of life preserved attitudes almost forgotten in Western Europe. What came as a surprise to those in authority was the revelation, finally, that the new Mexican also was aware of this anachronism.

Looking toward art and architecture, we savor a final irony in the viceregal story. The last effective gesture of the Spanish Crown had established an Academy of Fine Arts, stocking it with not only plaster casts of classical sculpture, but also professors of the Neoclassic faith. The centuries of inefficiency, self-interest, and corruption were to be redeemed by the purity of classical forms, and by renouncing the Baroque and all its manifestations. Neoclassicism was the revolutionary style of the nineteenth century; it served the empire only to the extent of finishing the Cathedral of Mexico, raising a splendid equestrian statue to a miserable king, and erecting a School of Mines, which proved suitable architecturally to the new republic.

What enchants us afresh is the old wild disarray of style and sequence. The North American missions might be feudal in their concept, but their portals were Ultra-Baroque or Palladian in design. It was in 1795 that the Hospital de Belén was finished in Guadalajara; it was the last of the medieval hospitals which followed the model set by the Reyes Católicos, Ferdinand and Isabella, in their hospital of 1501 at Santiago de Compostela. The Mexican feeling for hospitals was in itself an anachronism; they had kept alive that special medieval compassion, which prefers the sick more than the healthy, and shares their concern for the Four Last Things. Nowadays, if it occurred to some ill-advised rebels to burn a church's altarpiece, there would still be woodworkers able and willing to restore it. Surprising artifacts like pop bottles and sunglasses find their way into the venerable Baroque ensemble. In the end one thinks of Mexico itself as a wide, timeless conjunto, in which everything still has a place (and prehistoric flowers, for all we know, may well be blooming somewhere), because nothing comes amiss to this rich and selective taste, and time is not so much a flowing river as a very deep lake.

I

YUCATÁN

Yucatán was the first part of Mexico to be seen by Spanish eyes. After the discovery in 1517, three successive voyages stopped at "the island of Yucatán"; the third captain was Hernán Cortés, who in 1519 went on up the coast to conquer Aztec Mexico. Later, when Francisco de Montejo was sent by Cortés to the court of Charles V, he remembered that landfall and asked for the sanction to conquer Yucatán. This was ultimately accomplished, with the help of his son and nephew, between 1526 and 1546. Meanwhile, in the twenty years following 1535, some forty Franciscan friars arrived to convert the natives to the Christian life; in 1538 Mérida was made the seat of a bishop.

After that, one hears little of Yucatán. The Montejos, it turned out, had made a poor choice: there was no treasure in Yucatán, there were no mines, no rich lands, though the rain forests on the Honduras side did furnish timber. It was mainly a flat, grassy peninsula, where the rivers ran underground and the limestone lay near the surface, broken here and there by wells called *cenotes*. The only notable exports were honey and beeswax. So the Spaniards left it alone. There were a few Spanish cities, but not many Spaniards—perhaps 300 in a population of 300,000 in the sixteenth century. Most of the population always was Maya Indian.

Under this neglect, the rudiments of Mayan society still continued. That their culture had been highly developed, widespread, and homogeneous, and that in the sixteenth century it was declining—so that new buildings were rarely vaulted, and glyphs recorded only ancient lore—both helped Yucatán into the new life. It is true that the conquest of Yucatán took twenty years (where the

Aztec Empire had fallen in two); nowhere else in America was resistance more obstinate, more ingenious, and so nearly successful. But some Mayan families (like the Xiu of Maní) had accepted the Christians at once, and in the end the Spanish soldiers and friars took over. More than elsewhere in Mexico they worked through the structure of the old society, so that we know names, titles, genealogies, territories, and find them continuing throughout colonial times. It is true that here, as everywhere, terrible mortality resulted from epidemics, from the friars' policy of gathering the Indians into new towns around Franciscan churches, and from the Indians' despair of losing everything they had counted on. It is true that Bishop Landa's name became a symbol of intolerance, after he tried and tortured Indians for heresy, and burned their idols and pagan books, but it is also true that he was recalled to Spain and publicly rebuked. In Yucatán a great number of preconquest monuments, and whole cities, witness today to the lack of Spanish interference, and so does the language. Spanish colonial policy was not different for Yucatán, but one catches here a glimpse of how it might have worked out in the New World if Indian life had not been submerged by the influx of Europeans.

In architecture this colonial history is clearly visible: the early start, implemented by a functioning Indian society, and then a benign disregard. Only in Yucatán were the friars able to use buildings of the temple precinct for their monastery (at Mérida this was still visible in the mid-nineteenth century). The cathedral of Mérida—its dome dated 1598—was the only one in Mexico to be completed in the sixteenth century. Facing on the same plaza is the finest sixteenth-century palace facade in the Western Hemisphere, made for Francisco de Montejo II in 1549. Six big Franciscan monasteries were built, at Mérida, Izamal, Maní, Campeche, Dzidzantún, and Valladolid. Founded between 1542 and 1553, these were all finished, with their churches, schools, hospitals, wells, and orchards, around 1560.

When the Franciscan inspector Fray Alonso Ponce reported his visit of 1588, there were twenty-two Franciscan houses functioning; but he had a curious story to tell:

> The house at Titzimin was all completed, with its two-story cloister, cells and dormitories, all solidly built of stone and mortar. . . . In the yard or patio of the monastery . . . (which is rectangular and paved, with four chapels, one in each corner, and with many trees, orange and others, planted in rows) there is constructed of wood a *ramada* (a bower) thatched with the leaves of certain palms, very large, wide and long, with room for many people, made so ingeniously that there is not a nail or rope in the

whole thing, and in spite of this it is very strong; it has no walls, so that it is open to the air on all sides, just some forked poles, posts or columns of the hardest wood which support it, all bound together with withes like very flexible willow wands. In this *ramada* the people of the town gather to hear the sermon and Mass, which is said in a large chapel at the front of the *ramada*. The Indians serve in the choir (where the baptismal font is kept) which is at one side of the chapel, and on the other side is the sacristy. All the towns of the province have arrangements like this.

All over Yucatán, in fact, at one town after another Father Ponce was to find the monastery complex reduced to a simple residence for the friars, plus a chancel of masonry—equivalent to the apse of a church—using the churchyard itself as nave.

This solution to the problem of accommodating immense congregations in a country still without churches appears in the early years all over Mexico. Ordinarily the open chapel was a temporary solution, to serve until the church could be built, and it was for the Indians. Only in Yucatán (and in Tlaxcala, which was also aloof from Spanish immigration in the beginning) did the missionaries decide not to build churches at all. Later, when the Indian-Spanish ratio had shifted, and the old ways had been forgotten, they tired of standing in the rain and sun and of patching the thatch, and in place of the old temporary bowers built naves of stone in front of the old open-chapel sanctuaries. This was usually in the seventeenth century, and the new naves are often smaller in scale and usually inferior in workmanship to the old apses. But all over Yucatán, in town after town, one comes upon the stout open chapel of well-cut, well-laid stone, which has survived for these four hundred years and more.

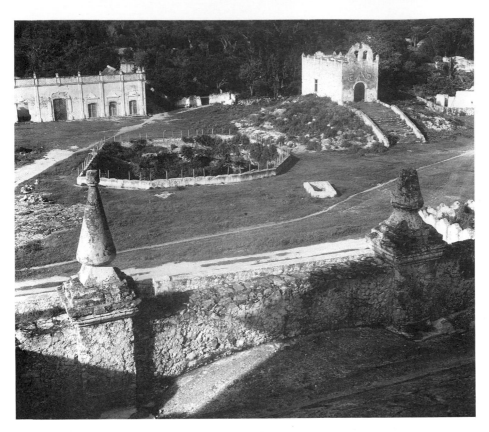

41. Cenote and chapel of La Santa Cruz.
 Yaxcabá, Yucatán.

42. Village well. Mama, Yucatán.

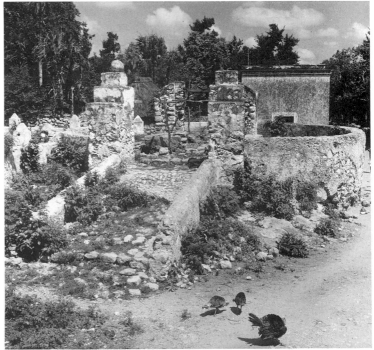

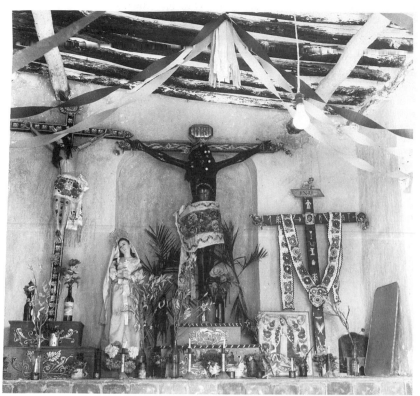

43. Altar, chapel of San Román. Izamal, Yucatán.

44. Parish church. Tepich, Quintana Roo.

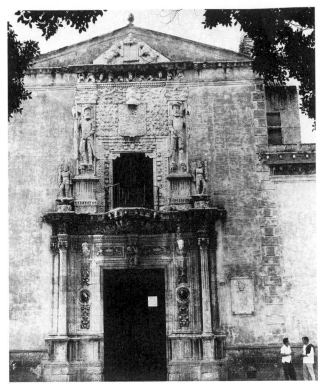

45. House of Montejo. Mérida, Yucatán.

46. Churchyard gate and arcade, Franciscan monastery. Izamal, Yucatán.

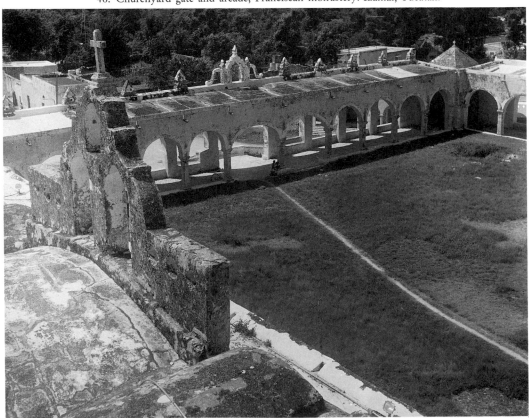

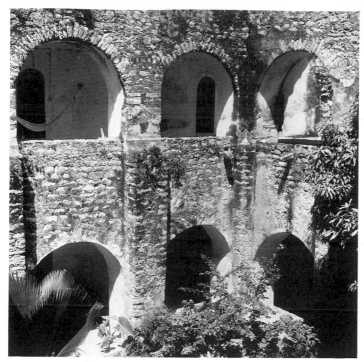

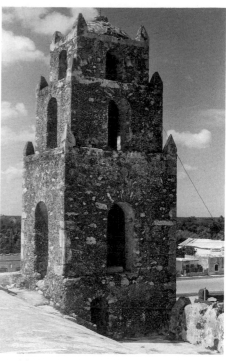

47. Cloister, Franciscan monastery. Izamal, Yucatán.

48. Tower, parish church. Temax, Yucatán.

49. Church of the Franciscan monastery. Dzidzantún, Yucatán.

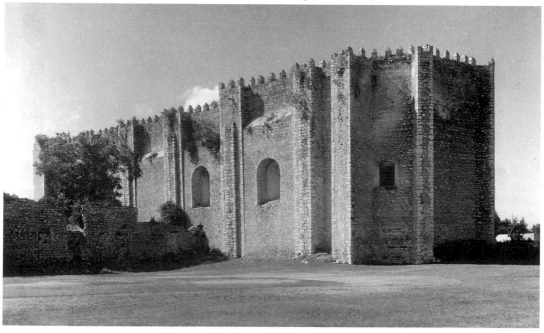

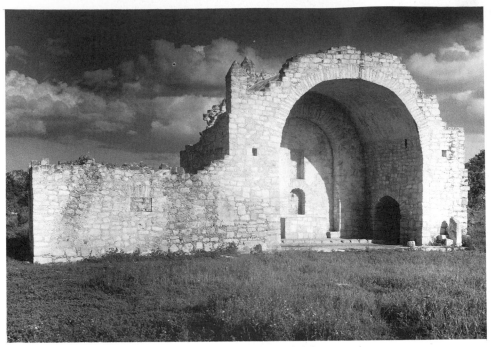

50. Open chapel (restored). Dzibilchaltún, Yucatán.

51. Church of San Juan. Sahcabá, Yucatán.

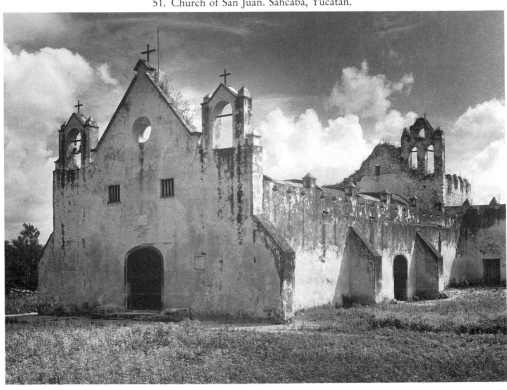

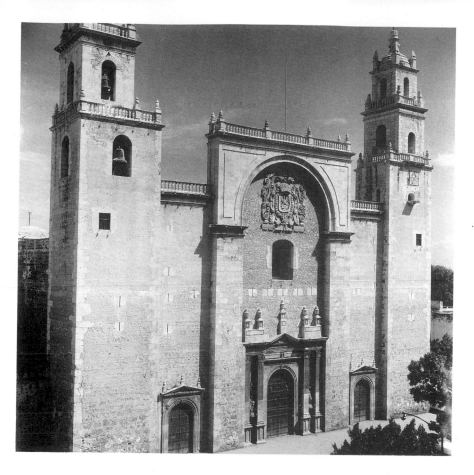

52. Cathedral of San Ildefonso. Mérida, Yucatán.

53. Vaulting, Cathedral of San Ildefonso. Mérida, Yucatán.

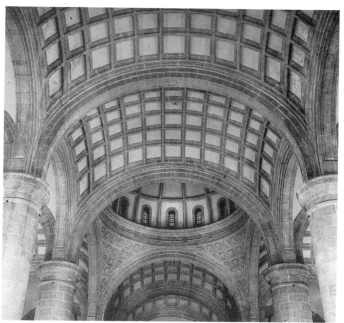

II

FORTIFICATIONS

It is worth noting that one of the things which surprised visitors to New Spain was that nothing was fortified. Europe had been a battleground as far back as history recorded, every city fortified, every road defended. Early on, the Crown used to inquire whether Mexico City should not be walled? Why weren't there forts at the approaches to towns? What was being done to guard the silver mines? Although the Spanish settlers were apprehensive in the sixteenth century, and there were many small revolts—and even one "war",—there never was a sustained Indian uprising, and the Spaniards never did get around to any systematic defenses. Mexico City was defended by its lake, and the only military structure was a fortified boathouse plus arsenal, known as the Atarazanas. In 1573 the ordinances for laying out new towns noted another, dynamic substitute for fortifications: "for purposes of defense, where there are horses, let [the streets] be wide." Writing his propaganda report in 1625 the Englishman Thomas Gage exclaims again and again at the openness of New Spain: "Now since all the Indians far and near are subdued," he writes of Oaxaca, ". . . this city, as all the rest of America (except the sea towns) lieth open without walls, bulwarks, forts, towers, or any castle, ordinance or ammunition to defend it."

The fact is that there were no enemies, except on the frontiers, where the small presidio fort was a refuge from unsubdued Indian bands, or on the coast, open to marauding English or French or Dutch privateers. Just about all the fortifications in New Spain were made to protect the treasure route back to Spain, whether in Acapulco (where the galleons came in from Manila) or in the Caribbean ports where they loaded for the voyage to Europe. They are a

testimonial to Henry Hawks, Francis Drake, Henry Morgan, Jean Lafitte and the others, to European quarrels and European methods of dealing with them.

After "that Lutheran pirate Francisco Draque" had taken Santo Domingo and Cartagena, Philip II in 1586 sent out his Italian expert, Battista Antonelli, to make plans for the ports. He reported on Portobelo, Cartagena, Panama, Havana, Veracruz, Santo Domingo, and Florida, and by 1600 had worked at many of them. The city of Veracruz was completely walled, and the island of San Juan de Ulúa, which guards its harbor, became a fortified anchorage. In the early seventeenth century the Castillo de San Diego was built at the mouth of Acapulco bay, to be rebuilt after an earthquake in 1776. On the Yucatán peninsula the city of the port of Campeche was enclosed in an irregular hexagon of wall stretched between bastions, after it had been sacked five times in the century before 1650. Traces of all of these can be seen today, abandoned, half-destroyed, or restored.

Only a few inland relics of defensive architecture remain: Perote's garrison fort on the Veracruz–Mexico road, for instance, or the Fuerte de Loreto on the hill above Puebla. There is a belief that the large mission churches of the sixteenth century were expected to serve as fortresses for their towns; their rugged architecture, with such medieval ornament as crenellated ramparts—on the churchyard walls as well as the church roof—may seem to support the notion. It is true that Viceroy Mendoza in 1536 suggested to the king that a good cathedral in Puebla would "take the place of and serve as a fortress": it is true that the Chichimecas once attacked the Augustinian monastery at Yuriria and shot an arrow into the statue of St. Nicholas on the facade. But the battlements (or *chemin de ronde*) of a monastery church, like the high, bare building itself, satisfy at most the psychological need for protection, rather than the defensive fact. Although the churchyard was enclosed, the wall was usually low, and the entrance arches ordinarily held no gates. If the monastery turned blank walls outward around its cloister garden, it was rather for privacy than for defense. When the Second Audiencia pronounced that "experience has shown that the monasteries of the friars are at once the fortresses, the city-walls, and the castles of this Kingdom," they were surely speaking metaphorically. We should not underestimate the Pax Hispanica under which so much of the Western Hemisphere enjoyed peace for three centuries, while the rest of the world expended itself in war and revolution.

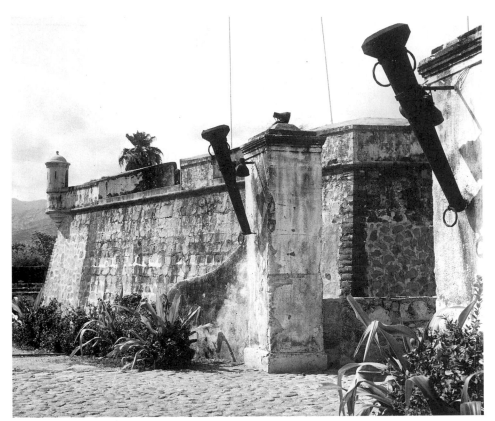

54. Portal, Fort of San Diego. Acapulco, Guerrero.

55. Moat and entrance, Fort of San Diego. Acapulco, Guerrero.

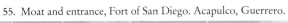

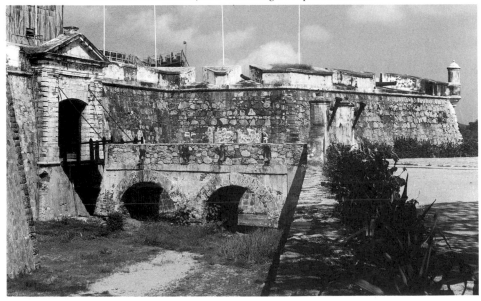

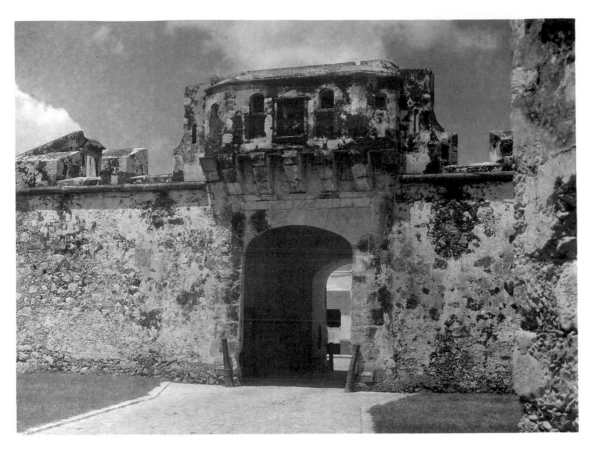

56. Land gate, Fort of San José. Campeche, Campeche

57. Redoubt, Fort of San Miguel. Campeche, Campeche

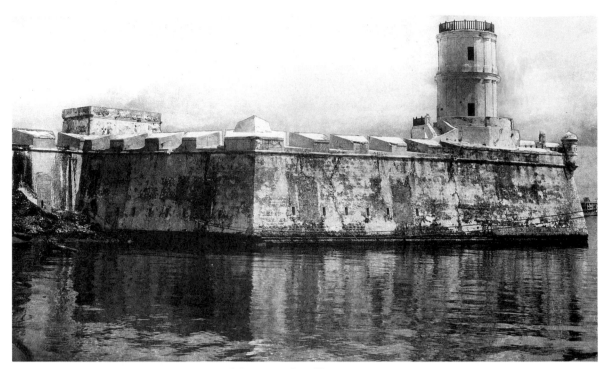

58. Fort of San Juan de Ulúa. Veracruz, Veracruz.

59. Chapel, Fort of Loreto. Puebla, Puebla.

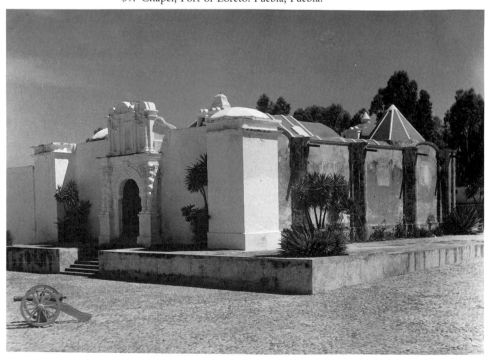

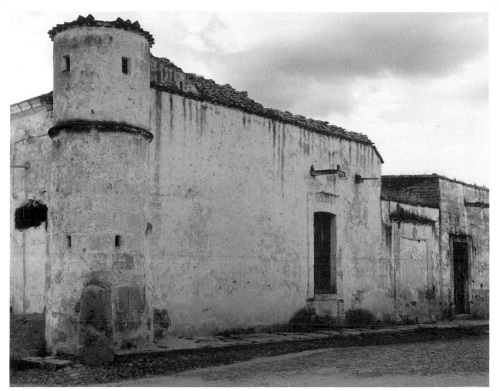

60. House on the plaza. El Teul, Zacatecas.

61. Patio, presidio fort. Ojuelos, Jalisco.

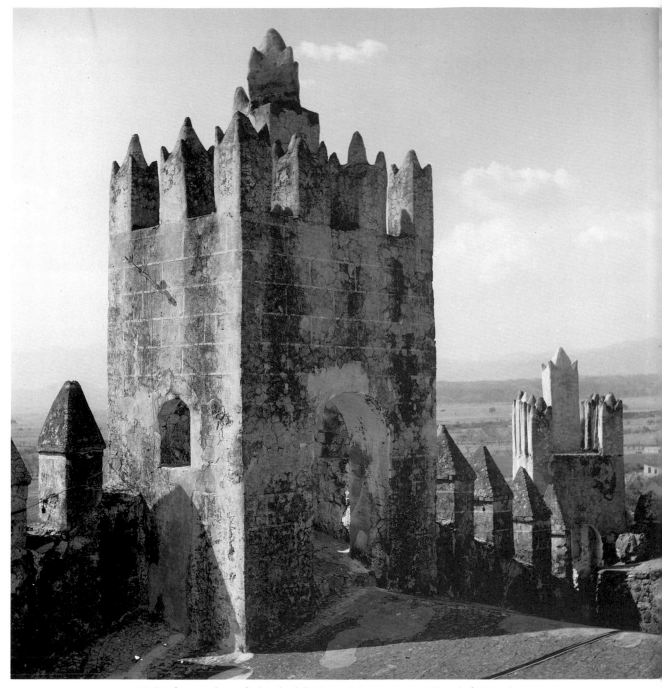

62. Merlons on the roof, church of the Augustinian monastery. Yecapixtla, Morelos.

III

NEW CITIES

ZUAZO: We are already in the plaza . . .
ALFARO: *Dios mio!* how level and immense, how agreeable, how ornamented
with high and impressive buildings on all sides! what regularity! what
beauty! what a situation and arrangement!

Everyone who came to Mexico City for three hundred years was amazed and
excited by the scale and the order of this, the largest city of Spanish America.
From the exclamations of Alfaro in 1554 to a not unsophisticated Count von
Humboldt, who called it in 1803 one of the handsomest cities in the world "for
its level site, for the regularity and breadth of its streets and the grandeur of its
public squares," the Europeans offered tribute. It was part of the openness of
New Spain, a rational city, freed from the crowded, twisting streets that had
grown by chance in Old World cities. But Mexico City was not alone: from the
Atlantic to the Pacific, from the uplands of Chiapas to beyond the Rio Grande,
the cities and towns, large and small, of viceregal Mexico were all laid out on a
special plan.

 The Spaniard had been a city-dweller for centuries. Roman, Christian, and
Moor, a long urban tradition had brought him through the Middle Ages; his
assumption was that men would shelter together in a community, from which
roads led out to the fields and to other towns, roads by which produce and
goods went back and forth. That was civilization.

In Mexico there were a number of reasons for urban settlements. The Spaniards should live together for security—and also to keep them from corrupting the Indians—and Spanish towns were founded to this end: Puebla, Morelia, Oaxaca, Guadalajara, Zacatecas. Indians, on the other hand, should be gathered into settlements for their conversion and the experience of Christian life, and for their protection. This was one of the few points on which civil authorities and missionaries were agreed. Between the fall of Aztec Tenochtitlán and the end of the century, most of the population had been so "congregated."

This was the true New World situation. Never before had the planning and founding of towns been contemplated on this scale, over such an area, with such resources, and with the authority to experiment as well as to prescribe. From the look of the cities even today it is clear that a master plan existed, which functioned both in Mexico and elsewhere in Spanish America. Set down in an unfamiliar colonial town, one can make one's way to the plaza, expecting to find there the principal church and the government buildings; one will know generally where to look for monasteries, markets, jail. Royal ordinances of 1573 describe this plan, but since most of the cities of Mexico had already been founded by then, this is obviously a codification of practices already in use.

Another typical American situation was the lack of experts. When Cortés began to rebuild the Aztec capital, he did call on Alonso García Bravo and another Spaniard, said to be "very good geometricians" (by which they meant surveyors), to lay out the center of the city for Spanish settlement. There is nothing to argue that they held theories of city planning; but they could hardly avoid being affected by the plan of Tenochtitlán, over which they were working. In any case, by 1525, when Cortés sent Hernando de Saavedra to colonize Honduras, he was already referring to an all-purpose *traza:* "You will lay out the public places which are indicated there, such as the plaza, the church, town-hall and jail, the meat market, slaughter-house, hospital, bank, exactly as I have had it drawn up on the plan...."

Who invented this plan, and from what experience, is not at all clear. Perhaps it is one of the examples of that most desirable fusion of Indian and European modes. Certainly it is a great example of what the Spanish empire was like: the determination of the Crown to control every detail of colonial life, its real effort to deal rationally with the new problems, the uniform solution which becomes boring but is on the whole satisfactory. In any case this low, two-story city, neatly and clearly laid out in straight open streets where sun and air can circulate, with its large open plaza at the center—with its public fountain and arcades—where the importance of church and government and noble family is registered in their location and housing, is still one of the best of urban solutions.

It can still be enjoyed in the provinces; it is not entirely submerged, even in the capital In some places forgotten towns of Yucatán, villages in the Sierra de Oaxaca, or the countryside of Michoacán—the plaza has a strangely convincing "colonial" air. One realizes that *colonial* is not so much a period as a kind of life, and that when we say "Mexican" we still mean the pattern of life created in that period.

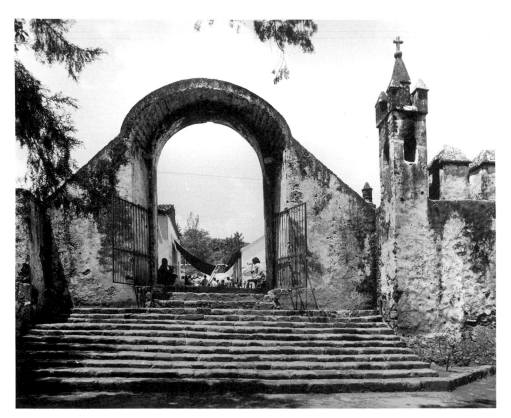

63. Churchyard gate, Dominican monastery. Tepoztlán, Morelos.

64. El Rollo. Tepeaca, Puebla.

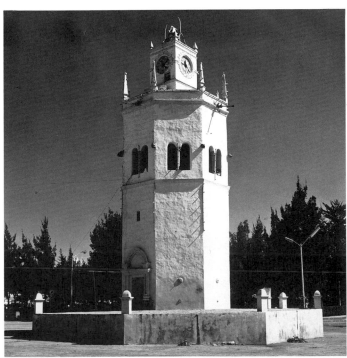

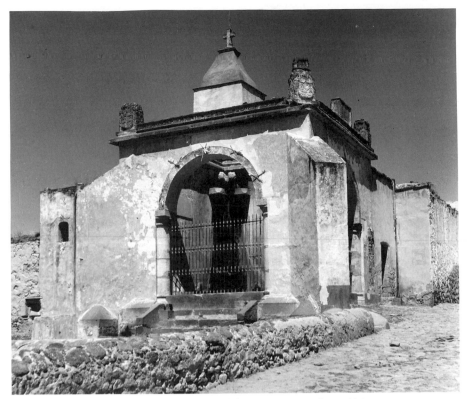

65. Water storage tank and fountain. Tepeapulco, Hidalgo.

66. Plaza fountain. Chiapa de Corzo, Chiapas.

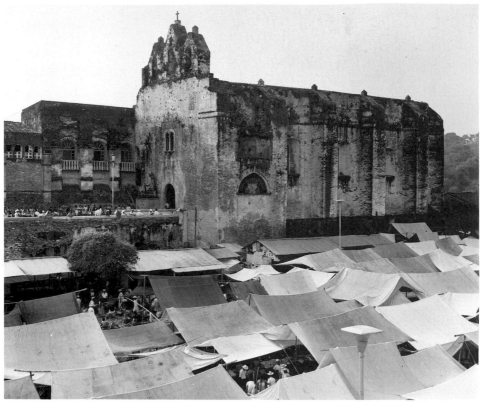

67. Market in the plaza and church of the Augustinian monastery. Huejutla, Hidalgo.

68. House of the Xiu family (Municipal Palace). Maní, Yucatán.

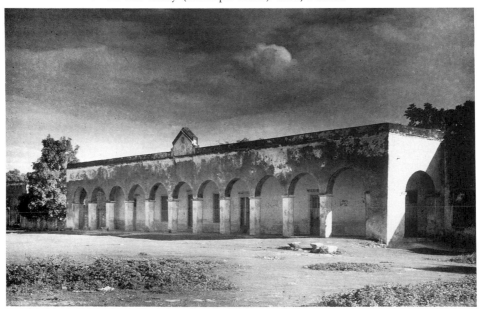

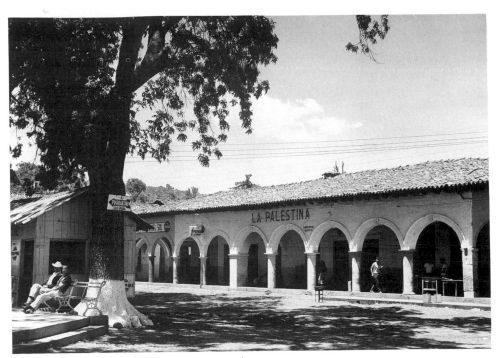

69. Plaza. Huango (Villa Morelos), Michoacán.

70. Plaza. Cherán, Michoacán.

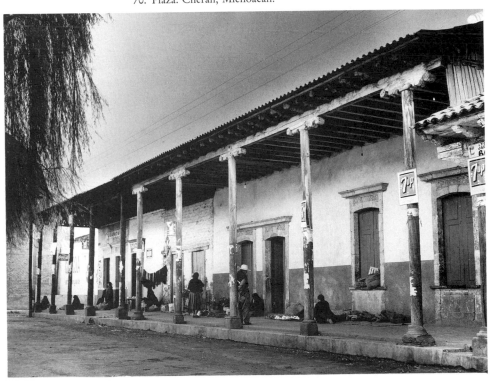

IV

THE FRIARS' MISSIONS
Central Mexico

The problem in presenting the sixteenth-century monasteries of the Mendicant Orders is to make choices. All are interesting, amazing—some are almost complete, some can show only a few scraps of masonry, some are winningly provincial or amateur, others have sophisticated parts—most are imposing, a few, beautiful. Individually, the remains of a monastery might seem insignificant; taken as a group they are an astonishing and powerful body of architecture.

One dilemma in selecting examples is that, in spite of the standard plan within which they were designed and built, all of the monasteries are different. In each, one feels the activity not only of an individual, or a series of individuals, of more or less sophistication directing the work, but also the action of a number of executants only loosely organized and supervised. When one says to one's self *the cloister,* for example, it might mean anything from one-story rubble masonry with cut-out arches, to the highly articulated two-story vaulted arcades for which unique capitals have been invented. Occasionally there are relationships among the buildings—as between the *posas* of Huejotzingo and Calpan—or the link of a documented (though mysterious) name, like Fray Juan de Alameda. But this neither diminishes nor explains the individuality of the buildings.

The charm of pilgrimage also enhances individual monasteries: even in the 1940s one had to search them out, traveling in unlikely vehicles with no assurance that there would be any architecture at the end of the road. The sixteenth-century buildings had hardly been noticed (and certainly not differentiated) before 1920, and this was partly because they were in fact off the beaten path of modern life—which at that time meant the railroad line. Even twenty-

five years ago there were few good roads, and the best guide was something like Father Ponce's record of his tour of inspection in the late sixteenth century.

So, with the caveat that for every cloister shown there are twenty others as interesting, we shall simply crowd in as many photographs as possible, to illustrate the rudiments of the plan, and to suggest its variations. To clarify a little further, they are arranged in chronological–geographical groupings, but loosely (for among other evidences of their individuality is a tendency to refuse any precise arrangement). The dating is another of their fascinations, but this is not the place to explore such mysteries: we simply offer reasonable assumptions from the evidence.

As for the general plan of the Mendicant monastery, it had taken form by mid-century; it was followed closely by the Franciscans and Augustinians (who had developed it) and less sympathetically by the Dominicans. There was a large, rectangular churchyard (in Mexico called the *atrio*), surrounded by a wall. Facing on this yard there was likely to be an open chapel; at the four corners were shrines called posas, and in the center a large stone cross. The church normally faced west, with the monastery building beside it to the south (except in hot country, where it was placed on the north, and in Yucatán, where it was often at the back of the church). Beside the facade of the church was the facade of the cloister, with an arcaded porch called the *portería* (which often doubled as open chapel); from this, one stepped through into the arcaded cloister. The cloister was of one or two stories, often with a well or fountain in the middle, usually arcaded all around. On the lower floor were such rooms as the dormitory, Sala de Profundis (assembly room), schoolrooms and other public places; above (reached by a monumental stairway) were dormitories and cells, the prior's rooms, sometimes a library (and, in Yucatán, a private chapel where the Sacrament was reserved). Other monastic offices, kitchens, workrooms, gardens, and orchards were in back.

The church was ordinarily simple in form, massive, high, austere. There was usually a plain, solid tower for bells, or an *espadaña* (a wall-belfry) above the roof—occasionally a free-standing tower. In addition to the west portal there was also a north door (in Yucatán, both north and south doors gave cross-ventilation), and on the south side, usually from the nave, a doorway gave into the cloister. Another door from the cloister led to the choir loft, which was raised above the west door. The sanctuary was a simple chancel, sometimes a semicircle or semihexagon, sometimes raised a few steps from the nave. Ordinarily it communicated with the sacristy (to the south). There were usually no chapels along the nave—until the Dominicans, and the seventeenth century, brought them—and probably few subsidiary altars in early years. Transepts were rare.

Lighting was by windows along the top of the nave wall, and from an ornamented window in the west front, over the choir. A very few churches dating from the great building period are in basilica form, with aisles divided from the nave by rows of columns and clerestory windows. The baptismal font has no allotted place—sometimes it stands in a proper baptistry, otherwise somewhere in the nave—perhaps because its original situation was the open chapel. There was but little other furniture: the altar with its altarpiece, pulpit, stoups, confessionals, a stand for choir books and stalls for the choir. Later on there might be an organ, and more altars and altarpieces. It is all quite simple, plain, and just about what any intelligent person who had spent his adult life in European monasteries would be able to describe and build.

In the beginning, the churches and cloisters were decorated with mural painting, presumably by Indians under direction of the friars. This was a form of decoration relatively quick and not too demanding; the most common type is a running "grotesque" border such as the Renaissance had adapted from Roman decoration—this they called *a lo romano* in New Spain. Often (as at Actopan) it is clear that the artists are copying graphic models, probably from books; these models are often poorly adapted to large mural use, so that they give a bizarre effect—a series of sainted and blessed fathers sitting in chairs, in large scale, all over the stairwell, for example. By 1570 there were enough European painters and wood-carvers and gilders in the country to begin providing large Renaissance retables for the monastery churches. The old-fashioned wall-paintings were whitewashed over (fortunately, since this has preserved them) and magnificent altarpieces were installed in the chancels, of which, incredibly, three monumental examples have survived.

Motolinía says that the Franciscans didn't get started building outside the city until about 1529. By 1541 (when he was writing) there were already forty foundations, he says. It is a surprise to find that there are still in existence remnants of this first period, including one, and probably two, complete units, at Epazoyucan and Tlaquiltenango.

Hundreds of small modest churches, however, scattered over the Mexican countryside, in small towns, and even hidden away in cities, suggest the sort of buildings put up in the early years. In themselves they are often all but undatable—built in the same way, of the same materials, by much the same people, whether in the sixteenth, the seventeenth, or the nineteenth century. Almost nothing is dated or documented; except for the evidence of a specific material (like ferro-concrete), only the garnishing of style betrays their position in time. In spite of total anonymity, a sort of nondescript poetry makes these modest churches very appealing. A few are inserted here to remind us that

whatever of "architecture" occurred in Mexico was grounded in popular tastes and skills.

Between 1540 and 1560, counting loosely, a great group of monasteries in Central Mexico were begun and (more or less) completed. Almost all of them represent the rebuilding in permanent forms of earlier provisional structures. They indicate the accretion of monastic personnel, the availability of laborers now trained to European building, and the greater repose of a period when the first conversion was accomplished. They were completed, however, at a progressively slowing pace, when the missionary movement was already over. The Indian population had declined drastically—there were neither so many workers available, nor so many residents who needed the church—and the monks were being replaced by secular clergy, turning the monasteries into parishes. The active period of monastic building was cut off around 1570 in central Mexico, which is not to say but that many foundations were finished, or improved, or rebuilt or decorated after that time.

This great body of architecture was accomplished within a span of some sixty years, but not the same sixty-year period everywhere. The dates of conquest and conversion, along with cultural lag, put outlying regions such as Jalisco or Michoacán or Oaxaca or Chiapas on a different time-schedule, not to mention places still farther away, like Baja California and Chihuahua. Indeed the only generalization one can risk is that each area has its special cycle of dating. Almost as important as the original events is the intervening history. Earthquakes, revolutions, and, above all, progress are bad for buildings; a combination of remoteness, poverty, and humble care preserves them.

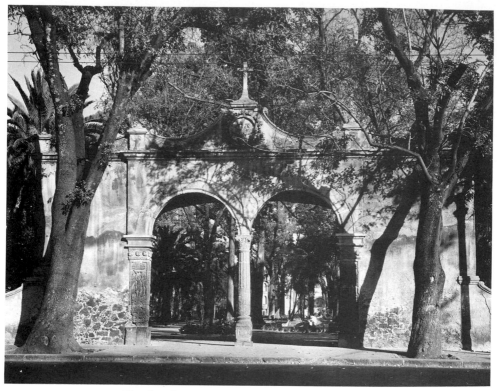

71. Churchyard gate, Dominican monastery. Coyoacan, D.F.

72. Churchyard gate, Franciscan monastery. Coatlinchán, México.

73. Churchyard cross. Acolman, México.

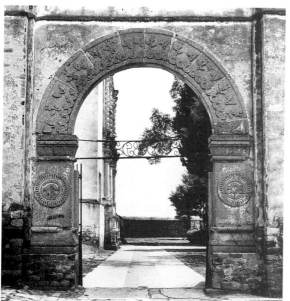

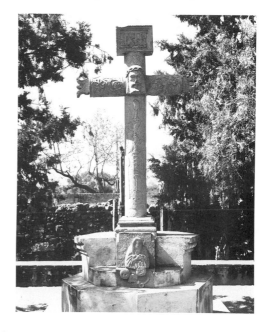

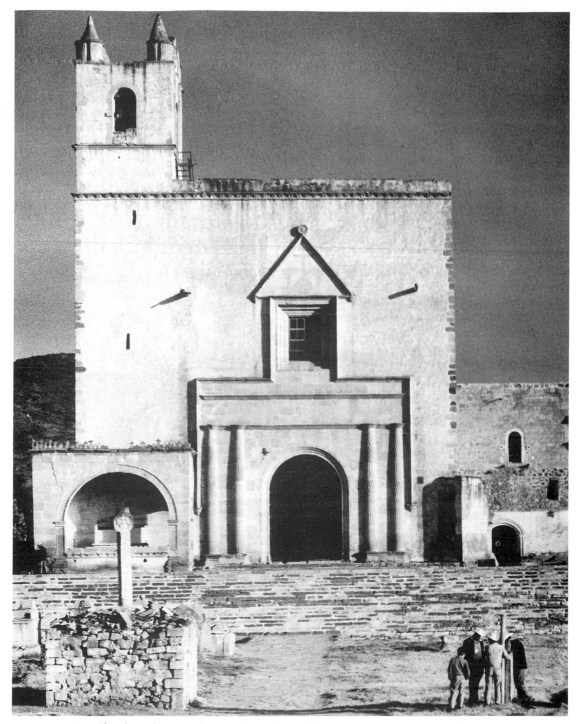

74. Church and open chapel of the Augustinian monastery. Epazoyucan, Hidalgo.

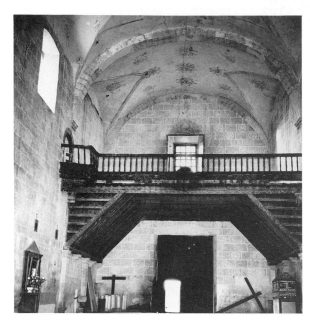

75. Choir loft, church of the Augustinian monastery. Epazoyucan, Hidalgo.

76. Cloister, Augustinian monastery. Epazoyucan, Hidalgo.

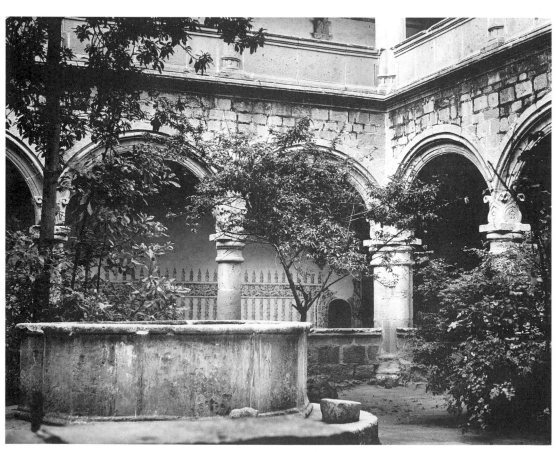

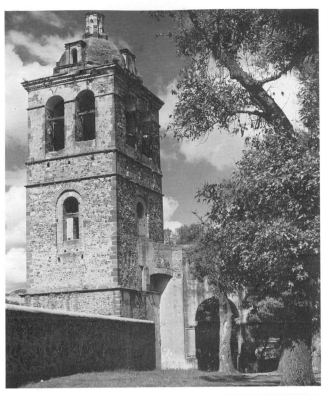

77. Bell tower, Franciscan monastery. Tlaxcala, Tlaxcala.

78. Ceiling over nave, church of the Franciscan monastery. Tlaxcala, Tlaxcala.

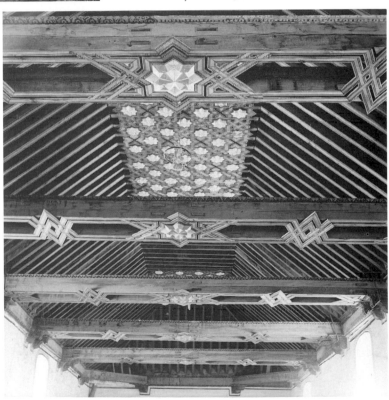

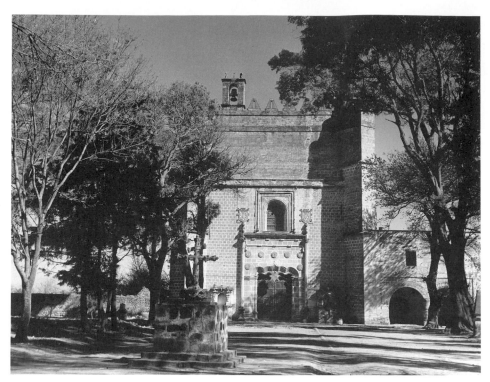

79. Church of the Franciscan monastery. Huejotzingo, Puebla.

80. Posa chapel I, Franciscan monastery. Huejotzingo, Puebla.

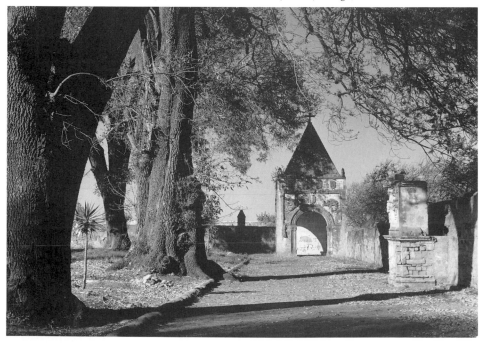

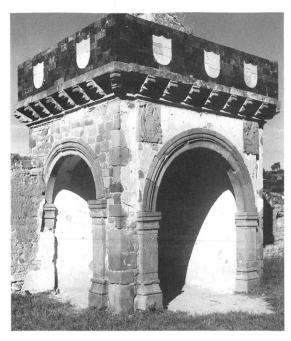

81. Southeast posa chapel, Franciscan monastery. Tlaxcala, Tlaxcala.

82. Angels bearing instruments of the Crucifixion and the Franciscan coat-of-arms, posa chapel II. Franciscan monastery. Calpan, Puebla.

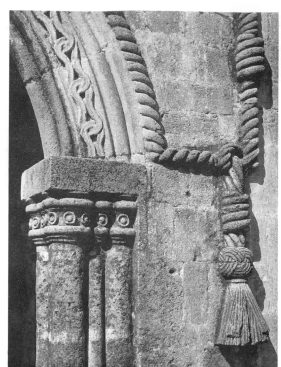

83. Franciscan cord used as decorative motif, posa chapel I. Franciscan monastery. Huejotzingo, Puebla.

84. Open chapel, Franciscan monastery. Tepeapulco, Hidalgo.

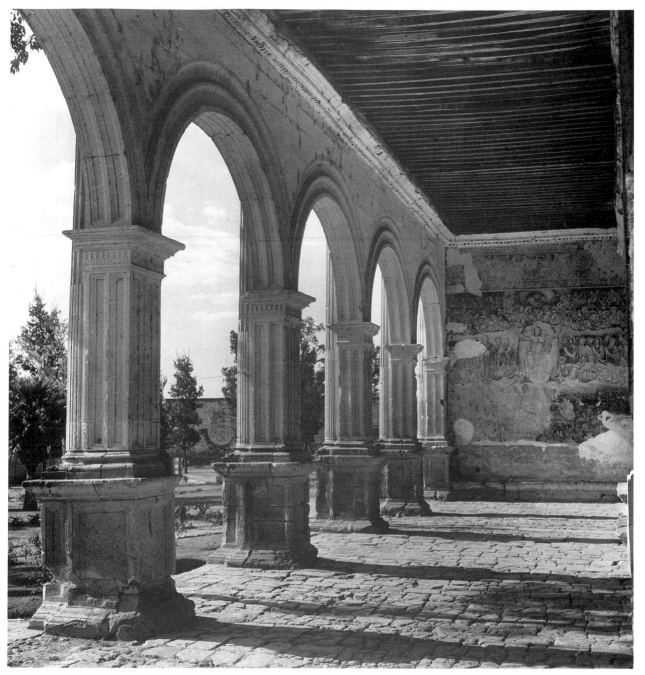

85. Open chapel, Augustinian monastery. Cuitzeo, Michoacán.

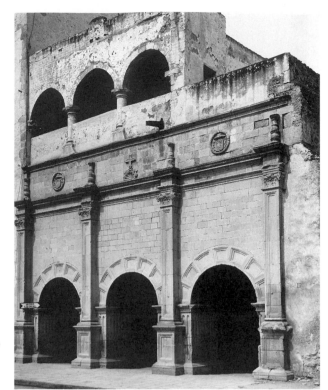

86. Portería, Augustinian monastery. Actopan, Hidalgo.

87. Facade, church of the Franciscan monastery (the Basilica). Tecali, Puebla.

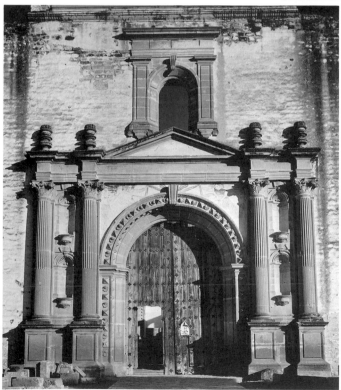

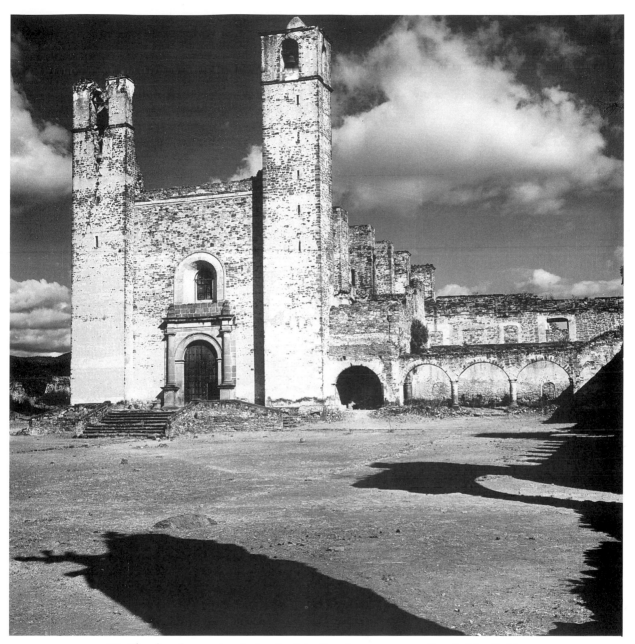

88. Church and open chapel, church of the Franciscan monastery. Cuautinchán, Puebla.

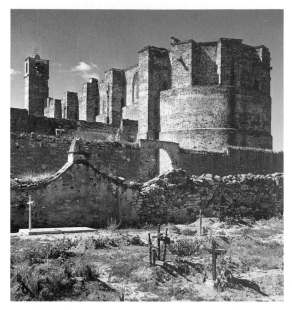

89. Apse, church of the Franciscan
monastery. Cuautinchán, Puebla.

90. Merlons and roof, church of the Franciscan monastery. Tepeaca, Puebla.

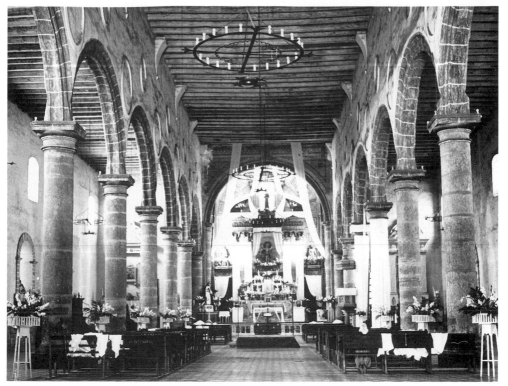

91. Nave, church of the Franciscan monastery. Zacatlán (de las Manzanas), Puebla.

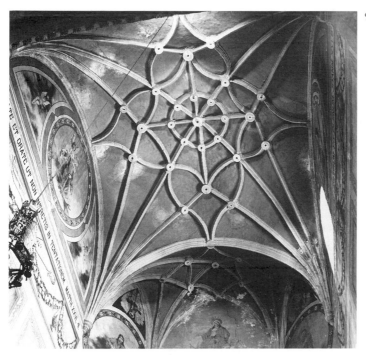

92. Vaulting of nave, church of the Augustinian monastery. Atotonilco, Hidalgo.

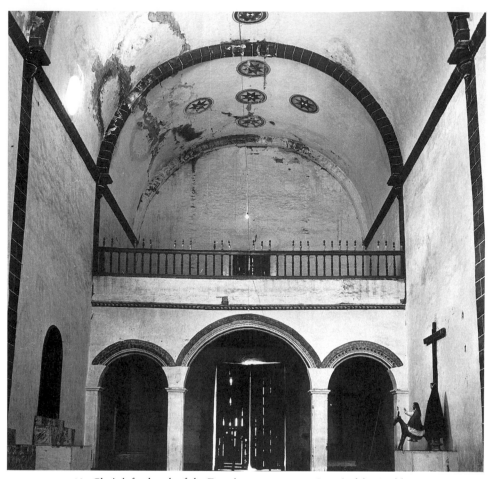

93. Choir loft, church of the Franciscan monastery. Cuautinchán, Puebla.

94. Stoup, formerly in the Basilica. Parish church. Tecali, Puebla.

95. Baptismal font, church of the Augustinian monastery. Zacualpan de Amilpas, Morelos.

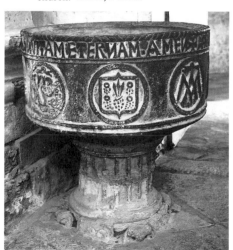

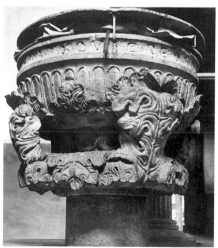

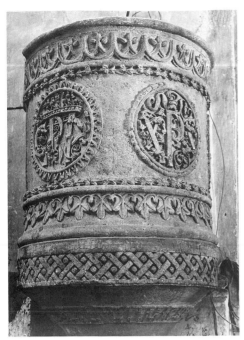

96. Pulpit, church of the Franciscan monastery. Huexotla, México.

97. Cloister, Augustinian monastery. Ocuituco, Morelos.

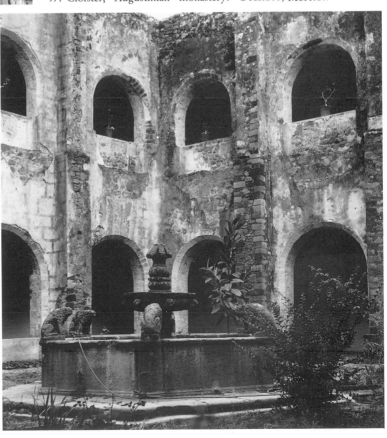

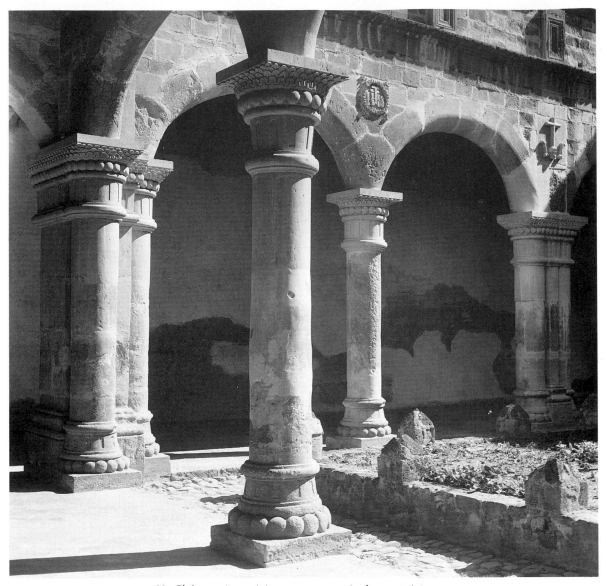

98. Cloister, Augustinian monastery. Acolman, México.

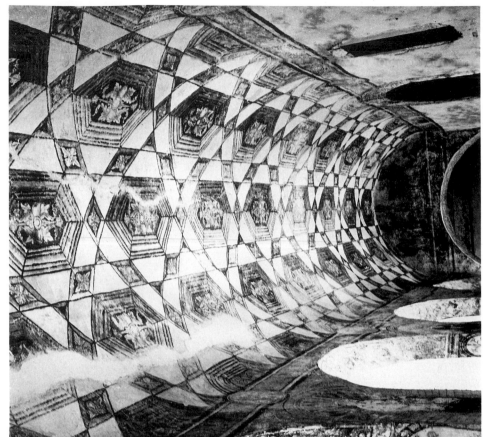

100. Vaulting over cloister walk, Augustinian monastery. Totolapan, Morelos.

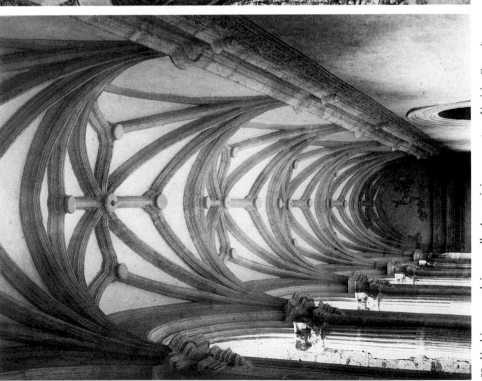

99. Vaulting over cloister walk, Augustinian monastery. Yuriria, Guanajuatc.

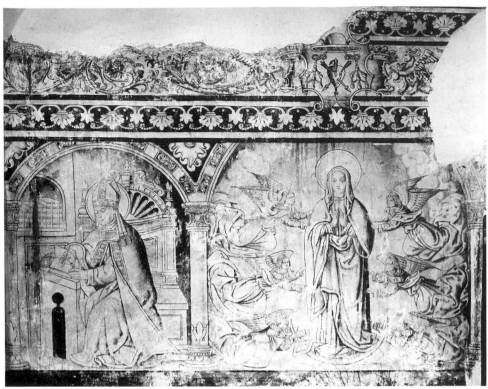

101. Anonymous. The Immaculate Conception and Saint Augustine. Augustinian monastery. Tlayacapan, Morelos.

102. Anonymous. The Crucifixion. Augustinian monastery. Tlayacapan, Morelos.

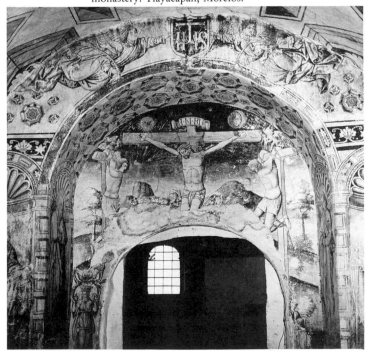

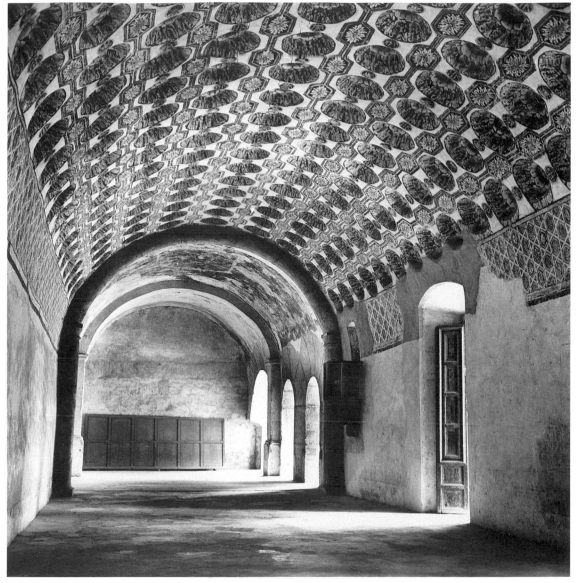

103. Refrectory, Augustinian monastery. Actopan, Hidalgo.

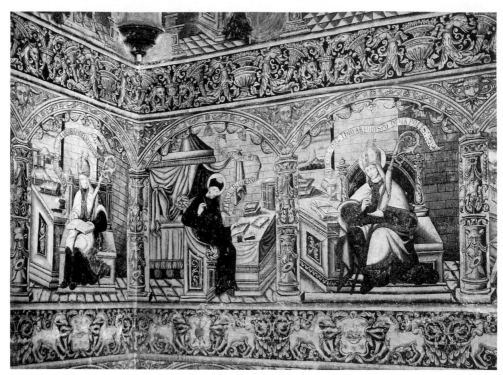

104. Anonymous. Augustinian Fathers. Mural in the stairwell, Augustinian monastery. Actopan, Hidalgo.

105. Parish church. Santa María del Pino, Hidalgo.

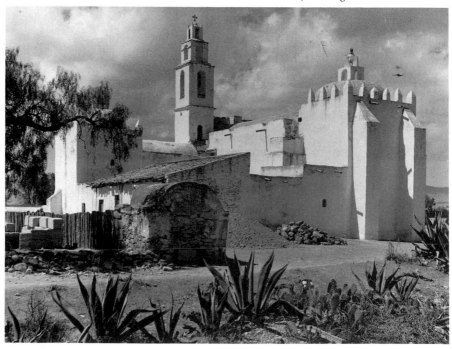

V

THE FRIARS' MISSIONS
Michoacán and Oaxaca

All through the sixteenth century the frontiers of Spanish civilization were pushed out. Spanish towns were founded, mines opened up, roads built, unknown territory explored, with the friars never far behind. The Franciscans continued in the vanguard; theirs were the earliest missions, they set up monasteries on the road to Veracruz, they went out to the west and the south, and on to the northern frontier. Northward, the Augustinians had early run a chain of missions into the present state of Hidalgo. Now the Dominicans, late in arriving and slow to leave the Spanish towns, began to move southward from Puebla.

Depending on the relative chronology of Spanish exploration and conquest, the foundations outside Central Mexico might date from 1525—or from 1725. What was done in the sixteenth century depended very much on the preconquest culture of the area. Places with a high Indian culture, like the Valley of Mexico, were the first to be conquered, and were converted in the first, eager period; if they brought more to the colonial culture, it was also more quickly drowned out. This was true also of Oaxaca, with its Zapotec and Mixtec cultures. In other places—like Michoacán—where peripheral preconquest cultures were less developed, colonial culture resulted in less imposing monuments, but an indigenous flavor lasted longer. On the other hand, what we have remaining of viceregal, and especially of sixteenth-century, building depends on subsequent history. Generally speaking, the less prosperous and central the place, the more ancient and the more complete are its monuments.

Michoacán had the worst possible introduction to Spanish rule, because it was "reduced" by Nuño de Guzmán, who was probably the worst conquistador

of all. This was followed, however, by the most benevolent of all the campaigns of acculturation, devised by the Bishop of Michoacán. Don Vasco de Quiroga, an influential jurist and member of the Second Audience, had taken holy orders and been consecrated Bishop precisely for this work. Taking his plan from the literary fantasy of one of his contemporaries, Don Vasco set about reconstructing Indian society on the pattern of Thomas More's *Utopia.* Architecturally, this resulted in a town grouped around a church and community hospital—a "hospital" in the medieval sense of an institution hospitable to all need, not only for the sick but for the hungry and the destitute, the aged and the young, for travelers as well as residents. The plan also included encouragement of the crafts, with community labor in workshops as well as in the fields.

The Indians of Michoacán had never been conquered by the Aztecs, and their sixteenth-century history is also individual. They settled on the hospital as the unit of culture; where other Indians built open chapels or elegant monasteries, they erected hospitals. It is hard to be clear about the lineage of the idea. Don Vasco founded his first town on the Utopian model, Santa Fe in the Valley of Mexico, in 1531 or 1532, before he ever saw Michoacán. But the Franciscans, who had entered Michoacán in 1525 at the request of the Tarascan ruler, Caltzontzin, also built hospitals there before the Bishop came. Fray Juan de San Miguel's hospital at Uruapan, the elegant hospital chapel at Acambaro, and the open chapel of the hospital at Tzintzuntzan bear witness to that. As so often in Mexico, it is less fruitful to distinguish the Bishop's work from the friars' than to merge them together. Thus in 1563 it was ordered that every town in Michoacán which had a church should also have a hospital. Even in 1792 a survey showed one township after another reporting that "all towns have hospitals in this sub-delegation"—often adding some note like "Don Vasco gave them land for the expenses of this hospital."

After Quiroga became bishop, the Augustinians also moved out into the west, with houses at Tacámbaro and Tiripetío and Huango; in the 1560s they held as many as thirty foundations (though some were soon given up). Although Don Vasco himself often quarreled with the Orders, it is a curious thing that the missionary effort in Michoacán seems all of one piece. We hear a good deal about extravagance and display—particularly at Ucareo and Huango—but except for the Augustinian monastery of Cuitzeo (which belongs architecturally to the northern campaign in Hidalgo), the churches are less pretentious architecturally than elsewhere. Perhaps they have survived less well, which might mean that they were built less skillfully as well as less grandly. Pitched roofs of wood and thatch, rather than vaulting, indicate a more modest environment, less wealth, fewer skilled workers. Certainly more of these modest ancient structures seem to

have survived in Michoacán—or to have been constantly rebuilt in the same way. Many an old barn-like building in a Tarascan village may yet be identified as its sixteenth-century chapel; the walled yards with roofed wicket-gates—like farm-yards—enclosing nondescript long buildings are perhaps always hospital units. Here and there a startling early facade or unique stone crucifix, or an architectural group on a small scale but full of character gives us a taste of what in most places they never had time to do.

Oaxaca, on the other hand, was territory of the Dominicans, and the mood there was quite different. This was the estate of Cortés himself—the Marqués del Valle de Oaxaca. At the time of the Conquest, this land of the Mixteca and the Zapoteca was rich, well populated, and famous for the skills of its craftsmen.

All of this suited the Dominicans well. Given their intellectual tradition, they were properly entitled the Order of Preachers, and although they too were Mendicants, they interpreted the vow of poverty on a different level from the workaday Franciscans. They had not shared to any extent in the first mass conversions, and tended to be more exacting about forms and less enthusiastic about the Noble Savage. Where the Franciscans and Augustinians had protested against demanding tithes of the Indians, refusing to collect them for their own use, the Dominicans ran their missions on this tax. In Oaxaca they established the silk industry, and built silk-barns instead of hospitals; Christianity came in here with a paternalistic economic flavor. For a while, after the middle of the century, it seemed as though this more worldly approach to the Indian problem might succeed. When all the rest of New Spain was undermined by epidemics and financial depression, Oaxaca continued with prosperity, increasing population, and more building. There were twenty-five houses in the province of Oaxaca by 1595, perhaps a third of them large and architecturally interesting. Then the epidemics caught up with them, the infant silk industry was crippled by imperial competition, and Oaxaca settled into its colonial inertia, shaken up from time to time by devastating earthquakes.

Because of the earthquakes, buildings tend to be massive; and they are hard to date because every few years something has had to be replaced or rebuilt or restored. Like the philosopher's stockings, the churches defy one to say exactly where the old stops and the new begins. Everything in the churchyard—the gates, the cross, the posas—may have been made in the eighteenth century, and yet the whole effect is still of the sixteenth-century plan. Valuable stone saints from sixteenth-century facades are put up again a century or more later; almost the same vault is rebuilt (though an incomplete fountain may be thrown away rather than restored), altarpieces are reassembled, even date-stones move around

so no one knows what they belong to. But the garrulous old chronicler, Francisco de Burgoa, hands down a good many scraps of information about what the Dominicans did in the century before he wrote, and it is not impossible on many sites to match his account with what we see. At Cuilapan he speaks of a Portuguese brother, Antonio Barbosa, and also of Fray Domingo de Aguiñaga, who "began and gave form and splendor to this town and monastery." For Yanhuitlán he claims, "the most superior craftsmen ... were pulled out of the Escorial," and later a "great Italian master" was consulted on earthquake damage. Although these reports may not be dependable in specifics (old-fashioned Yanhuitlán shows little relationship with the Escorial), they point up one distinction of the Dominicans: they prided themselves on using professionals, both members of their Order and secular consultants. And although one cannot connect names with work, we are aware of certain architectural personalities in Oaxaca: the man who built the basilica at Cuilapan, the man who built the churches of Yanhuitlán and Coixtlahuaca, and most intriguing of all, the Master of Teposcolula, who designed the open chapel there, and the one at Coixtlahuaca.

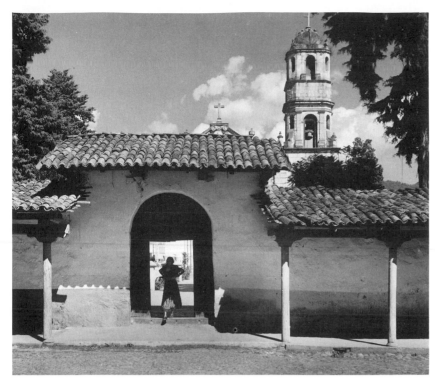

106. Churchyard gate. Santa
Fe de la Laguna, Michoacán.

107. Chapel of the Franciscan
hospital. Uruapan,
Michoacán.

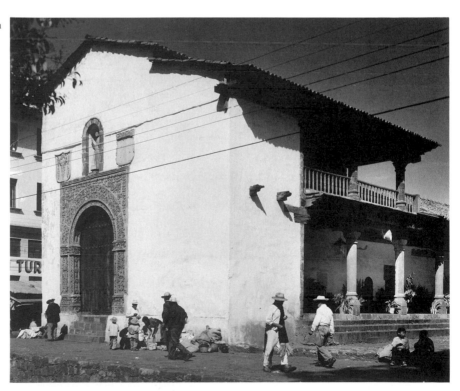

>117<

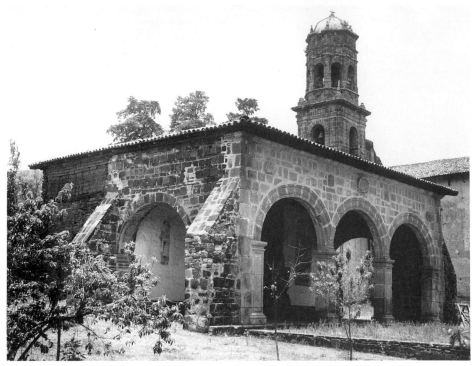

108. Open chapel of the Franciscan hospital. Tzintzuntzan, Michoacán.

109. Facade, chapel of the Franciscan hospital.
Acámbaro, Guanajuato.

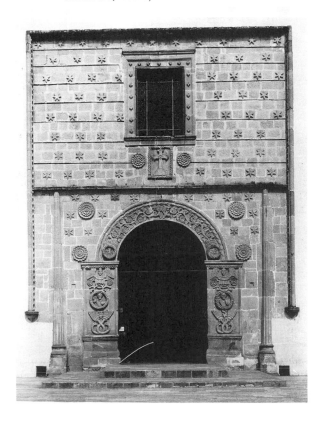

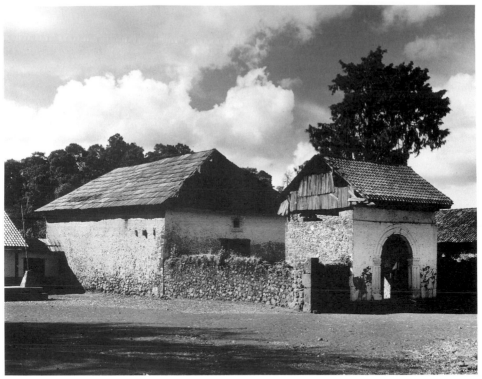

110. Franciscan hospital. Zacán, Michoacán.

111. Franciscan hospital. San Lorenzo, Michoacán.

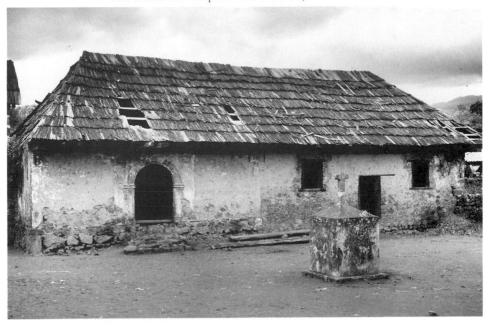

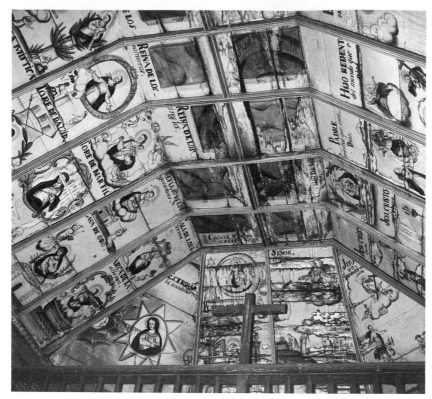

112. Ceiling, chapel of the Franciscan hospital. Zacán, Michoacán.

113. Main altar, chapel of the Franciscan hospital. San Lorenzo, Michoacán.

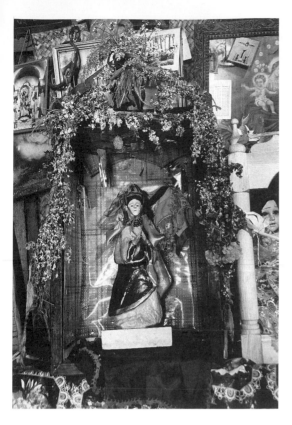

114. The Immaculate Conception. Formerly patron
 saint of the hospital chapel. Household shrine.
 Turícuaro, Michoacán.

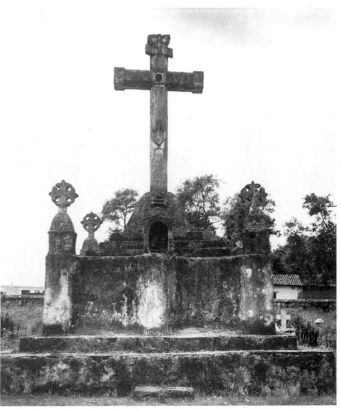

115. Churchyard cross, parish church. Santa Fe de
 los Alzate, Michoacán.

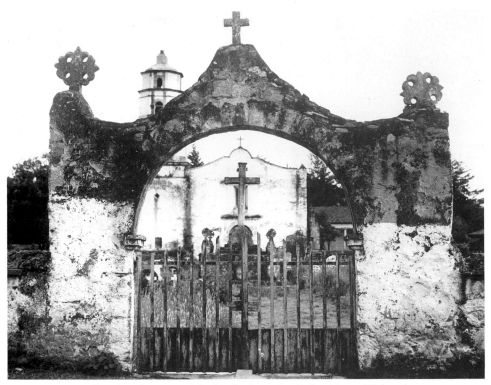

116. Churchyard gate, parish church. Santa Fe de los Alzate, Michoacán.

117. Chapel of San Francisco Uricho. Uruapan, Michoacán.

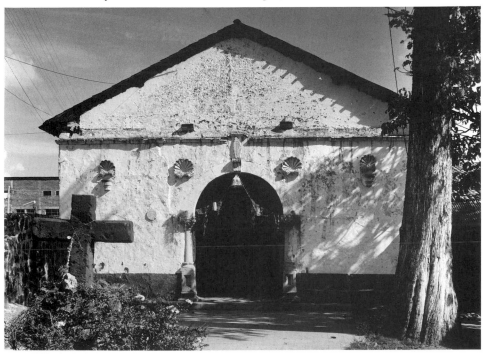

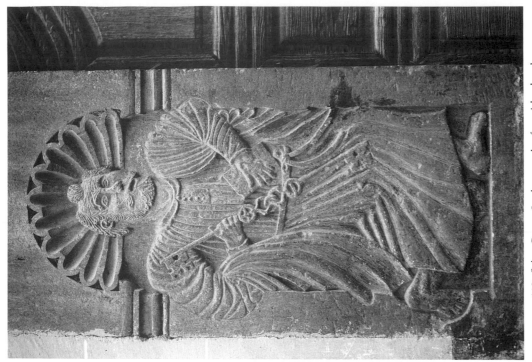

119. Saint Peter. Jamb, portal of parish church. Jaracuaro Island, Michoacán.

118. Figure of Christ on churchyard cross. San Angel Zurumucapio, Michoacán.

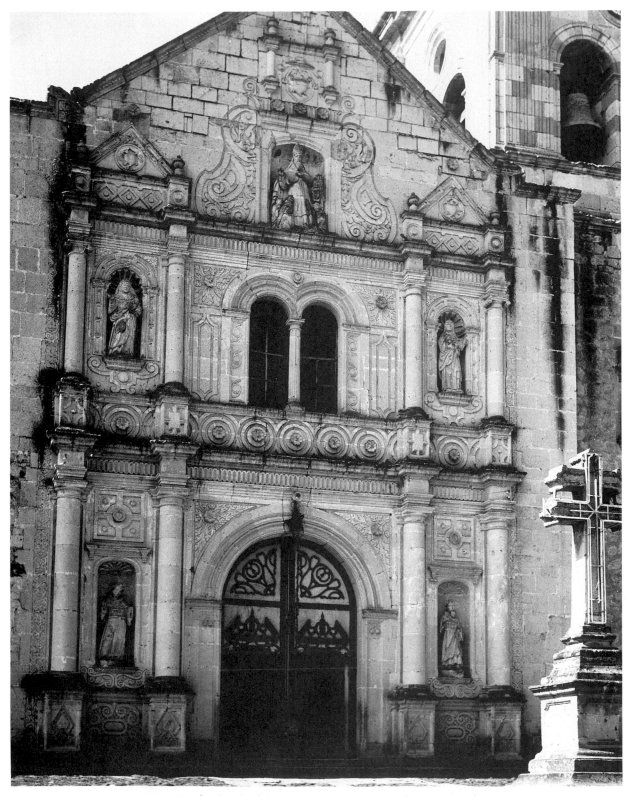

120. Facade, church of the Augustinian monastery. Charo, Michoacán.

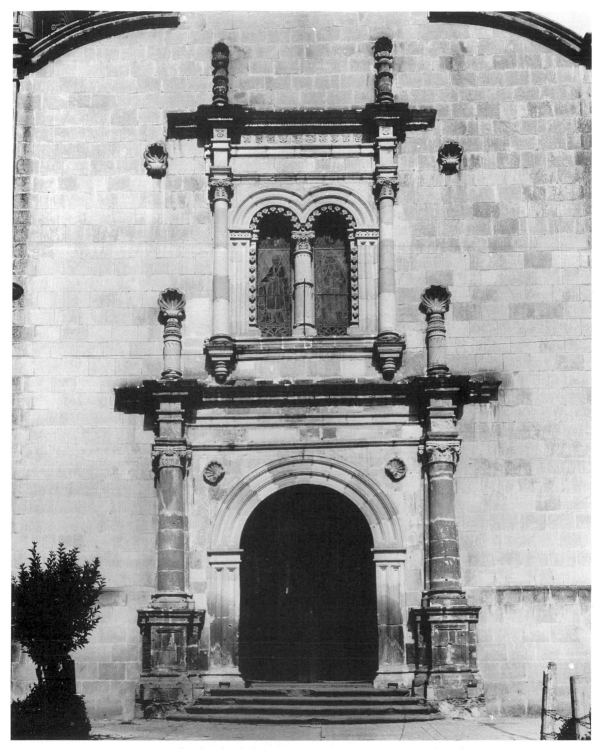

121. Facade, church of the Franciscan monastery. Zacapu, Michoacán.

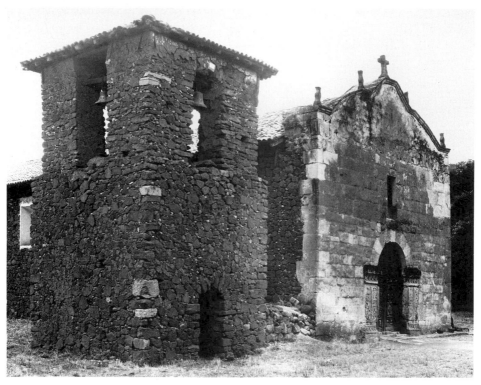

122. Parish church. San Nicolás Obispo, Michoacán.

123. Facade, parish church. San Nicolás Obispo, Michoacán.

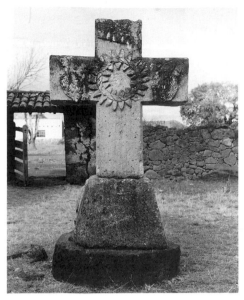

124. Churchyard cross, parish church. San Nicolás Obispo, Michoacán.

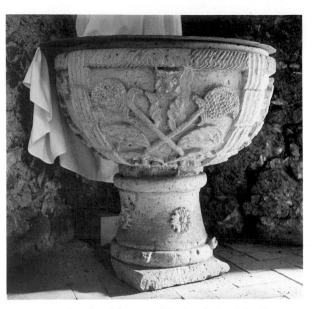

125. Baptismal font, parish church. San Nicolás Obispo, Michoacán.

126. Choir loft, parish church. San Nicolás Obispo, Michoacán.

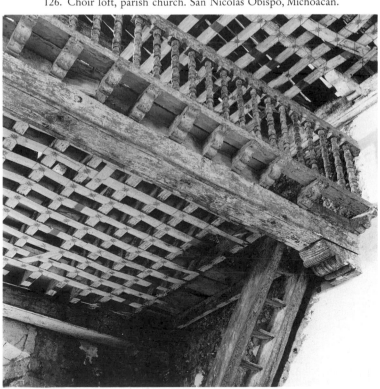

127. Cloister, Franciscan monastery.
 Tarecuato, Michoacán.

128. Churchyard gate, Church of
 San Miguel. Tulancingo,
 Oaxaca.

>128<

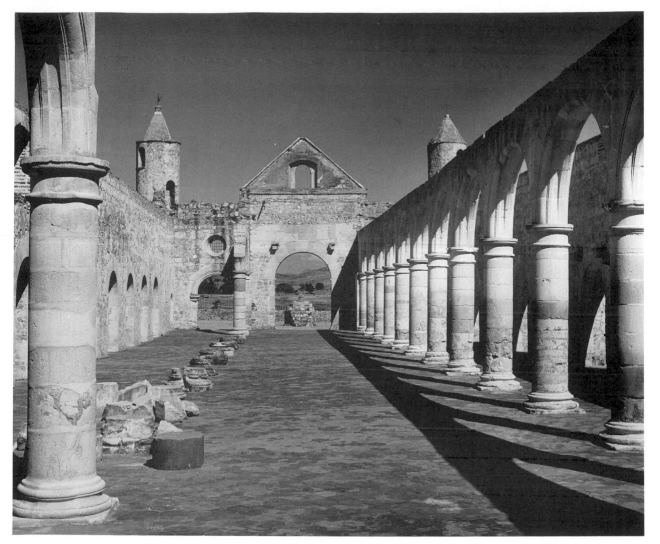

129. Nave, the Basilica (former church of the Dominican monastery). Cuilapan, Oaxaca.

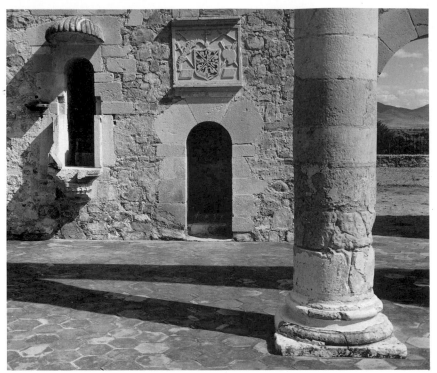

130. Pulpit in nave wall, the Basilica (former church of the Dominican monastery). Cuilapan, Oaxaca.

131. Apse, church of the Dominican monastery. Yanhuitlán, Oaxaca.

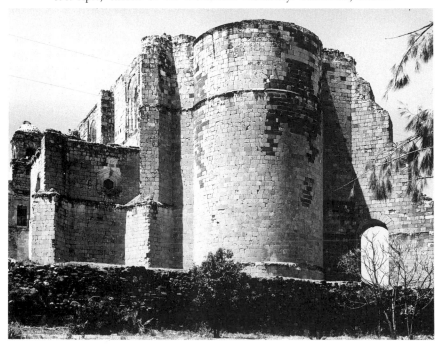

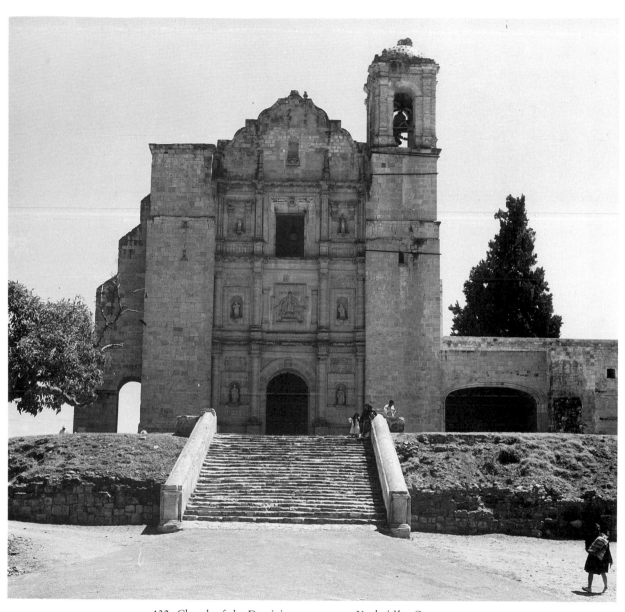

132. Church of the Dominican monastery. Yanhuitlán, Oaxaca.

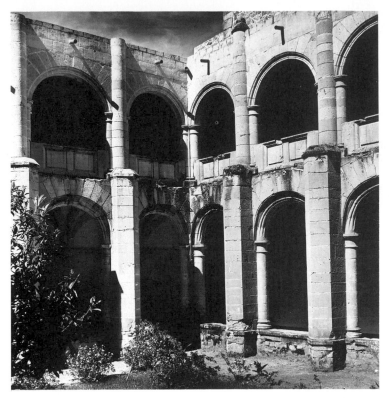

133. Cloister, Dominican monastery. Cuilapan, Oaxaca.
134. Organ in choir loft, Dominican monastery. Yanhuitlán, Oaxaca.

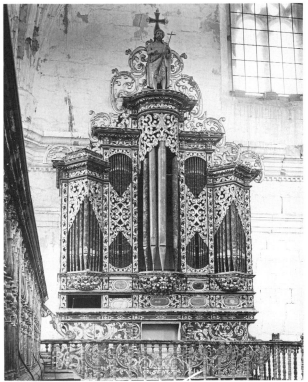

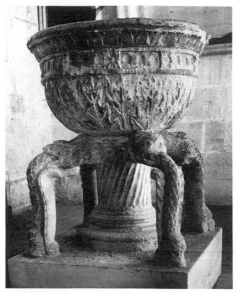

135. Baptismal font, church of the
Dominican monastery.
Cuilapan, Oaxaca.

136. North door, parish church.
Topiltepec, Oaxaca.

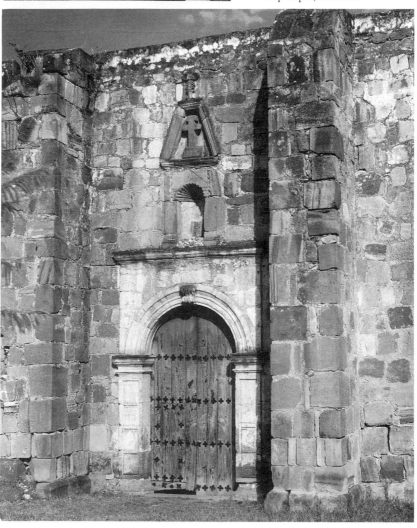

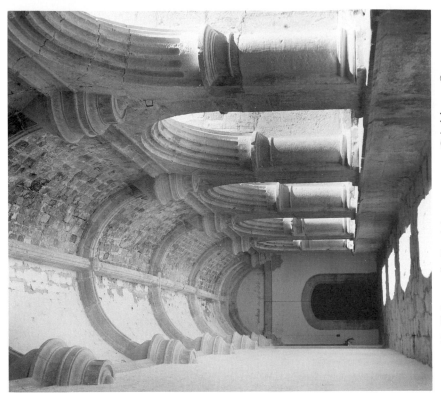

138. Cloister walk, Dominican monastery. Coixtlahuaca, Oaxaca.

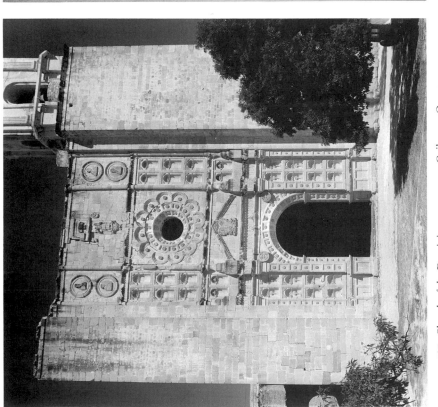

137. Church of the Dominican monastery. Cuilapan, Oaxaca.

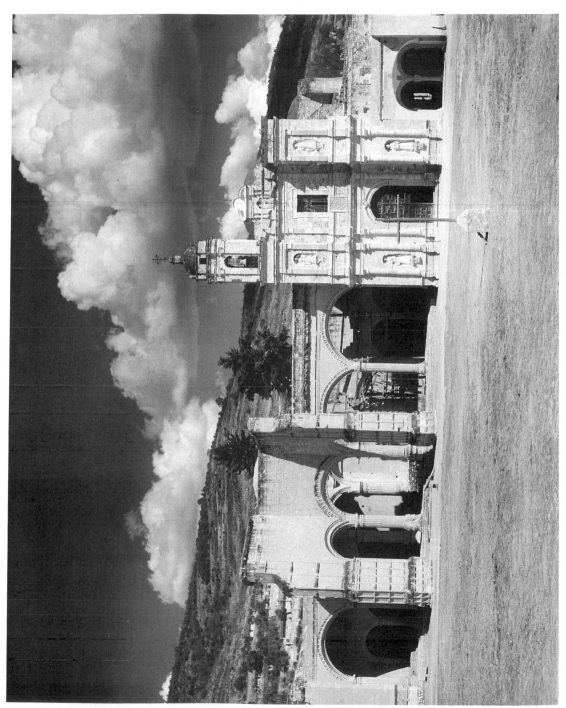

139. Church and open chapel, Dominican monastery. Teposcolula, Oaxaca.

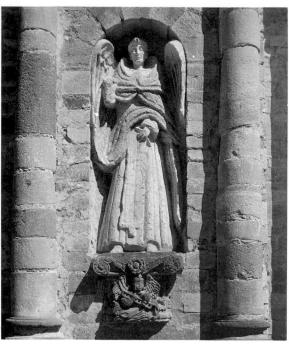

140. Saint Dominic. Facade, church of the Dominican monastery. Teposcolula, Oaxaca.

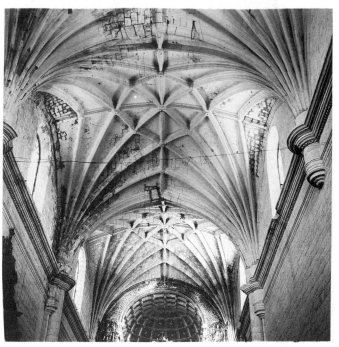

141. Vaulting, church of the Dominican monastery. Yanhuitlán, Oaxaca.

142. Doorway in choir loft, church of the Dominican monastery. Coixtlahuaca, Oaxaca.

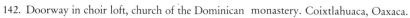

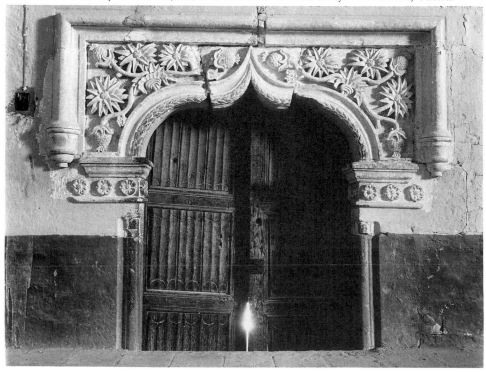

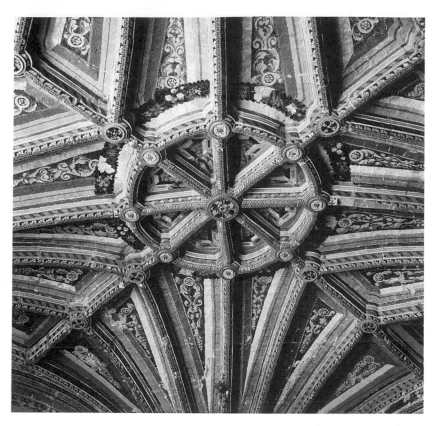

143. Vaulting under choir loft, church of the
 Dominican monastery, Coixtlahuaca, Oaxaca.

144. Choir loft, church of the Dominican monastery.
 Yanhuitlán, Oaxaca.

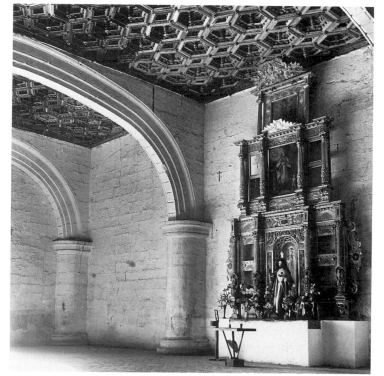

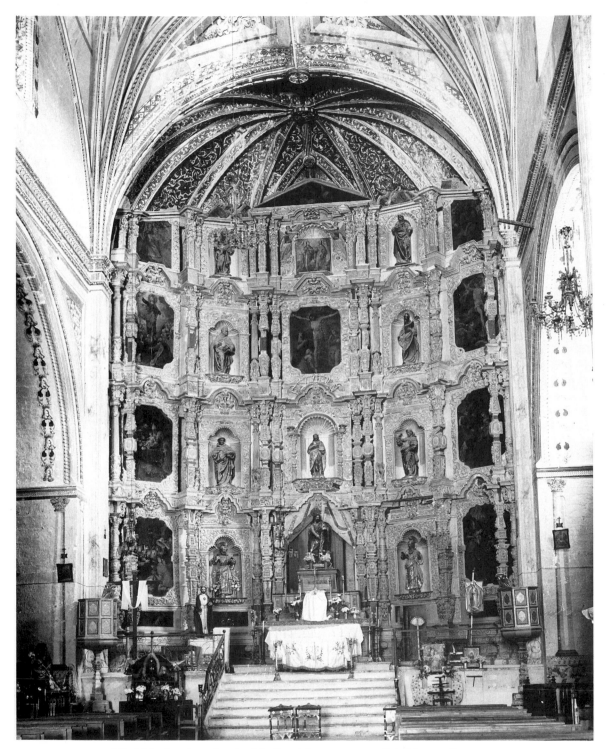

145. Main altarpiece, church of the Dominican monastery. Coixtlahuaca, Oaxaca.

VI

TEQUITQUI AND RETABLES

Tequitqui—the art which shows an Indian quality—occurred only while there was a living memory of preconquest art in New Spain. In situations where it had no importance for the cult, where it seemed to fill a purely decorative function, and where, in short, it didn't matter, decoration might—in those early days—be left to the stonecutter, who would in all probability be an Indian. At a time when this Indian stonecutter would still have a repertoire of the preconquest decoration to which he had been trained, it might very well intrude. Even if the friars gave him a pattern—the grotesque borders *a lo romano* (often used to frame murals) or the pilasters on a printed title-page from Antwerp—he would tend to merge new motifs with those he knew so well. At least he would continue to cut the stone as he had been trained—flat though bulging, let us say, rather than half-round—even though he had better tools of metal for faster and more virtuosic carving. And as these craftsmen acquired the tricks and the taste of the new manner, they would be allowed to take over more and more of the work— often with a notable improvement over the run-of-the-mill woodcut from Flanders which served as model.

We find *tequitqui* always in the detail—on the doorways of churches or their chancel arches, on the gateways and posas and open chapels and crosses of the churchyard (which especially belonged to the Indians). There may have been early facade sculpture (indeed a few reliefs and re-used saints have survived), but it is the quite meaningless knots and flowers, the Indian types of relief, and the Indian habits of composition that engage us. Sculpture had been the great art of the Aztecs, and it was the stonecutters most often who preserved these ecumenical

mementos of the past. But unobtrusive or overt bits of the Indian past can also be found among the Renaissance patterns and sacred stories of the mural paintings with which the friars had their Indian workers cover the enormous blank walls of church and cloister.

The Indians were not allowed, of course, to express their own opinions about the new religion; the Church of Rome could tell them exactly what a *Púrisima*, for example, should look like: the Virgin of the Immaculate Conception, as perfected by the painters of Spain in the first half of the sixteenth century. The Indians could contribute native materials: a very light wood for making images or, even lighter, a paste like papier-mâché made of the pith of corn stalks. Crucifixes of corn pith, especially if they are large, restrained and humane in mood, are likely to be of sixteenth-century manufacture. But ecclesiastical legislation kept a firm hand on any step aside from orthodoxy in representation. If any "Indian Madonnas" have come down from those days, it is thanks to their unimpeachable lineage: they are very famous, such as the image that Don Vasco de Quiroga obtained for Pátzcuaro, now the patron saint of the Basilica.

If unconscious heresy was a problem to the Church, the innocent competition of Indian artisans was even more of a problem to immigrant European artists. By the 1560s there were enough of these in Mexico to begin the production of what was to be the greatest Mexican art form: the monumental altarpiece they called a *retablo*. This was ordinarily of wood, made up of reliefs and sculpture in the round and paintings, all assembled in an architectural framing and finished in color and gold leaf. By the end of the century they had whitewashed over the murals in a good many of the large churches and hung up a glorious retable on the apse wall.

That three of the very large altarpieces in Renaissance style have survived from the sixteenth century in quite good condition is little short of miraculous. Equally miraculous is the fact that we have the contracts for the one in the Franciscan monastery at Huejotzingo. It records a great change—the first critical change in the art of New Spain. Somewhere in this last part of the sixteenth century there is a shift, like a fault-line running across the country, from undated, unrecorded decoration painted on walls or carved on the doorways by anonymous and unpaid Indians, to this contract (in the year 1580) between the community of Huejotzingo and a Flemish painter, Simón Pereyns.

Pereyns had arrived in Mexico in 1566. The period of the Renaissance retable in the later sixteenth century exactly follows his career, and we should meditate on it in passing, for—like the secularization of the missions, like the plagues of the 1570s, like the ending of tequitqui decoration—it, too, marks the

end of the Mendicant period. Pereyns came with the viceroy Gastón de Peralta, and first painted battle scenes for the Viceregal Palace, as if to prove himself a Renaissance man. Then, working with assistant painters, with cooperating wood-carvers, with carpenters and joiners and gilders, he furnished altarpieces for the towns of Tepeaca, Cuautinchán, Malinalco, Ocuilán, Mixquic, Tula, Huejotzingo, Coixtlahuaca, and for the Old Cathedral in Mexico City. By the time he died (after 1616), he had been twice denounced to the Inquisition (which is the reason we know so much about his career), and had got off with no more punishment than painting a Virgin at his own cost for the cathedral of Mexico. He had also trained a generation of painters, and helped to change the whole character of church decoration in New Spain.

Pereyns' altarpiece for the church at Huejotzingo and the altarpiece at Xochimilco, which much resembles it, were both made for Franciscan monasteries. Here we have the professional organizer at work—a far cry from newly Christian Indians obediently copying from engravings onto the monastery walls. Here we have the full splendor of the Renaissance altarpiece: immense, rich, sober in structure, noble in effect. Fitted harmoniously to the whole height of the chancel, these retables are very big, like the naves in front of them. At Xochimilco there are seventeen statues, eight paintings and a relief panel, to say nothing of apostles on the predella, of God the Father, Faith and Hope, and two paintings as finials—with two niches now empty. The saints stand quietly, grave and benign, richly robed, reflecting the gold of columns and friezes like glory itself. Restored in recent years, it is all very splendid, and there is not a trace of Indian taste or style in it.

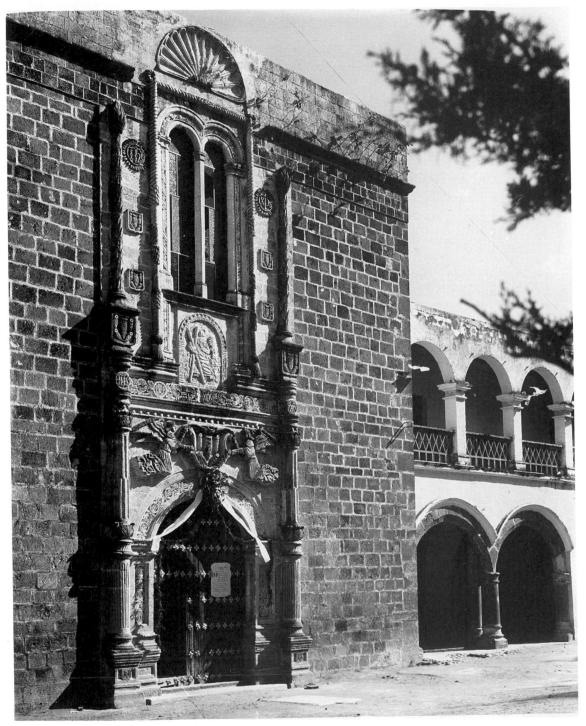

146. Church of the Franciscan monastery. Calpan, Puebla.

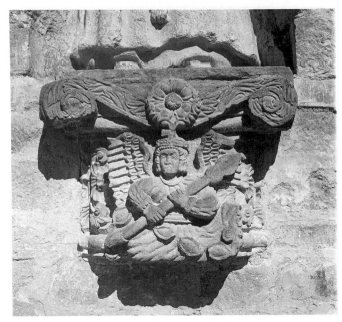

147. Capital (used as a pedestal), facade. Church of
the Dominican monastery. Teposcolula, Oaxaca.

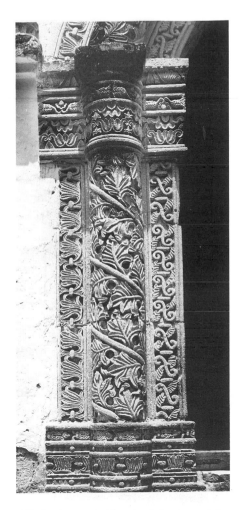

148. Jamb, portal. Church of the Augustinian
monastery. Molango, Hidalgo.

149. Eagle Knight capital, doorway of a house.
Cholula, Puebla.

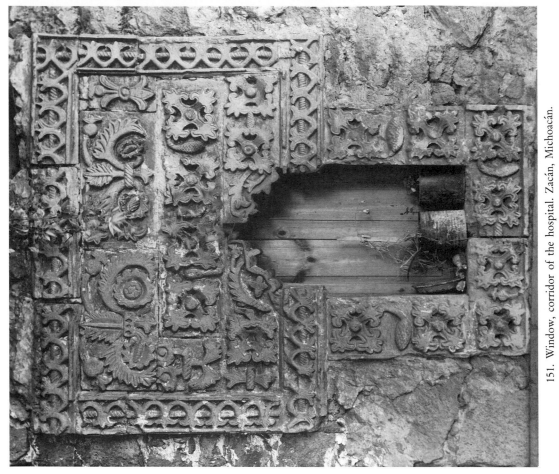

151. Window, corridor of the hospital. Zacán, Michoacán.

150. Jamb, portal of the hospital chapel. Acámbaro, Guanajuato.

152. Baptismal font with date (4 rabbit: 1562), church of the Franciscan monastery. Acatzingo, Puebla.

153. Baptismal font, parish church. Jalalcingo, Veracruz.

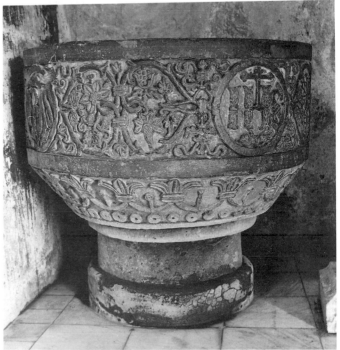

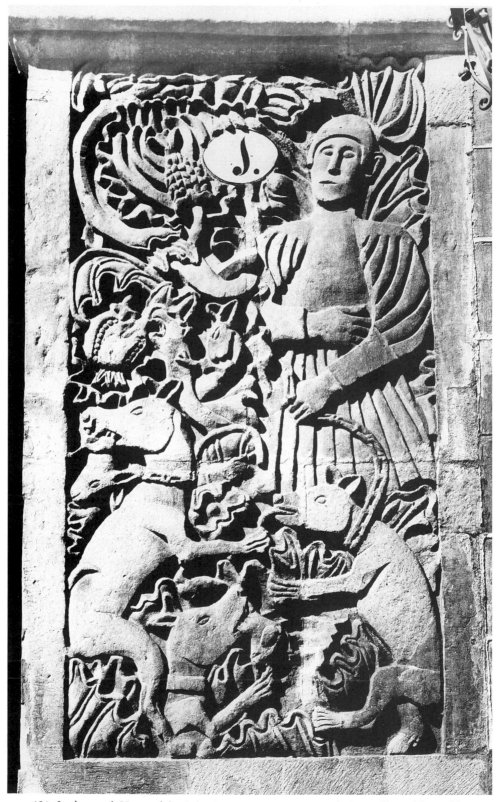

154. Jamb, portal. House of the Animal-Killer (Casa del que Mató el Animál). Puebla, Puebla.

155. Vestiges of mural and pegs for altarpiece, the Basilica
 (former church of the Franciscan monastery). Tecali, Puebla.

156. Juan de Arrúe and assistants. Main altarpiece,
 church of the Franciscan monastery. Cuautinchán, Puebla.

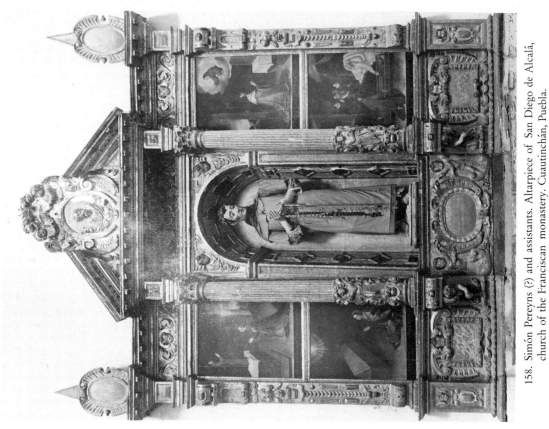

158. Simón Pereyns (?) and assistants. Altarpiece of San Diego de Alcalá, church of the Franciscan monastery. Cuautinchán, Puebla.

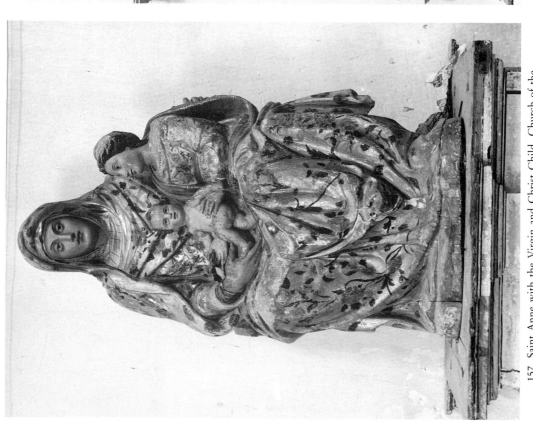

157. Saint Anne with the Virgin and Christ Child. Church of the Franciscan monastery. Cuautinchán, Puebla.

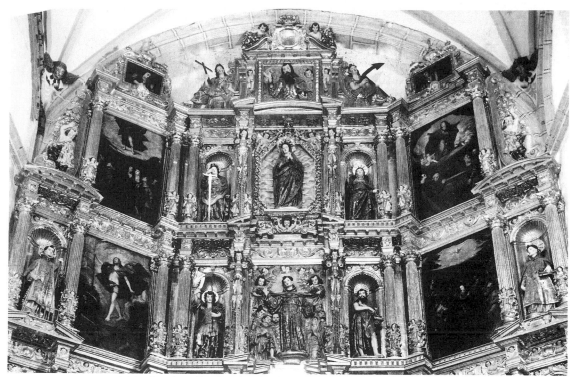

159. Main altarpiece (detail). Church of the Franciscan monastery. Xochimilco, D.F.

160. Three Apostles. Main altarpiece (detail), church
of the Franciscan monastery. Xochimilco, D.F.

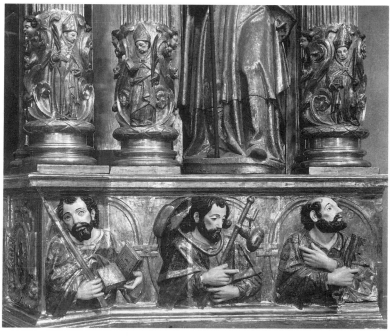

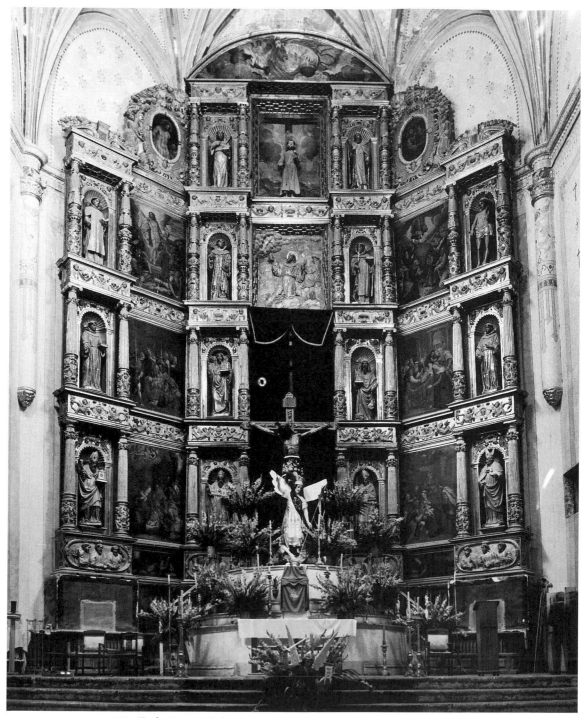

161. Simón Pereyns, Pedro de Requena and assistants. Main altarpiece, church of the Franciscan monastery. Huejotzingo, Puebla.

VII

CATHEDRALS

Six cathedrals were begun in the sixteenth century, planned and re-planned, built and rebuilt. And since, like most cathedrals, their building spanned several centuries, they stand apart as a group, yet are coherent in their common history. Fashionable and well-financed, the Mexican cathedrals played a special role in architectural history. These great buildings, with all their variations, are a remarkably homogeneous special group (with the exception of Oaxaca, where continuous rebuilding threw them back on local resources), representing up-to-date, professional Spanish architecture. Everyone thought of them as belonging in the long series of Spanish cathedrals. As such, they represent the colonial yearning to be identified with the homeland.

Bishop Montúfar first considered building a cathedral "like Seville," and then realized that it had to be simpler, like Segovia or Salamanca. The king took a personal interest, continually interfering, suggesting architects, ordering halts, deeply concerned.

Constructions of such magnitude and sophistication (compared to the monastery churches) needed trained labor and European experts. Indeed, shadowy figures are clearly named in the documents. In Mexico City, a procession: Claudio de Arciniega, Juan Miguel de Agüero, Melchor Dávila, Juan Gómez de Mora, Melchor Pérez de Soto, Joseph Damián Ortiz, Manuel Tolsá. At Puebla we find Luis de Arciniega, Francisco Becerra, Carlos García de Durango, Pedro García Ferrer, and José Manzo. In spite of all the documentation, one feels far from knowing exactly who did what and when, but it is clear that they were professionals. There is nothing homemade or improvised in these buildings. Like

the institution itself, the edifice expresses tradition, conviction, assurance, majesty. Not everything that the cathedrals offered was welcomed by their parishioners, but they provided a demonstration of the authorized possibilities, where one style after another was introduced to the colony.

Only one cathedral was finished before the seventeenth century: that of Mérida in Yucatán, whose dome is dated 1598. Others were established and planned and their foundations laid: Puebla, Mexico City, Oaxaca, Guadalajara, Morelia, and San Cristóbal of Chiapas. But as we now have them, they are buildings of the seventeenth century, finished in the eighteenth.

Thus at Guadalajara (Jalisco), where work was started only after 1569, they went ahead steadily and dedicated their church in 1618. Morelia (Michoacán), whose first cathedral burned in 1584, had a new plan approved in 1660, but the towers were completed (and the inscription placed on the facade) only in 1744. In Oaxaca the church finished in 1579 was ruined in a series of earthquakes in 1603, 1604, 1608, and finally in 1674. After that, Burgoa reported, "The cathedral is being remade sumptuously," but it was not consecrated until 1733.

The history of the Cathedral of San Cristóbal seems evasive; it was always "in construction," but always adobe, and in 1901 was badly hurt by an earthquake. It is the only cathedral in Mexico today with an *artesonado* ceiling; these were placed over the naves of sixteenth-century churches such as San Francisco in Tlaxcala and are still being replaced in the twentieth, as at Calpulalpan, Oaxaca.

In Puebla, where the old cathedral had been dedicated in 1539, building began on the new one around 1555, to be consecrated finally by Bishop Palafox nearly a century later (1649). As for the Metropolitan Cathedral in Mexico City, it was in progress from the laying of the cornerstone right on through the centuries—the dome closed in 1664, the portals dated 1688, with the cupola and towers finally finished in 1813, just before the end of the viceroyalty.

The Cathedral of Mexico was planned originally to have nave and aisles of the same height (like the Spanish cathedral of 1546 at Jaen); this was changed to a basilica with a higher nave (like the new Cathedral of Valladolid in Spain). The Cathedral of Puebla made the same switch in roof form, although construction of the high nave had not yet begun. In Mexico City you can find just about everything that happened on the cathedrals in the viceroyalty—Gothic vaults, Purist doorways, the first twisted columns, more than a hint of the Herrerian, seventeenth-century choir stalls enclosed in a screen made in Macao from the drawing of a Mexican artist, altarpieces from every century except the sixteenth (which previous to the 1967 fire was represented by two paintings on the Altar del Perdón, however), the first estípites in Mexico, on the Altar de los Reyes, and nineteenth-century painting in the dome.

Such a building is a sort of chronicle of history, of all the styles and habits and events that passed through the colony. The early east end shows bays of ribbed vaulting, before the builders settled on more contemporary saucer vaults. The door of the Chapter Room is one of the purest examples of the classical Purist style. The facade, including its almost popular reliefs, like the side doors and detail of the nave, is Herrerian Baroque. Most of the chapels are furnished in rich Mexican Baroque, as is the sacristy. The magnificent Altar de los Reyes is the cardinal example of Ultra-Baroque. Finally, the cupola and the towers and their statues are the contribution of Neoclassicism from the Academy.

Puebla's history was somewhat more compact and seems even more homogeneous, because the interior was totally refurbished in early Neoclassical tonality, all gray and white and gold. None of the other provincial cathedrals are so much catalogues of changing style, although Guadalajara's vaulting makes a surprisingly medieval effect from within, and Morelia's three portals are models of Herrerian design. Only Oaxaca has a local character, with its picture-book facade all in moss-green stone; only San Cristóbal in Chiapas shares in the popular decoration of its region. Other cathedrals began as monastic churches (Cuernavaca and Huejutla).

The northern cathedrals came somewhat later, most of them begun as parish churches finally furnished by mid-eighteenth century, elevated and enlarged. Durango was built 1695–1765; Aguascalientes, 1704–1738; Chihuahua, 1726–1741; Zacatecas, 1718–1752, its towers completed much later; Monterrey, already begun in 1630, but its facade not finished until 1800. Not so carefully fostered by Spanish authorities, these churches illustrate a solid regional development of seventeenth-century Mexican Baroque. Zacatecas, also originally the parish church, stands unique and unsurpassed; in its facade and two side portals we have the finest popular decoration which New Spain produced.

The cathedrals of New Spain were Mexican mainly by geography; they are truly colonial architecture. Moved into position on the main plaza, flanked by the Palacio de Gobierno, the cathedral throws into relief the Mexican quality of other buildings. And they have other messages. They sound a note of temporal authority, reminding us that the king of Spain was also head of the church in the Americas, and that the archbishop was as much his emissary as was the viceroy. They testify to the ascendancy of the secular clergy, and to their orientation to a Spanish congregation.

Indians in their hand-woven clothes (one thinks) must always have looked lost in such buildings. And yet on Corpus Christi day—when the immense Cathedral of Mexico is crowded with children in native dress pretending to bring their tithes—one sees how they have made it their own. The building, like a

good Christian, seems to be all things to all men. Its presence on that historic plaza does not seem alien. Its effect is of a great natural object that has matured over several centuries, cared for by successive generations, expressing their hopes and convictions, a work of art so overpowering and so ancient that it contains everything: every material, every style, every ritual, every race.

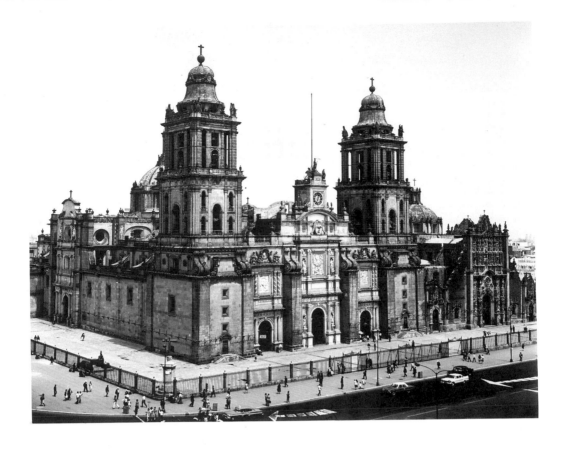

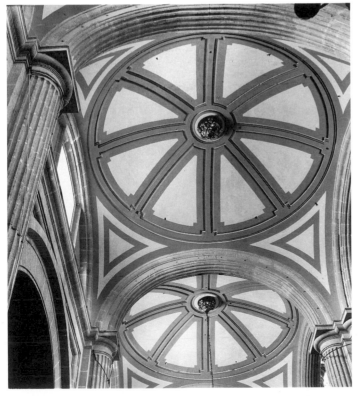

162. Cathedral, México, D.F.

163. Saucer vault, nave of cathedral.
México, D.F.

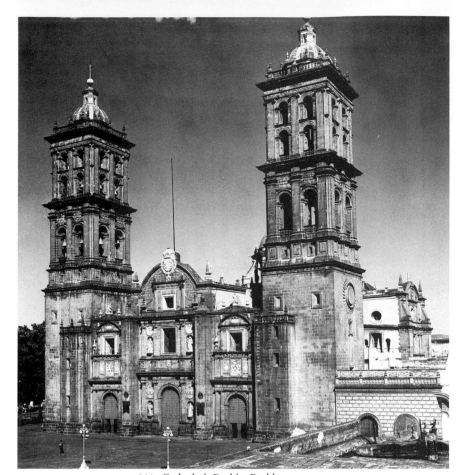

164. Cathedral. Puebla, Puebla.

165. Pulpit, cathedral. Puebla, Puebla.

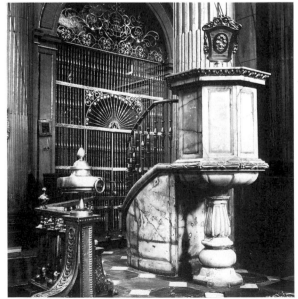

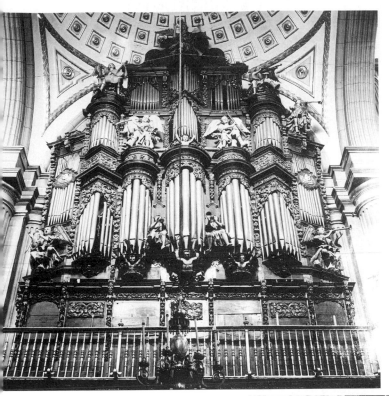

166. Organ, cathedral. Puebla, Puebla.

167. Choir stalls, cathedral. Puebla, Puebla.

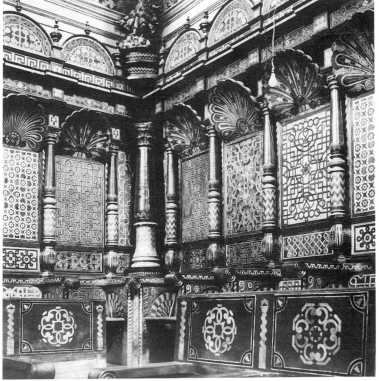

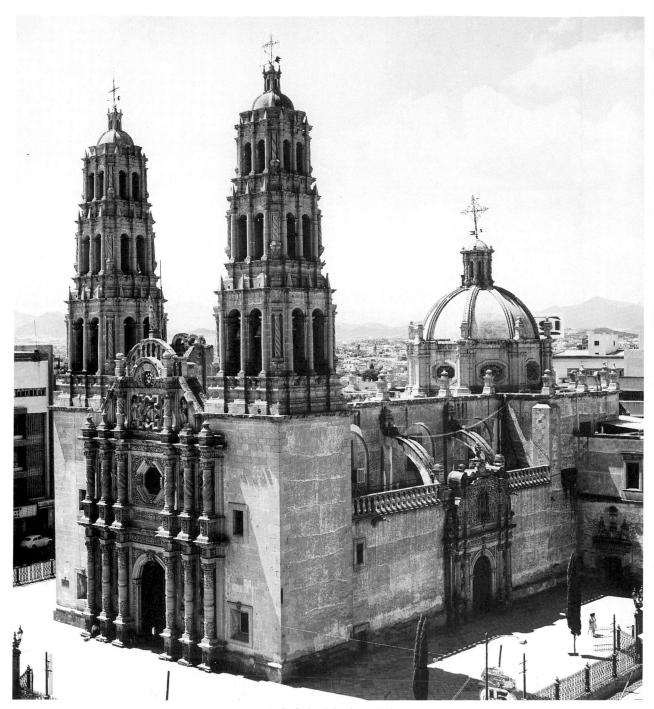

168. Cathedral. Chihuahua, Chihuahua.

>158<

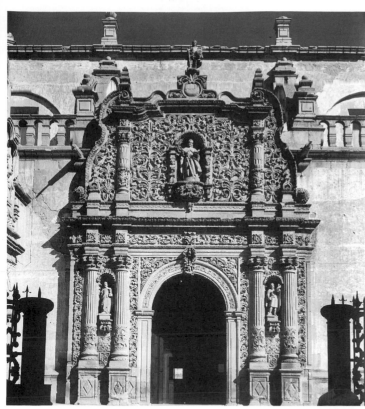

169. South door, cathedral. Chihuahua, Chihuahua.

170. Nave of cathedral. Chihuahua, Chihuahua.

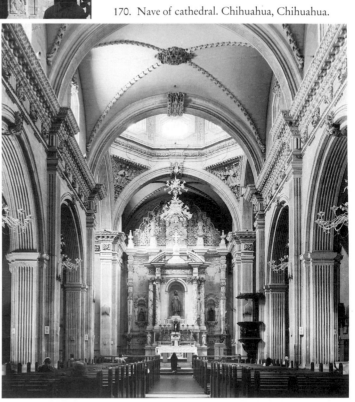

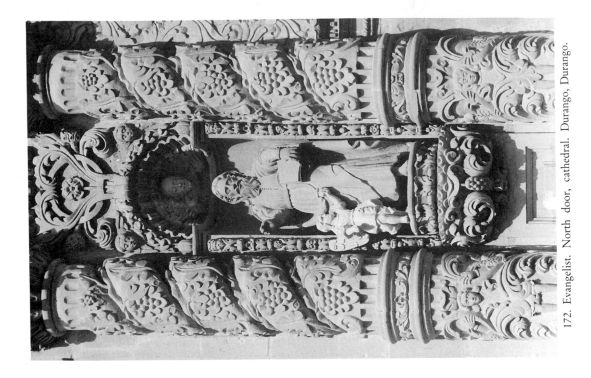

172. Evangelist. North door, cathedral. Durango, Durango.

171. North door, cathedral. Durango, Durango.

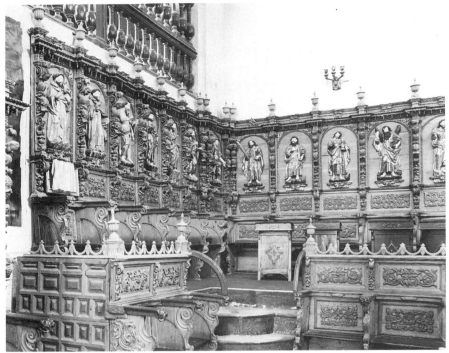

173. Choir stalls, cathedral. Durango, Durango.

174. Choir stalls, cathedral. Durango, Durango.

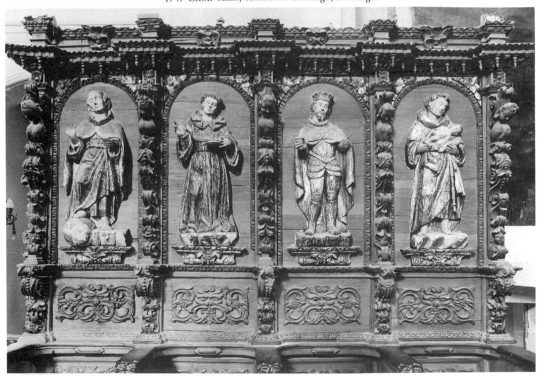

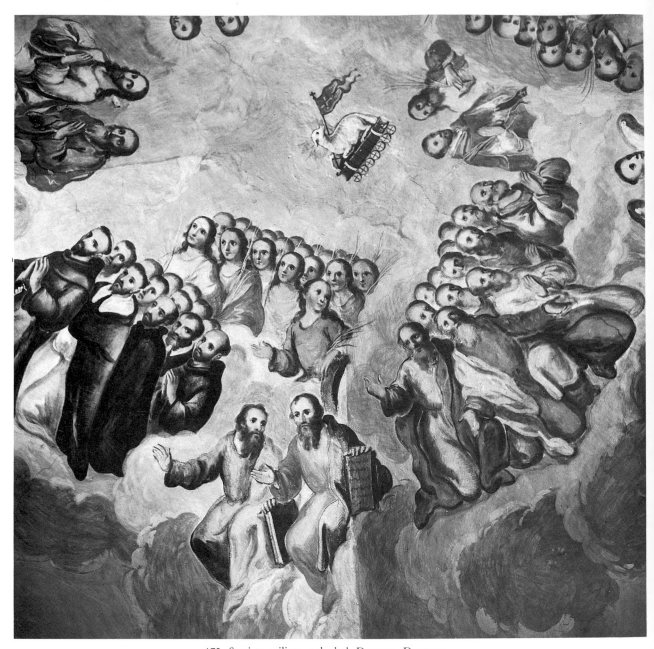

175. Sacristy ceiling, cathedral. Durango, Durango.

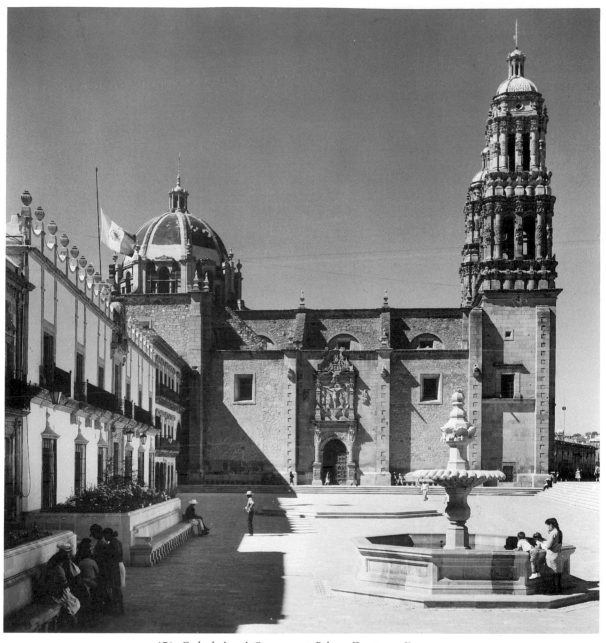

176. Cathedral and Government Palace. Zacatecas, Zacatecas.

177. Upper facade, cathedral. Zacatecas, Zacatecas.

178. Crucifixion, west portal. Cathedral. Zacatecas,
Zacatecas.

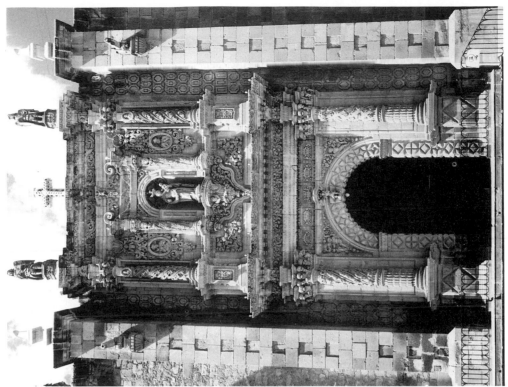

180. East portal, cathedral. Zacatecas, Zacatecas.

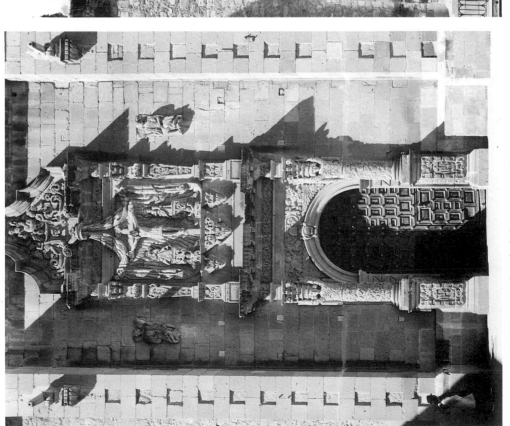

179. West portal, cathedral. Zacatecas, Zacatecas.

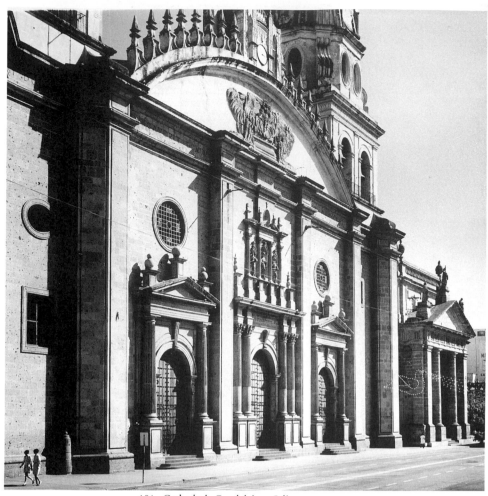

181. Cathedral. Guadalajara, Jalisco.

182. Vaulting, cathedral. Guadalajara, Jalisco.

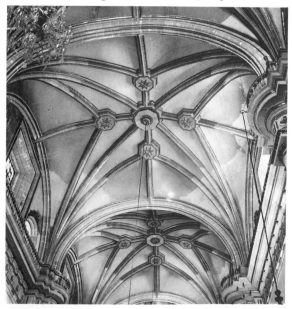

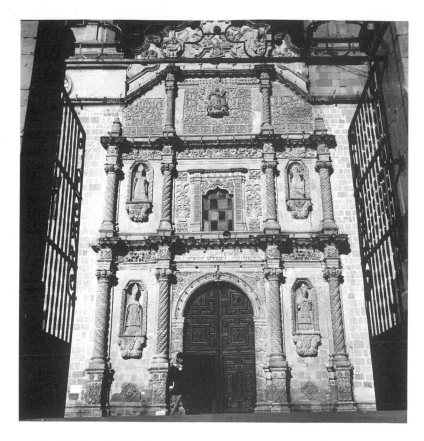

183. Facade, cathedral. Aguascalientes, Aguascalientes.

184. Facade, cathedral. Oaxaca, Oaxaca.

VIII
THE BAROQUE ENSEMBLE

Standing inside a church like Santa Prisca in Taxco, or Santo Tomás in Ixtlán de Juárez—or even San Juan Evangelista Analco in the mountains of Oaxaca—one comes to understand that the Baroque spirit is vested in the totality. A Baroque interior cannot be totted up in sums of twisted columns or estípites, although these and other typical forms make up each of the altarpieces that line the nave and fill the chancel. What is essentially Baroque about the nave is that it *is* lined and filled and garlanded and garnished—walls and ceilings, choir and chancel, arch and dome. The Mexicans call this ensemble the conjunto, and one of its Baroque characteristics is that the parts are transfigured by their functioning in the whole—even routine carving on the altarpiece, and uninspired paintings, even a rayon petticoat on the saint.

Outdoors there is rather less scope for the Baroque mood, but the Mexicans have done very well. Skylines are broken up with towers, cupolas, *espadañas* (bell-walls), and varied finials. The transepts, the apse, buttresses, and portals—concave and convex—help to vary the whole. The facade is flat and smooth only when it is made of some automatically dramatic material, like tile glazed in several colors. Usually it has its columns, its recesses, its pedestals and canopies, its statues and reliefs and windows and doorways to trap and vary the strong clear light. Was it a yearning for the indoor richness which led them to make the facade an outdoor retable? It has the same framing, the same pattern of verticals and horizontals, within which saints are framed or their stories are displayed in relief.

This repetition of the unit—not only up and down the nave but also on

the front and sides of the building outdoors—is an important device of the Baroque ensemble. Altogether it works to tell you that life is not the bare and unrewarding affair we sometimes think, but full of promise and harmony, over and over, unending.

Because of this intention—and this success—one finds it boring to catalogue and classify the artifacts that exemplify the Baroque. (Besides, as Manuel Toussaint asked, how can we expect to put in order something which by its very nature defies order?) It is enough to list them, like an inventory of treasure.

In the seventeenth century the cathedrals were steadily building, as we have said. Their sober Herrerian detail is echoed in parish churches, in the facades of new Mendicant churches, in the houses of late-arriving Orders—Mercedarians, Carmelites, Jesuits—and in convent buildings, for the nuns who were arriving in this century. This is the great block of seventeenth-century architecture. The stately portals—piling up pyramids of somewhat relaxed Renaissance detail, with columns and niches and saints and occasional volutes, large reliefs framed like paintings and numerous coats of arms—are the most correct and least stimulating architecture of the viceroyalty.

When the economy of New Spain began to pick up, in the last quarter of the century, things began to change, but unobtrusively, like the tide coming in. One thing it brought (from Europe, of course) was the twisted column—the Solomonic helix of Bernini—which began to replace classical columns on the portals. The effect—in sober stone—was novel, but still solemn. Only when twisted columns invade the gold-leaf retable do we feel the contrapostal energy of the form, its scattering of light, implied movement, and general vivacity. Twisted columns were already stipulated in 1688 in the contract for remodeling the high altarpiece of Santo Domingo in Puebla, and a series of altarpieces, large and small, explored the mode, carrying on the tradition of the Renaissance retable. It was as though New Spain had found what it had been looking for.

Then an even more dramatic immigrant arrived: the estípite. This device of the High Baroque serves as substitute for the shaft of the classical column: a compound vertical made up of an inverted obelisk, plus a cube (or several cubes) often decorated with medallions. In a syntax as strict as a classical order (though considerably more resourceful), the estípite stretches between a more or less orthodox base and a square Corinthian capital, and this is surmounted by a full (though broken) cornice; in the inter-estipital space a statue in a niche offers additional vertical counterpoint. It is not hard to see that this arrangement offers a good deal more opportunity for invention than, let us say, the Ionic order. But really to appreciate its possibilities, the variety, the innovations, the improvisation,

one has to have looked at hundreds of altarpieces and facades, early and late, sophisticated or childish, humble or imposing. From its first statement on the Altar de los Reyes of the Cathedral of Mexico to the one-saint retable on an adobe church—as far as Arizona and Texas—this style (which the Mexicans like to call the Churrigueresque) made all others seem banal.

Using these various devices—Renaissance orders, the helicoid column, the estípite—in all the wealth of materials (red and green and white and black and peach-colored stone) with gold leaf and brilliant tile, and acres of oil painting and stucco decoration over walls and ceilings, the Mexicans assembled their Baroque ensembles. They took what they liked (with no shame for being eclectic), and many of the ecclesiastical interiors that resulted seem almost miraculously harmonious. They strike the senses like a rich chord of music. One can look at the detail and enjoy it or criticize it; but one cannot argue with the whole.

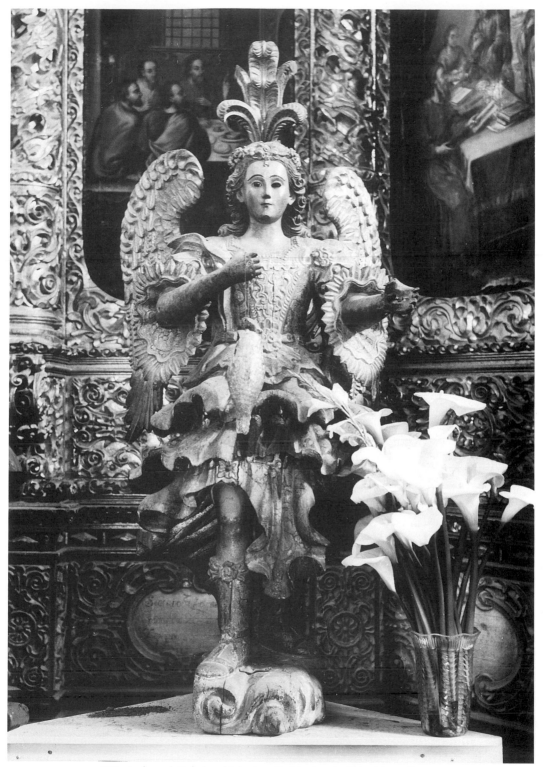

185. Archangel Rafael at high altar. Parish church. Calpulalpan, Oaxaca.

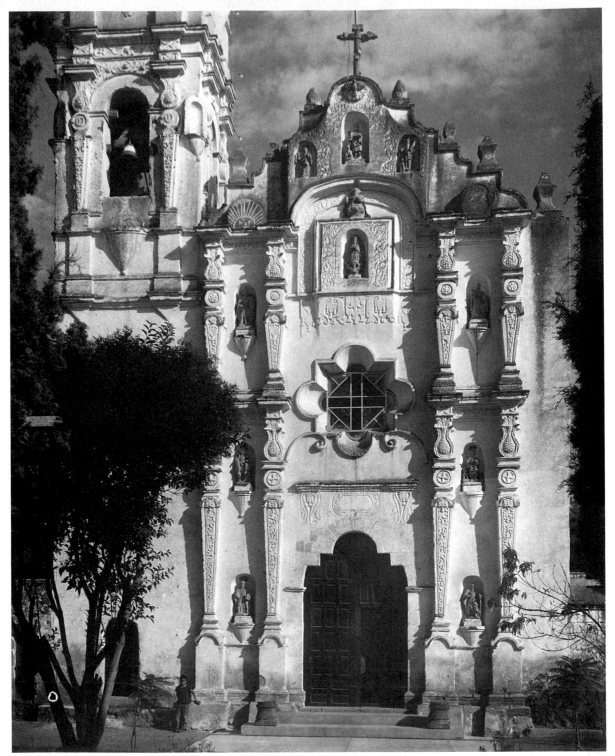

186. Church of San Lucas. Xoloc, México.

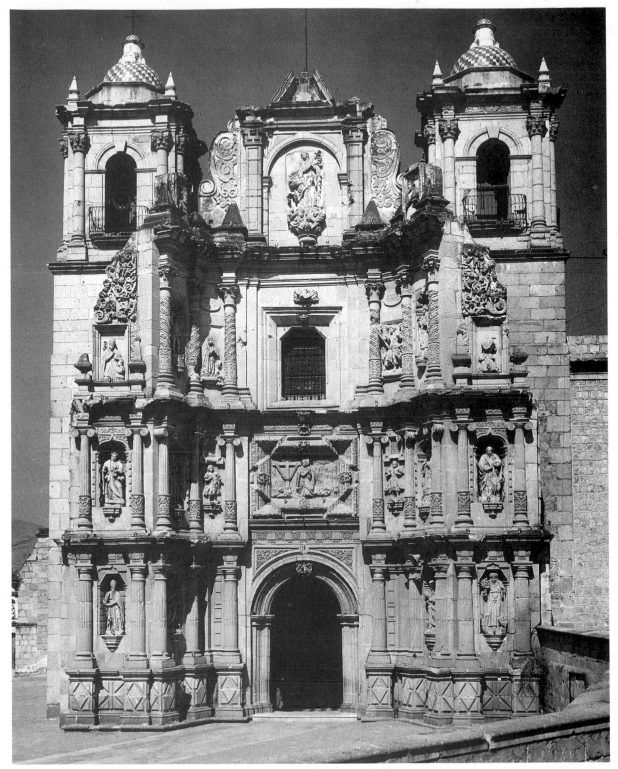

187. Sanctuary of Nuestra Señora de La Soledad. Oaxaca, Oaxaca.

>173<

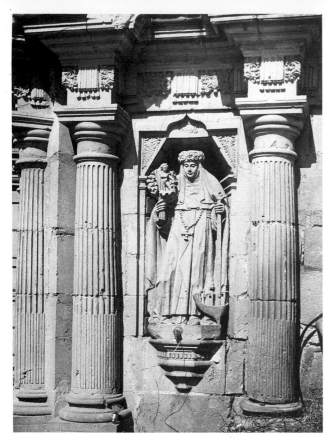

188. Saint Rose of Lima, facade. Sanctuary of Nuestra Señora de La Soledad. Oaxaca, Oaxaca.

189. Church of the convent of Santa Rosa. Morelia, Michoacán.

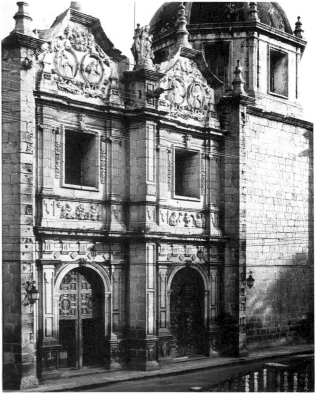

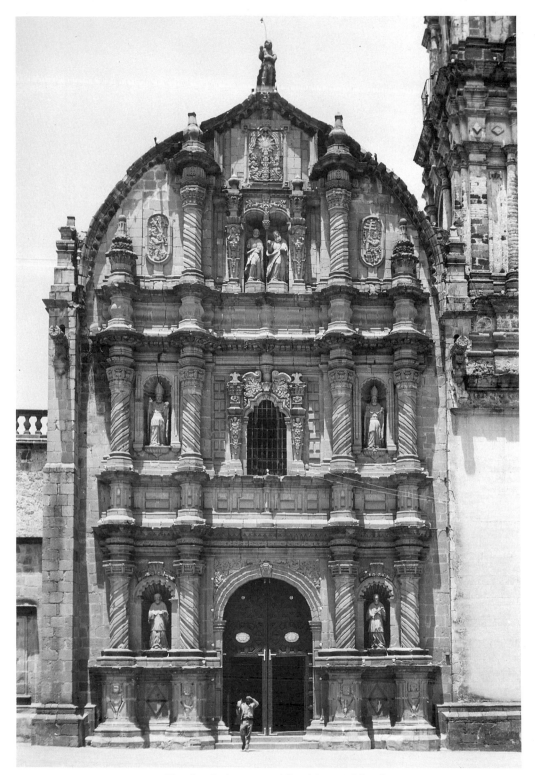

190. Church of El Carmen. Tlapujahua, Michoacán.

191. Saint on facade, Church of El Carmen. Tlapujahua, Michoacán.

192. Chapel of Loreto. San Luis Posotí, San Luis Potosí.

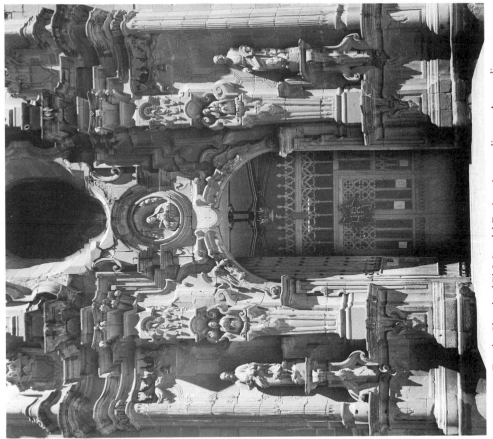

194. Facade, Church of El Señor del Encino. Aguascalientes, Aguascalien es.

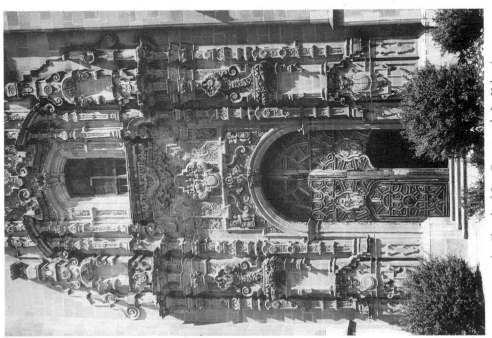

193. Facade, Church of San Cayetano de La Valenciana. Guanajuato, Guanajuato.

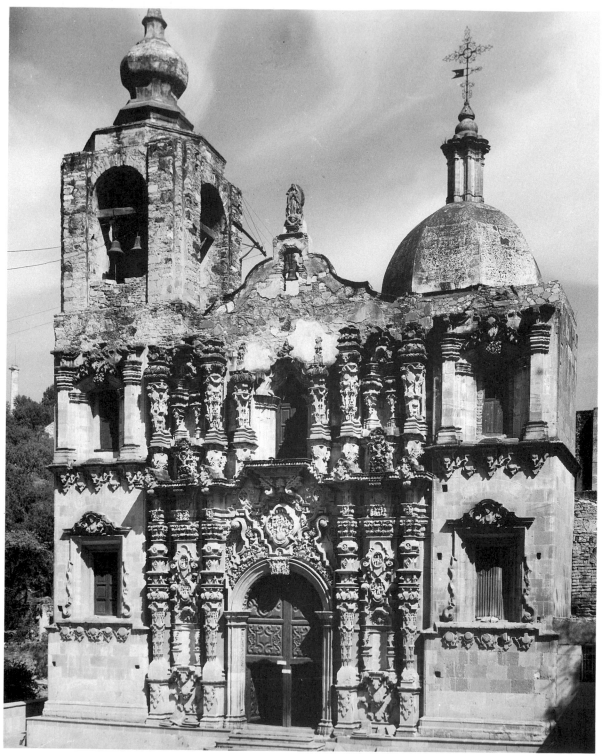

195. Sanctuary of El Señor de Villaseca. La Cata, Guanajuato.

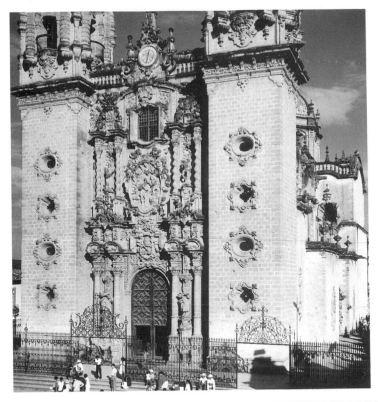

196. Facade, Church of Santa Prisca and San Sebastián. Taxco, Guerrero.

197. Door to south tower, Church of Santa Prisca and San Sebastián. Taxco, Guerrero.

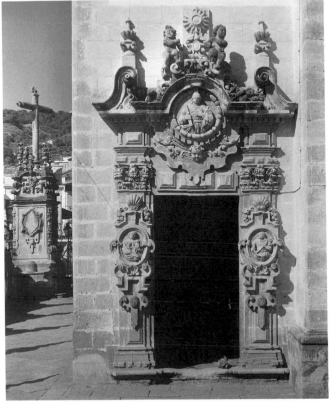

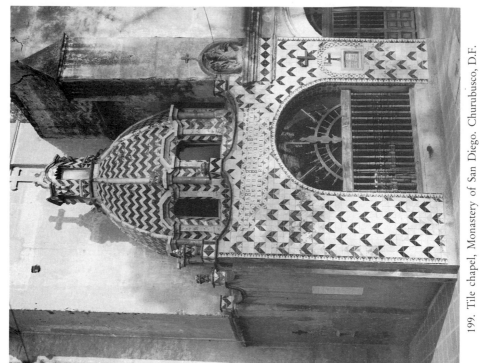

199. Tile chapel, Monastery of San Diego. Churubusco, D.F.

198. Nave (toward chancel), Church of Santa Isabel. Tepetzala, Puebla.

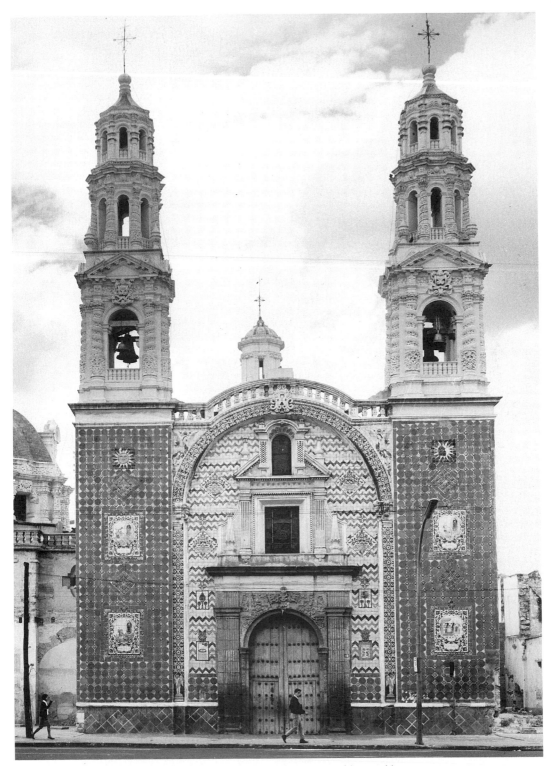

200. Church of La Guadalupe. Puebla, Puebla.

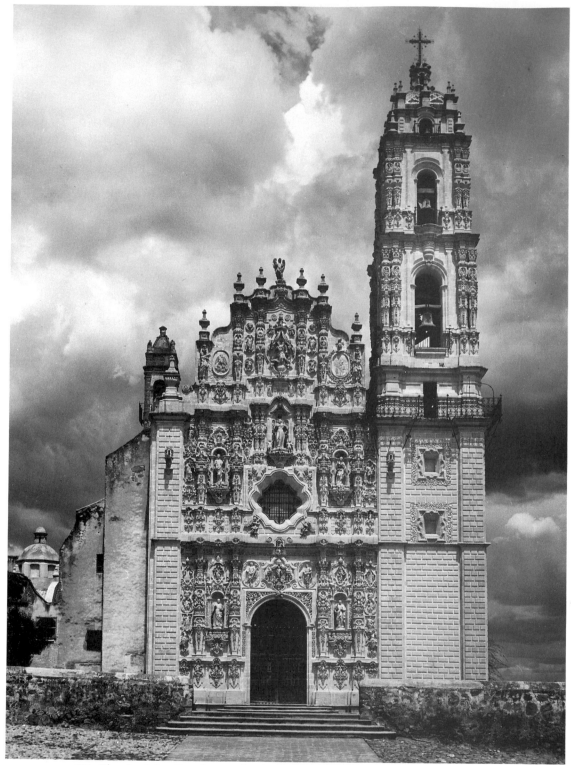

201. Church of San Francisco Xavier (Museo Nacional del Virreinato). Tepozotlan, México.

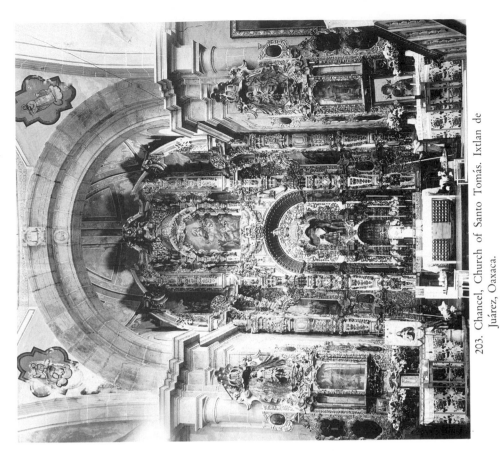

203. Chancel, Church of Santo Tomás. Ixtlan de Juárez, Oaxaca.

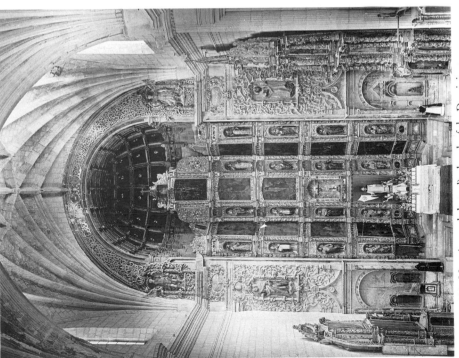

202. Nave (toward chancel), church of the Dominican monastery. Yanhuitlan, Oaxaca.

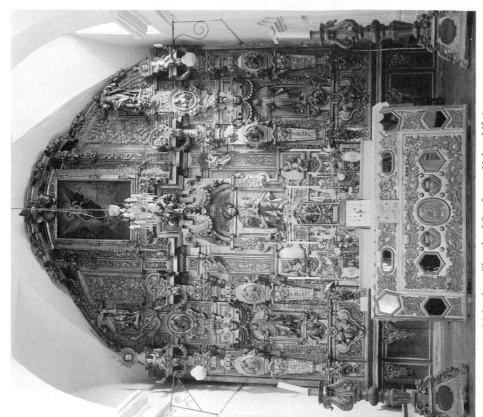

205. Main altar, Church of San Lucas. Xoloc, México.

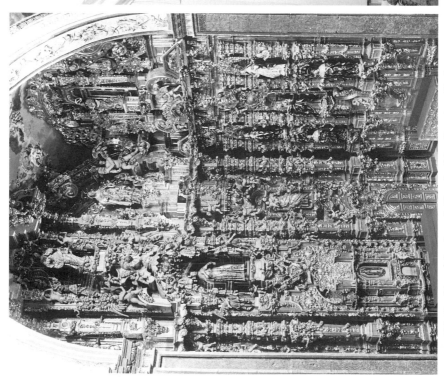

204. Retables of the chancel, Church of San Francisco Xavier (Museo Nacional del Virreinato). Tepozotlan, México.

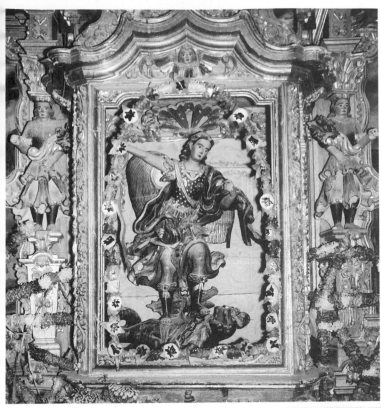

206. Saint Michael. Altarpiece in nave, Church of San Juan Evangelista. Analco, Oaxaca.

207. Three Apostles. Main altarpiece, church of the Franciscan monastery. Ozumba, México.

208. Altar table, parish church. Tecali, Puebla.

209. Saint Clara. Chapel of Aranzazú. Guadalajara, Jalisco.

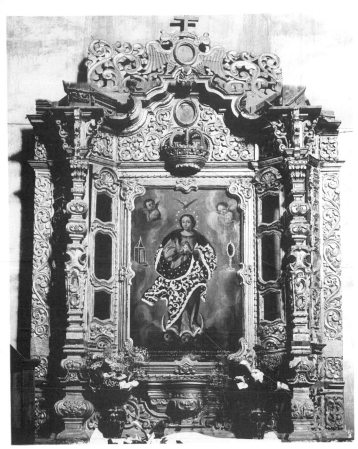

210. Altarpiece, parish church. Calpulalpan, Oaxaca.

211. Confessional, church of the Dominican monastery. Teposcolula, Oaxaca.

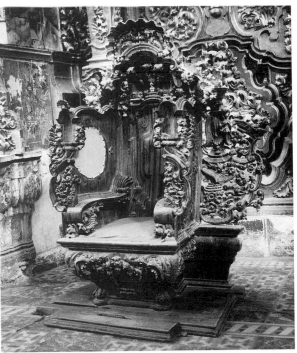

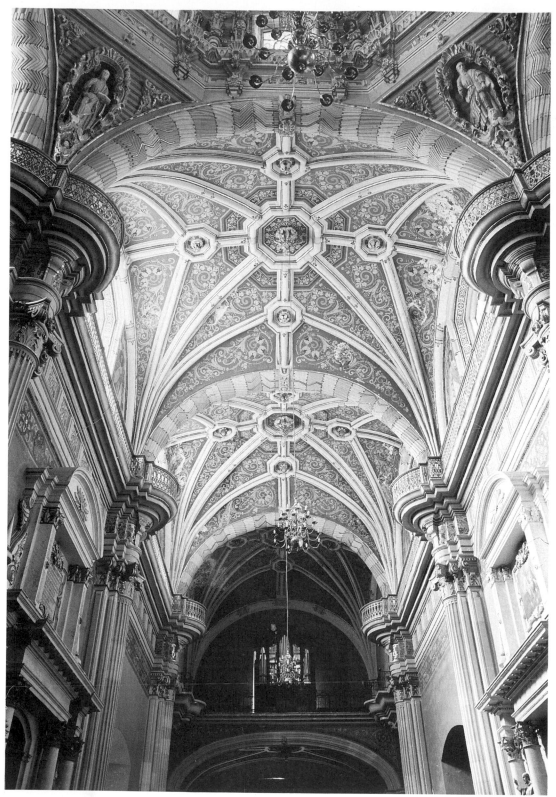

212. Vaulting of nave, parish church. Lagos de Moreno, Jalisco.

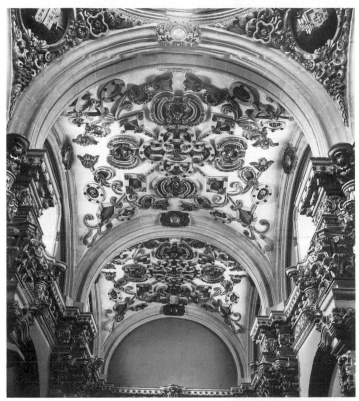

213. Vaulting of nave, chapel of Aranzazú, Church of San Francisco. San Luis Potosí, San Luis Potosí.

214. Pendentive, chapel of San Ildefonso, Church of San Marcos. Puebla, Puebla.

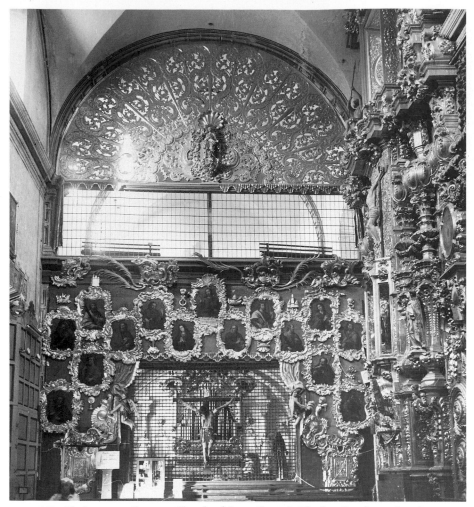

215. Choir screen, Convent Church of Santa Rosa de Viterbo. Querétaro, Querétaro.

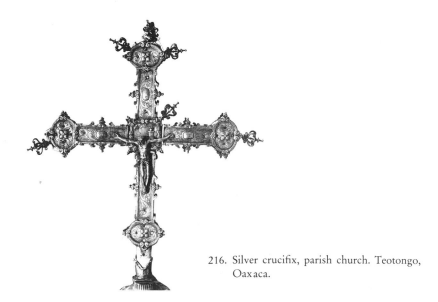

216. Silver crucifix, parish church. Teotongo, Oaxaca.

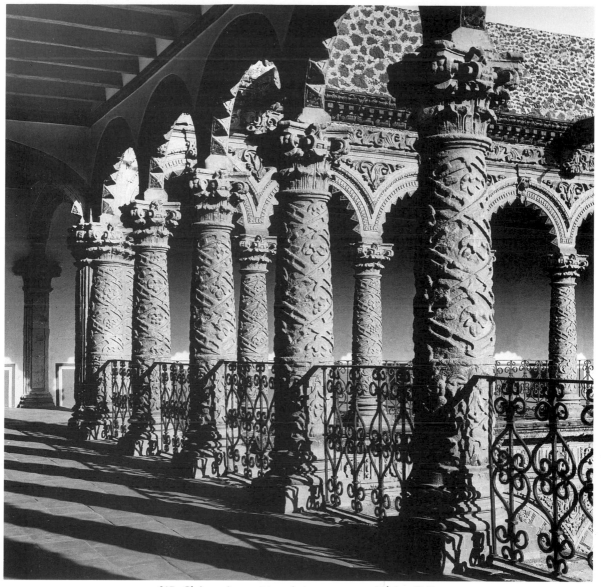

217. Cloister, former Mercedarian monastery. México, D.F.

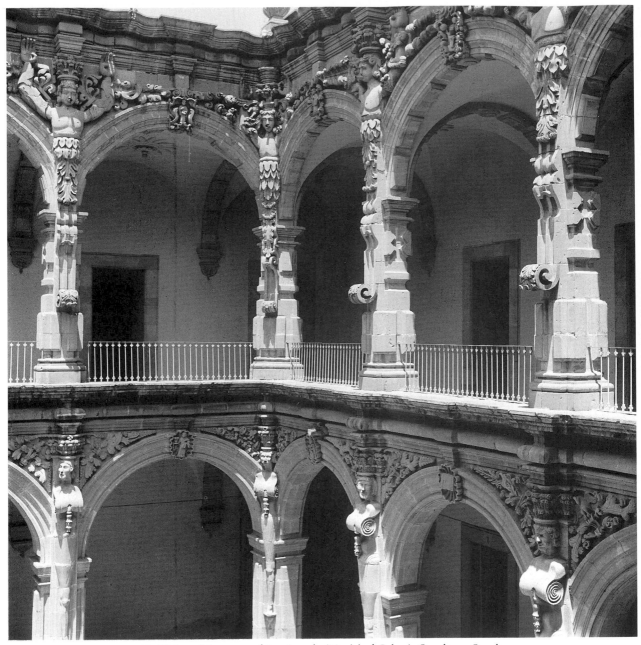

218. Cloister, Monastery of San Agustín (Municipal Palace). Querétaro, Querétaro.

219. Buttresses, Church of the Convent of Santa Rosa de Viterbo. Querétaro, Querétaro.

220. Chapel. Hacienda Ciénega de Mata, Jalisco.

IX

POPULAR ART

Popular art—or folk art—remained practically invisible to the art historians and connoisseurs of the past. Like the women who accompanied the conquistadors into Mexico, popular art was always there, but disregarded, of no importance. The people who used and appreciated it were the same kinds of people who made it, and by this very appreciation they disqualified themselves in the larger field of aesthetic judgment.

In Latin America, because of history and racial grouping, the question of popular art—that is to say, of unofficial, homemade art—has a peculiar aspect. When sophisticated people discovered a stucco church front crowded (against all rules of taste) with Christian iconography, or an incredibly naive example of a Baroque altarpiece, or a church ceiling overgrown with gold and polychrome foliage, or saints at once inept and passionate, they could defend their interest by calling it Indian. When pressed, they could retreat to the position that it was mestizo or *creole;* it was the hybrid offspring of the colonial encounter. They had better have forgotten the races and called it Mexican, which is what it certainly is.

Popular art is a universal phenomenon; it is what people make everywhere, though its characteristics vary in different places and at different times. In the viceroyalty of New Spain, the earliest popular art was the tequitqui, and this was, indeed, Indian. After preconquest Indian styles were forgotten, all the training of artists, all the techniques and styles they learned, and all the uses of art were European. But in the seventeenth century there is a great deal of work which simply cannot be called proper European art. It will not meet the standards

of style and correct usage; it diverges from the best official art of the capital; it is retarded in reference to metropolitan fashions in style; and it is eccentric. It is also, paradoxically, extremely conventional, and subservient to accepted canons; and it is apt to lack the technical skill which orthodox training affords. This situation continues right up to the introduction of Neoclassicism, which (combined with the shock of Independence) finally broke off the long tradition of viceregal art. All Baroque decoration in Mexico partakes of a popular quality, inasmuch as it seems to rely on the rendering of traditional detail by experienced craftsmen, rather than on the execution of specific designs supplied from outside the craft. So in the later seventeenth and in the eighteenth century, art in New Spain became truly Mexican, as the greatest decorative projects were taken over by folk artists. As time passed, the focus seemed to move toward the popular end of the spectrum—or perhaps one should say that folk art became dominant at one end, while strict Neoclassical tenets took over at the other. It is, in a sense, at that moment—when Neoclassicism denounces the rich, irresponsible expressions of Baroque tradition—that popular art, as such, is differentiated.

One catches the first whiff of the popular mood in decoration. Just as tequitqui offered astonishing decoration around churchyard gates and on baptismal fonts, the fonts and pulpits of the seventeenth and eighteenth centuries often prove unorthodox. Sometimes they follow the proper model, but without fluency, in ignorance; sometimes they seem to bring from the fields flowers and leaves quite different from the acanthus of accepted usage. Popular art is thoroughly eclectic; it takes decorative motifs as if from a catalogue, and uses them with a feckless freedom, turning the armorial lions back to back, glorifying the inappropriate two-headed eagle.

Often appealing in itself, this carving is apt to be nonarchitectural, unrelated to function. Architecturally there is a lack of synthetic feeling: disproportion of component parts, for example, as in a chapel which at first seems to be a large building far away, but turns out to be small and conglomerate, with oversize tower and transept, or a whole cathedral made out of one Gothic tower. Sometimes a quite proper design is invaded, taken over by the popular taste for elaboration; this had already happened in the sixteenth century at Yuriria, where an almost perfect copy of the perfect Plateresque facade of San Agustín Acolman was irretrievably changed. But whether the decoration of the upper facade "destroys" the Plateresque design or improves it is in fact a matter of taste. Usually in Mexico a popular Baroque facade is based on one of the orthodox plans—the structural division by columns and cornices, the framing of doors and windows, the figures of saints between the columns, the large central relief, and so on. But as the detail is executed it gets out of control, and seems to grow and

take over the structure, too big, too much, and extending too riotously over everything.

Often, especially in the state of Puebla, the smothering of form is assisted by glazed tile, which wraps up the whole facade—moldings, capitals, and bell tower alike—in patterned color. Inside, the quite sober structure of a mission church may be transformed by decorative painting on the walls and vaults into a flower-garden gaiety. The material which really liberated the popular artist was stucco—a hard plaster that could be carved like stone, not so delicately, but much more freely. This was used all over Mexico in the seventeenth and eighteenth centuries, but there were two regions which produced especially astonishing facades. One was the Sierra Gorda of Querétaro—in distant towns where Fray Junípero Serra had taken over older missions for the Franciscans in the mid-eighteenth century—the other, an area between the states of Morelos and Puebla, where somewhat later facades (on somewhat earlier churches), apparently more restrained in effect, prove on closer inspection to offer an almost unbelievable iconographical orgy. A number of even more unbelievable interiors, entirely covered with plaster relief in color and gold, shows the same innocent passion for ornament, compounded and ubiquitous. With hundreds of altarpieces filling up the gaps—all carved and colored and gold-leafed—these interiors seem less the debased echoes of great metropolitan models than the compost from which they flower.

The figure sculpture required by the Baroque facade was also provided by popular tradition. It is worth observing that even on the most sophisticated examples—the Sagrario Metropolitano, for example—one does not remember what the saints look like or who they are; they are simply factors in the total effect, like the columns and the scrolls. So the saints were turned out, for the two remaining centuries of colonial church building, by more or less able, more or less sophisticated, more or less gifted stonecutters: there was not a Michelangelo among them. Large narrative or devotional reliefs on the facades are equally anonymous; occasionally we find one which, for better or worse, crosses the line from correct competence into popular art, like the story of St. Augustine's dream on the side portal of the old Augustinian church in Zacatecas. Or in an otherwise elegant environment, like the Rosary Chapel in Puebla, one comes upon the panels of the Life of the Virgin, which tell the old stories with gusto and plenty of charm but are quite inadequate in treating the spatial problems of high relief. All the retable workshops were as anonymous and conventional as the facade sculptors. What occasionally brings variety, in outlying territories and country places, is an idiosyncrasy of invention, not necessarily crude in execution, and often in the surest taste. Thus a tradition developed in Yucatán (so much cut off

from central Mexico), which would be easier to appraise if the parishioners had felt less free to freshen up their altarpieces by repainting them every now and then.

The popular artist in colonial Mexico was also much involved in the making of images. For a long time, while memories of preconquest religion remained, the people—that is, the Indians—were not allowed to paint holy figures, or to carve them, so that there are no tequitqui images. But it was impossible that properly examined members of a guild in Mexico City could supply the thousands of churches in the country, much less the household shrines, and so (like so many other things in Mexico) practice went off at a tangent from the law. Even today there are plenty of images which must be called folk art, saints not so much disrespectful of tradition as untamed by it, surmounting it. There is Santiago (St. James) on his white horse, the very symbol of *mexicanismo* since, like the horse, he arrived with the conquistadors and helped them, only to be conquered and in the end become a patron of the Indians. Companion chevaliers are St. Martin, and Christ riding on an ass on Palm Sunday. St. Sebastian is a young boy, proudly enduring the arrows; St. Anne is a beautiful young mother, who holds, as if in a dream, her daughter Mary and *her* son Jesus. Technically, the wood-carver may not have been equal to the problem (even Leonardo had trouble with it), but the intrepidity of the true folk artist carries him through, just as it finds a solution for that most evasive concept, the Holy Trinity—three bearded men seated side by side. If one believes art—Fine Art—to be a matter of exemplifying with elegant perfection some authorized ideal, then the crucifix in the adobe chapel must be an object of scorn. Gone are the perfect Greek proportions, gone the humanistic visage: strangely proportioned—perhaps roughly carved—the Crucified has an Indian face and incredible wounds. If such a figure embarrasses those educated to the blond prettiness of images from Lourdes or Barcelona, it is because of its terrible truth. The popular artist is not always nice, and he is often inadequate to his aim, but the aim is to tell the story as it was, and make you feel the lash on your own back.

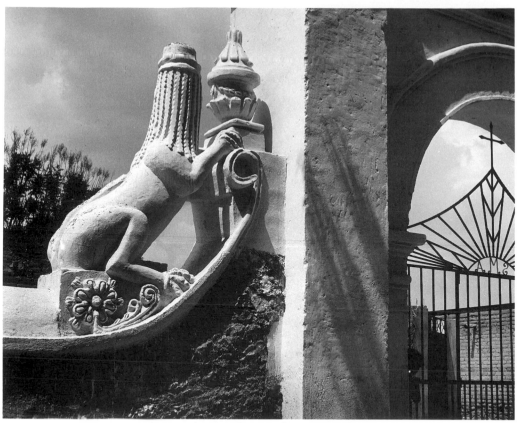

221. Lion on churchyard gate. Chiconcuac, México.

222. Churchyard gate. Chiconcuac, México.

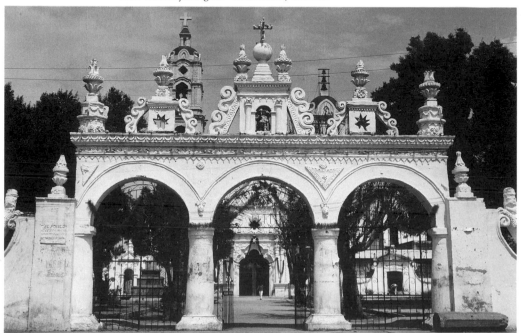

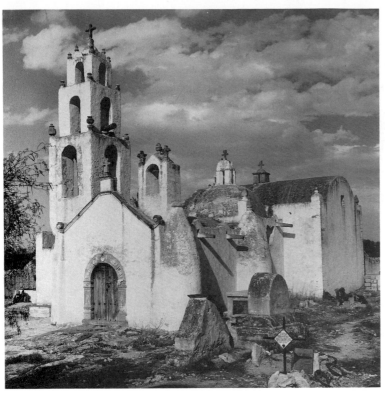

223. Chapel of La Santa Cruz. Zozea, Hidalgo.

224. Cathedral. San Miguel Allende, Guana-
juato.

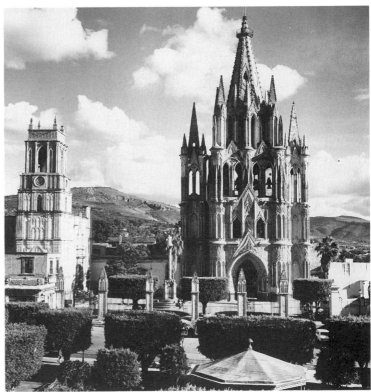

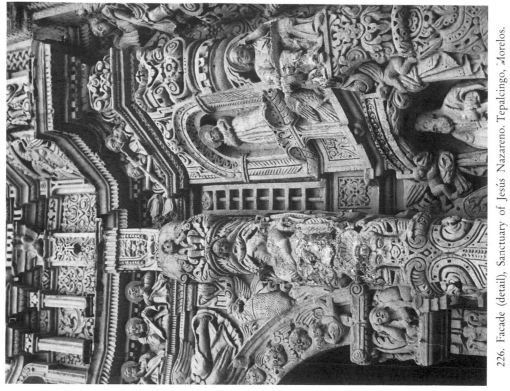

226. Facade (detail). Sanctuary of Jesús Nazareno. Tepalcingo, Morelos.

225. Sanctuary of Jesús Nazareno. Tepalcingo, Morelos.

227. Church of Santa María. Jolalpan, Puebla.

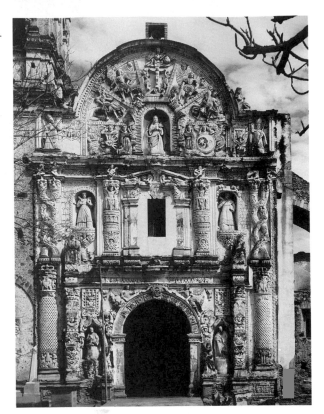

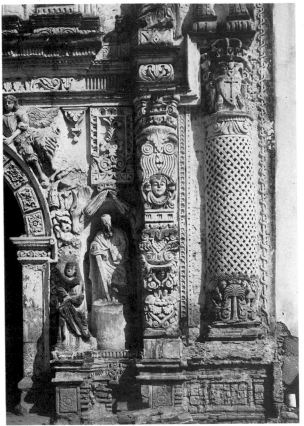

228. Facade (detail), Church of Santa María. Jolalpan, Puebla.

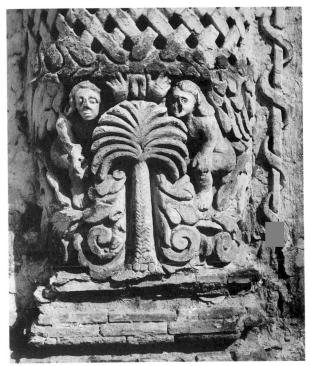

229. Adam and Eve, facade (detail). Church of Santa María. Jolalpan, Puebla.

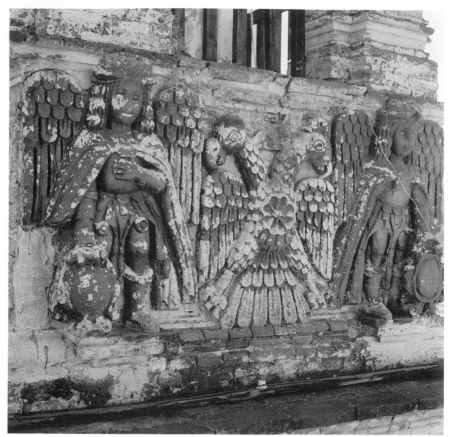

230. Archangels and Double Eagle. Base of tower, parish church. Hueyotlipán, Tlaxcala.

231. Tower, church of the Dominican
monastery. Tlacolula, Oaxaca.

232. South portal (detail), Church of Santo Tomás.
Ixtlan de Juárez, Oaxaca.

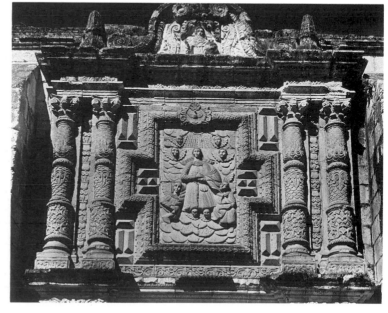

234. Chapel of Santiago. Ajusco, D.F.

233. Facade, church of the Augustinian monastery. Yuriria, Guanajuato.

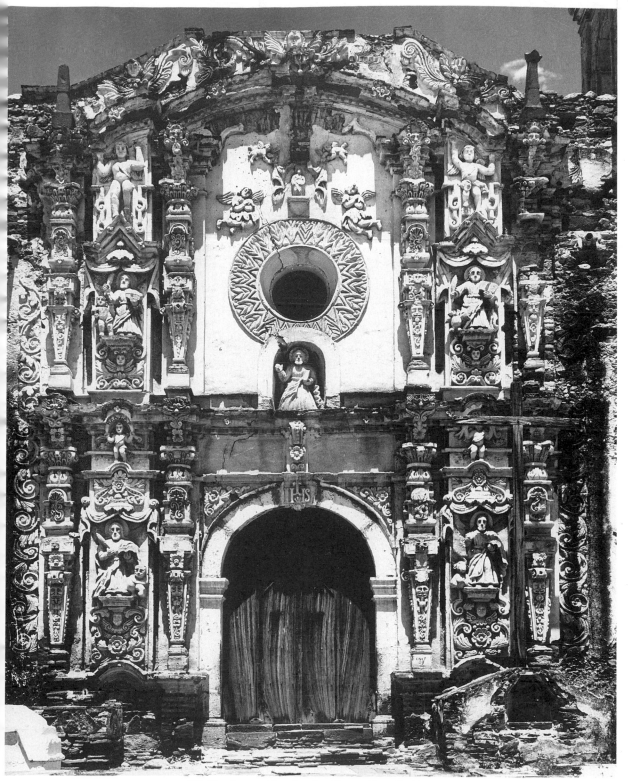

235. Facade, parish church. Tecomatlán, Puebla.

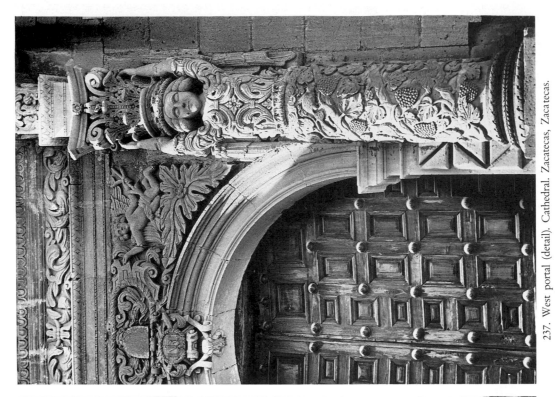

237. West portal (detail). Cathedral. Zacatecas, Zacatecas.

236. Facade (detail), Church of San José. Irapuato, Guanajuato.

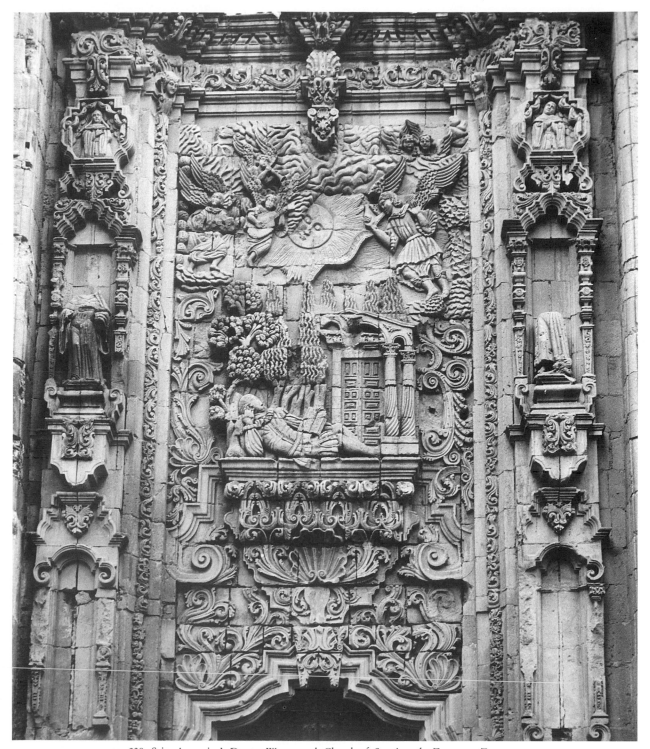

238. Saint Augustine's Dream. West portal, Church of San Agustín. Zacatecas, Zacatecas.

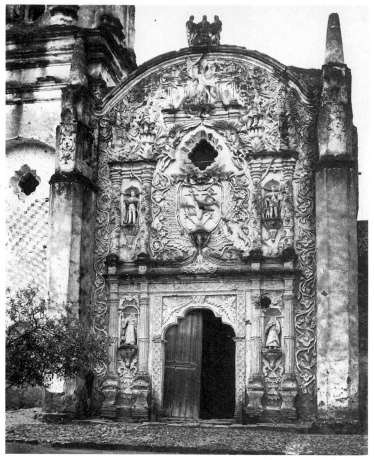

239. Church of the Franciscan monastery. Concá, Querétaro.

240. Facade (detail). Church of the Franciscan monastery. Jalpan, Querétaro.

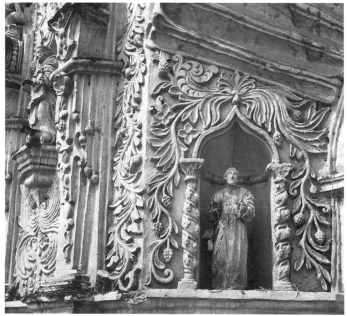

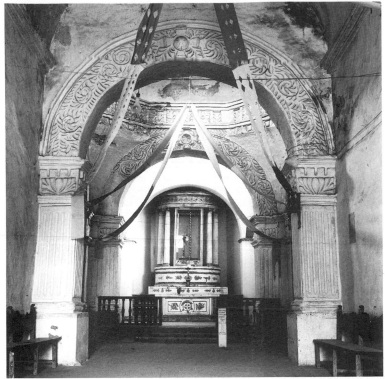

241. Nave, chapel of La Santa Cruz. Tepalcingo, Morelos.

242. Altarpiece of the Redemption, parish church. Chignautla, Puebla.

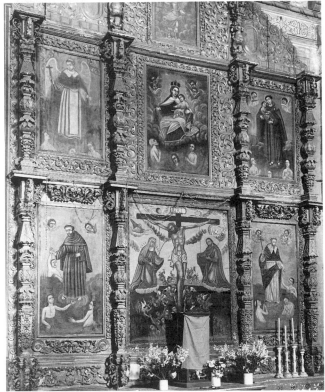

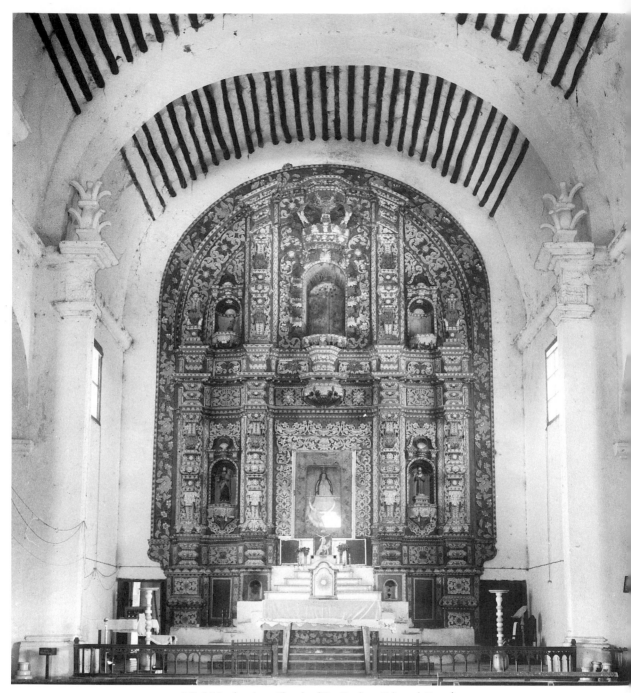

243. Main altarpiece, Church of San Esteban. Calotmul, Yucatán.

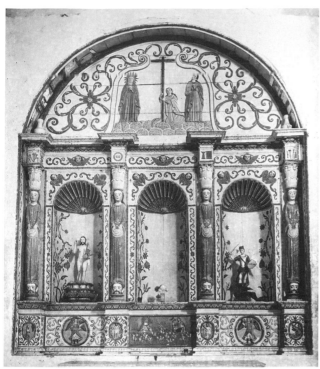

244. Altarpiece, church of the Franciscan monastery. Teabo, Yucatán.

245. Main altarpiece, church of the Franciscan monastery. Okutzcáb, Yucatán.

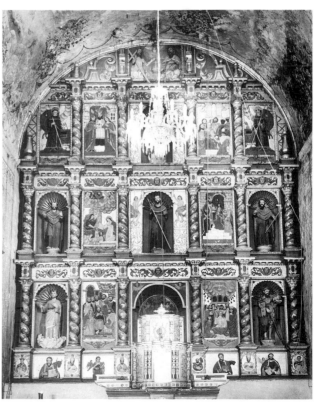

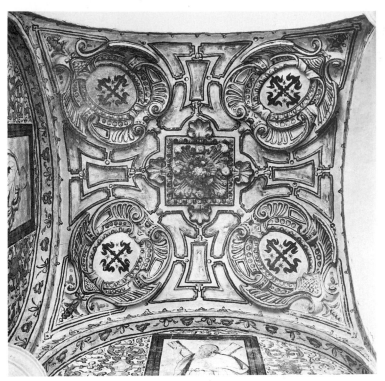

246. Vaulting over cloister walk, church of the Dominican monastery. San Pedro y San Pablo Etla, Oaxaca.

247. Pendentive, Church of Santa Isabel. Tepetzala, Puebla.

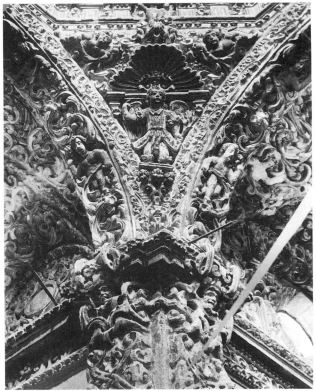

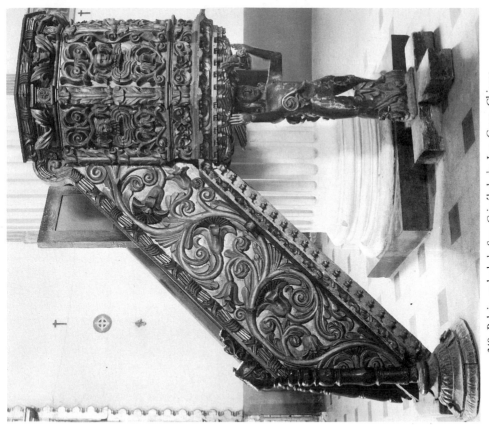

249. Pulpit, cathedral. San Cristóbal de Las Casas, Chiapas.

248. Pulpit, parish church. Santa María de La Paz (Ignacio Allende), Zacatecas.

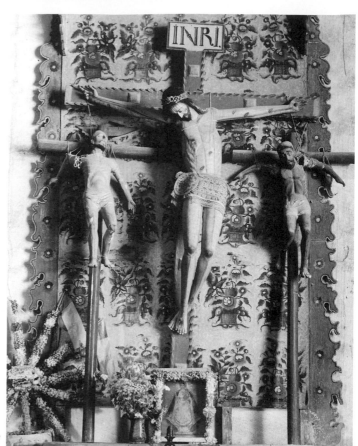

250. Crucifixion. Church of San Juan
 Evangelista. Analco, Oaxaca.

251. Crucifix, parish church. Tancítaro,
 Michoacán.

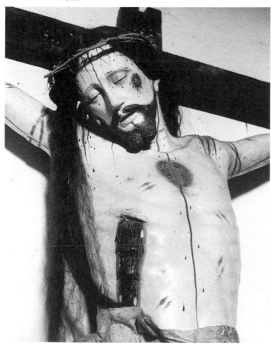

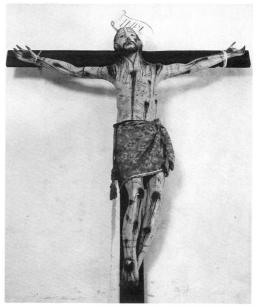

252. Descent from the Cross. Chapel of El Calvario.
 Pátzcuaro, Michoacán.

>214<

253. Saint Anne with the Virgin and Child. Church of La Concepción. Mococha, Yucatán.

255. Standing Gentleman. Cabildo (Government Palace). Tlaxcala, Tlaxcala.

254. Saint Sebastian. Church of San Luis. Tlacoxtlemalco, D.F.

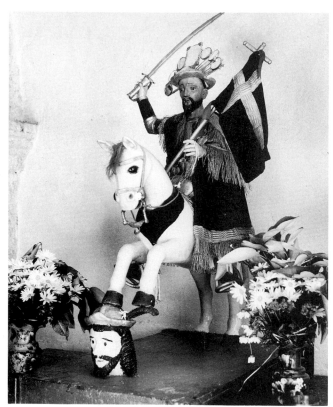

256. Santiago Matamoros. Church of San Miguel. Tulancingo, Oaxaca.

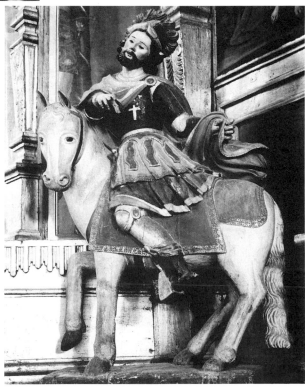

257. Saint Martin. Church of La Caridad. San Cristóbal de Las Casas, Chiapas.

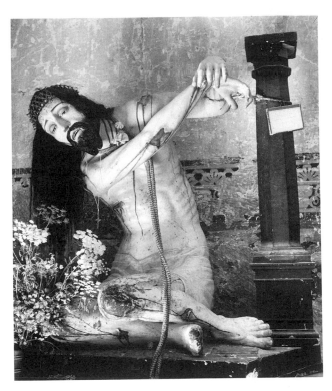

258. Christ Tormented. Church of the Dominican monastery. Coixtlahuaca, Oaxaca.

259. The Holy Trinity. Church of San Bartolo. Coyotepec, Oaxaca.

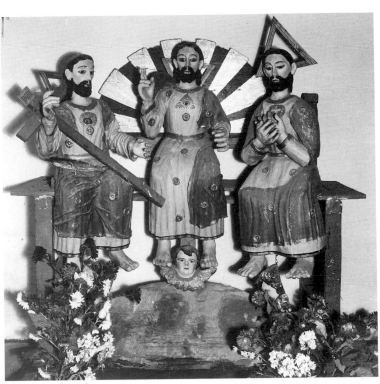

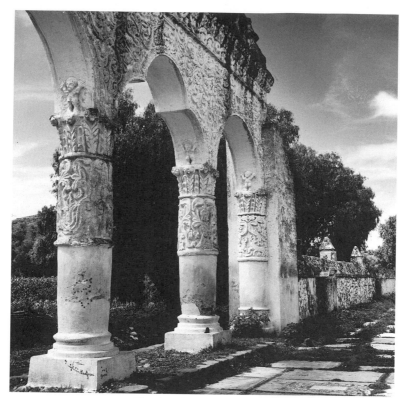

260. Churchyard gate. Papalotla, Mexico.

261. Cemetery gate. Sotuta, Yucatán.

262. Chapel of Tetela Barrio. Libres, Puebla.

X

CIVIC ARCHITECTURE

It would be a mistake to think that churches were the only appreciable buildings of viceregal Mexico, although their importance is apparent, and their number overwhelming. Churches were only one part of the colonial network—a very significant part because they touched the people's lives most intimately, most democratically. But the Crown was concerned with every aspect of life in New Spain, as architecture fully witnesses.

In laying out the town, a building for the civil government was put on the plaza, along with the church. As time passed and the community and the country changed, this building was frequently rebuilt and assigned to new functions—the town hall becoming a state capital—but it is surprising in how many of the provincial cities the government buildings still stand on the plaza as they always have. Even more surprisingly, it is likely to be the same building that marked the culmination of colonial growth in the seventeenth or eighteenth century. Even in Mexico City, the National Palace still stands on the Zócalo, at right angles to the cathedral. There the Palacio de los Virreyes had occupied the Casas Viejas (Old Mansions) of Montezuma. Bought from Martín Cortés in 1562, it was constantly being changed until, after the big riots and fire of 1692, it was finally built new. Except for the third story added in 1927, and the normal refurbishing of a building in use, this is substantially the seventeenth-century building—in sober Baroque, typical of its time, an eighth of a mile long, with immense patios. In Tlaxcala they are still using the sixteenth-century Cabildo, though its recent "restoration" and bedizening with unsuitable "colonial" detail now obscures the character of the most venerable civic building in Mexico. In

Guadalajara, in Morelia—wherever they were able to build impressively in the eighteenth century (and have not been too prosperous since)—you will find the same rich but dignified building, usually with its colonnade outside on the plaza, and its arcaded patio within. It is solid, impressive, conservative: the Spanish colonial government was not a haphazard or ramshackle operation. In some cities—Aguascalientes, Durango, Zacatecas—the present government palace was once the sumptuous home of a mine owner or *hacendado*.

Schools in the beginning were for Indians, especially for the sons of Indian nobles, whom the humanistic Franciscans hoped to indoctrinate with Hispanic culture as well as Christian doctrine. The most famous attempt was the Real Colegio de Santa Cruz in the monastery of Santiago Tlatelolco in Mexico City. Founded by Viceroy Mendoza and Bishop Zumárraga in 1536—dedicated to the higher education of these boys—it lasted only twenty years before it was deliberately allowed to decline. Meanwhile in Pátzcuaro Bishop Quiroga was trying a double curriculum in his Colegio de San Nicolás: educating Indian boys to be Christians and preparing Spanish boys for the priesthood. This was moved to Morelia in 1580, and later taken over by the Jesuits; now the University of Michoacán, it may well be the oldest continuous educational establishment in the New World.

There were also special schools of various types, starting in the early sixteenth century with the Franciscan and Augustinian schools of arts and crafts. Only the seminaries have left appreciable buildings, put to various uses in the twentieth century.

In 1551 the Royal and Pontifical University of New Spain was founded, and in 1553 inaugurated; placed proudly on the corner of the Zócalo, across the canal from the Viceregal Palace, it offered the pure traditional scholastic curriculum here on the frontier. Now the old building is gone, though two of its portals have been saved. But there are still a number of school buildings dating to the eighteenth century. The Jesuit Colegio de San Ildefonso, the magnificent structure now used by the National Preparatory School, was finished about 1740. Most of the provincial universities, like that of Michoacán, occupy the eighteenth-century buildings of their colonial predecessors—in Puebla and Querétaro, for instance. Above all, the Colegio de San Ignacio, a school for girls (always called Las Vizcaínas because it was endowed by three Basque miners), still serves its original purpose. Built between 1734 and 1766, it is one of the most beautiful of viceregal buildings, and demonstrates that a somewhat eccentric establishment may foster originality in architecture.

The promptness and dedication with which the Spanish founded hospitals we have already remarked in speaking of the community-hospitals in Michoacán.

Only two years after the fall of Mexico, Hernán Cortés had already endowed the Hospital of the Immaculate Conception (1525). Built on the site where the conquistador met the emperor, it is now known as the Hospital de Jesús, and is still in operation today, four hundred and fifty years later. Some of the structure seems to date back to the sixteenth century, though the double stairway is probably from the mid-seventeenth century. By 1600 there were, beside the nursing facilities of the monasteries, hospitals along the road to Veracruz and the roads to Oaxaca and the west; in 1620 Vázquez de Espinosa reported nine "famous" hospitals and "numerous others of lesser reputation" in the capital. Some were founded by religious orders, some by individual benefactors. It would be a century and a half before anything remotely comparable could be shown in the English colonies.

It reminds us again that New Spain had behind it the immense organizations of the Spanish monarchy and the Roman church, and that it took shape in the late medieval mood of the Reyes Católicos, Ferdinand and Isabella. Indeed the large Hospital de Belén in Guadalajara, which was finished in the last decade of the eighteenth century, is nothing less than a final example of the architectural formula developed in the Hospital de los Reyes in Santiago de Compostela (1501–1511). The plan—so elegant to the eye and mind—makes six long wards converge in double cruciform; with the sunny eccentric patios between the wings, it is a still-functioning exemplar of that combination of symbol and good sense which was the Middle Ages.

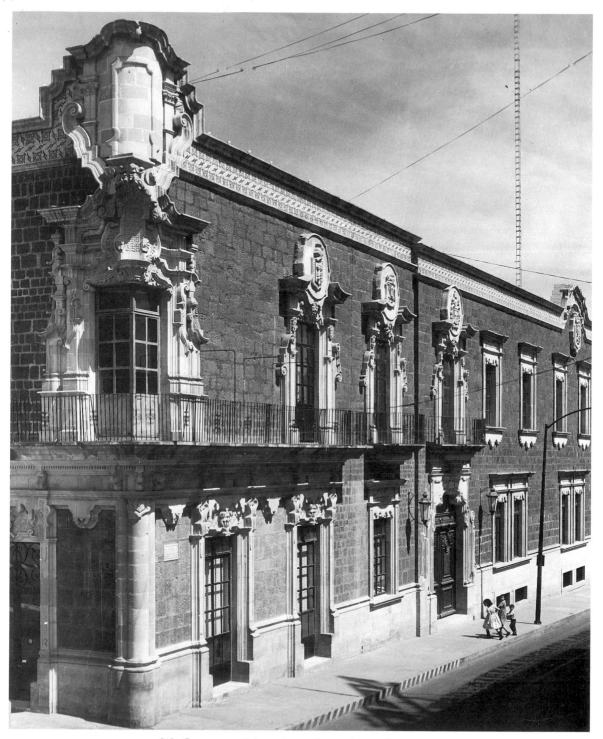

263. Government Palace. Aguascalientes, Aguascalientes.

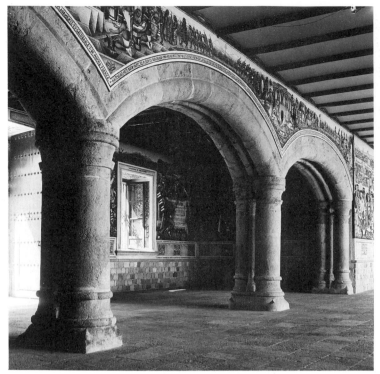

264. Arcade (restored). Cabildo (Government Palace). Tlaxcala, Tlaxcala.
265. National Palace (former Viceregal Palace). México, D.F.

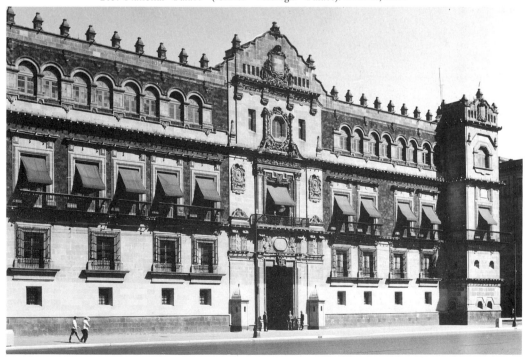

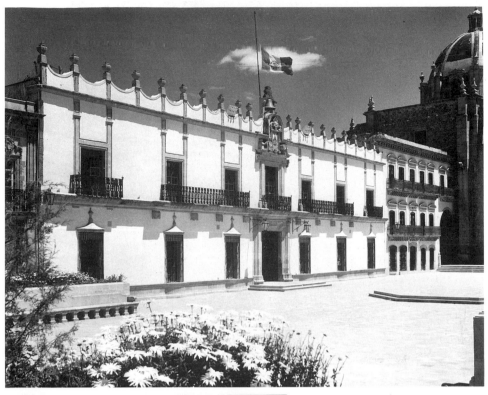

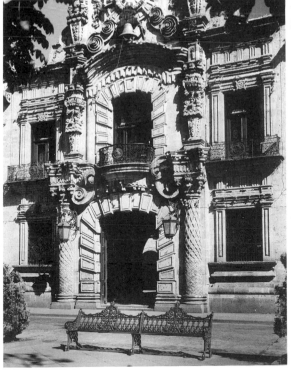

266. Government Palace. Zacatecas, Zacatecas.

267. Facade, Government Palace. Guadalajara, Jalisco.

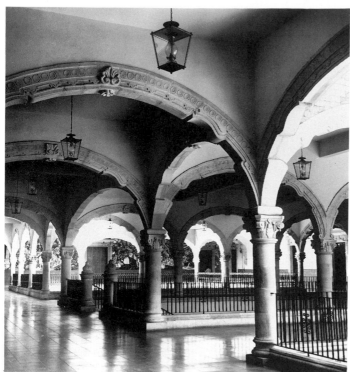

268. Arcade, patio. Government Palace. Aguascalientes, Aguascalientes.

269. Colegio de San Nicolás. Pátzcuaro, Michoacán.

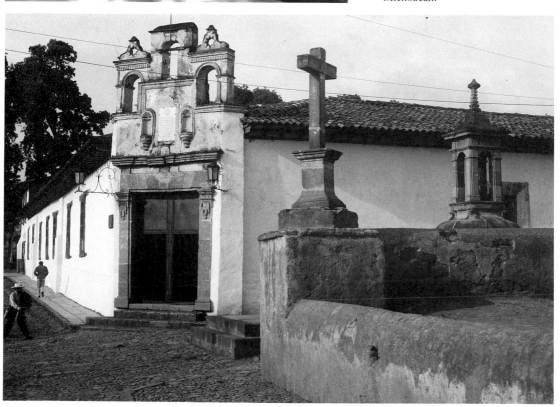

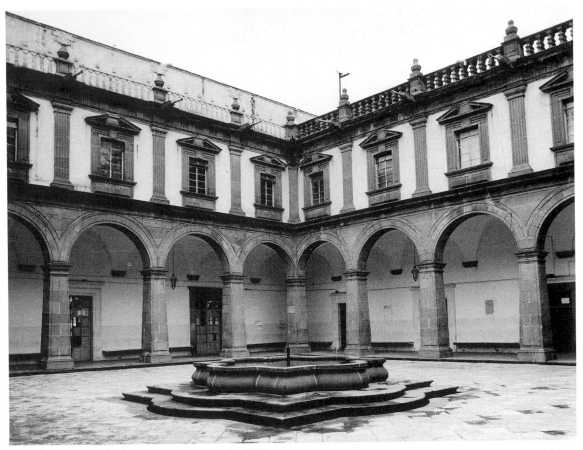

270. Patio, Colegio de San Ildefonso (University of Puebla). Puebla, Puebla.

271. Portal, Colegio de San Ildefonso (National Preparatory School). México, D.F.

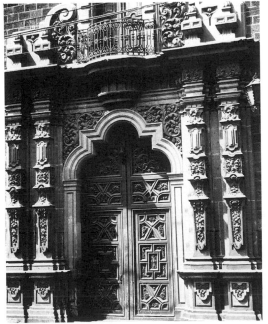

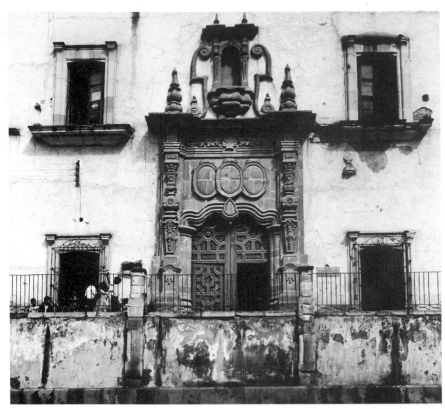

272. Facade, Colegio de San Luis Gonzaga. Zacatecas,
Zacatecas.

273. Palafox Library. Puebla, Puebla.

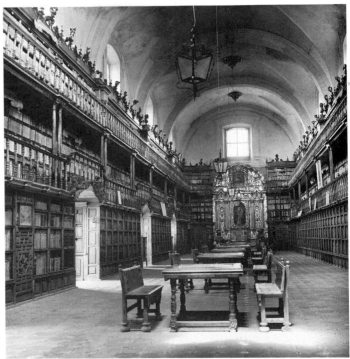

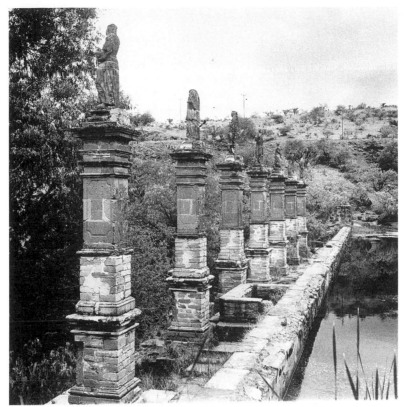

274. Dam. Marfil, Guanajuato.

275. Puente Grande (bridge). Acámbaro, Guanajuato.

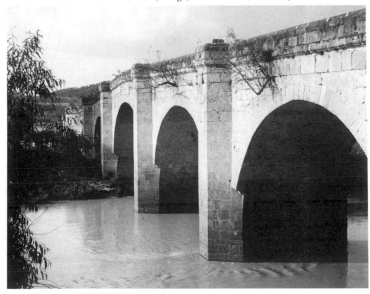

276. Aqueduct Los Arcos del Sitio, near Tepozotlan, México.

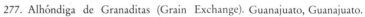

277. Alhóndiga de Granaditas (Grain Exchange). Guanajuato, Guanajuato.

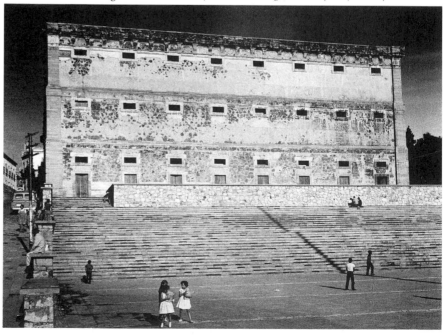

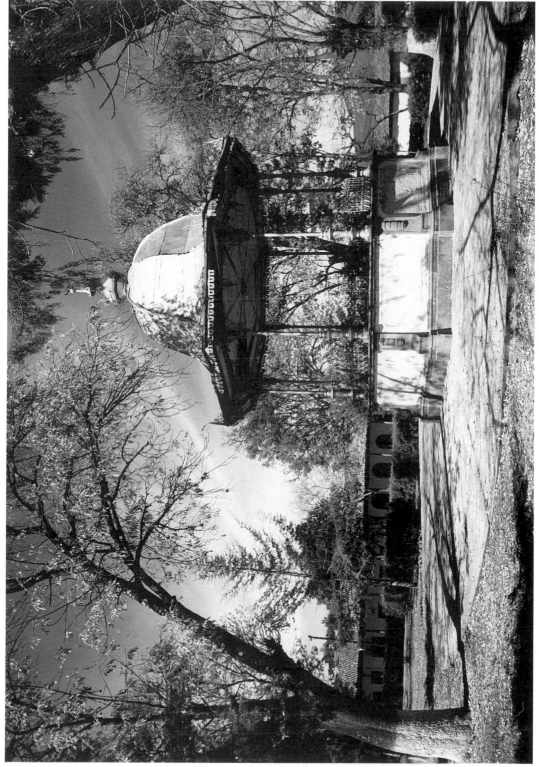

278. Bandstand in plaza (formerly in main plaza, Pátzcuaro). Zurumútaro, Michoacán.

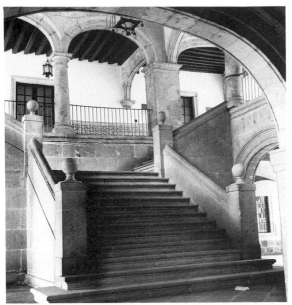

279. Stairway, Hospital de Jesús. México, D.F.

280. Juncture of wards, Hospital de Belén. Guadalajara, Jalisco.

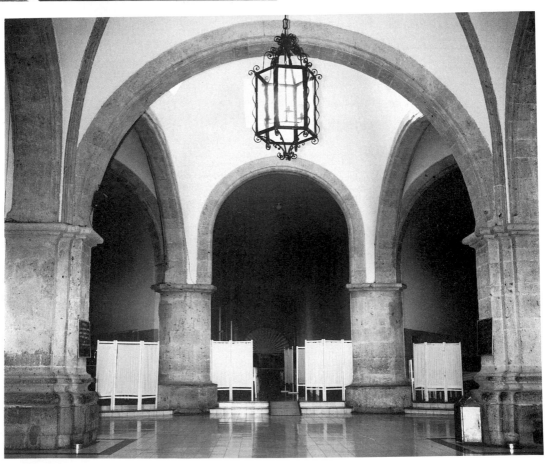

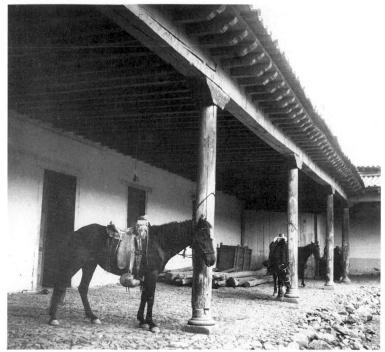

281. Patio of mesón (muleteers' hotel). Acuitzio, Michoacán.

282. Patio of Mesón de La Salud (muleteers' hotel). Pátzcuaro, Michoacán.

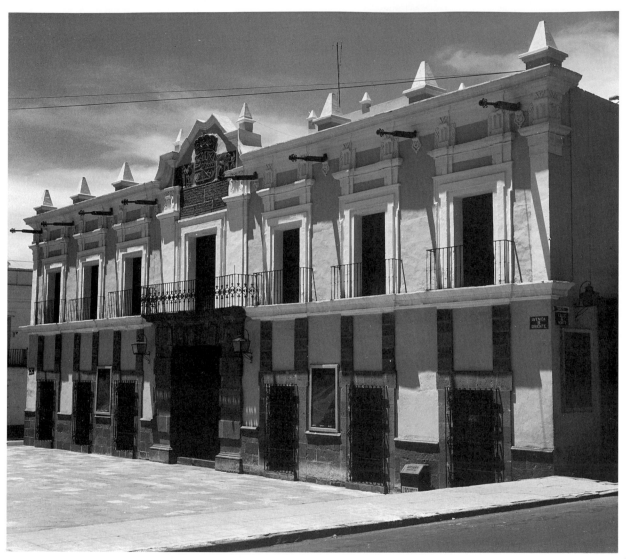

283. Colonial Theater (restored). Puebla, Puebla.

XI

HOUSES

What we think of today as Old Mexico is essentially eighteenth-century Mexico. It was in that prosperous century that buildings took their final form, while the viceregal society, matured over two hundred years, enjoyed the way of life that was soon to end forever. At that time noble families rebuilt their houses in the provincial cities and on their country estates, and they put up the great houses with the coats of arms over the doorways in Mexico City. The city grew on every level and more people than ever before were housed in solid, permanent buildings. The capital was so ornamented that a nineteenth-century traveler could hail it as "the city of palaces." Even now it is an extraordinary experience to wander through the center of town; one can still identify some forty noble houses, along with countless others that are large and handsome. These are the visible manifestations of the new moneyed nobility of Mexico; with another of those distortions of time which we have come to expect, they seem still to hold the life that Fanny Calderón de la Barca described with such zest.

Not that the eighteenth-century house was so different from older houses in Mexico. There is little point, architecturally, in allotting these buildings to different periods; it is more suitable to divide them into categories of size—the small and humble house, the large house, the noble house—than to exaggerate time changes. The humble house used local materials, was often influenced by preconquest usages, and belongs to popular architecture. The large house developed around a patio, on one or two floors; variations in plan and design are social and environmental rather than stylistic. In the city it was natural to save land by building two stories; even in the country, raising the dwelling to the second story

made for dryness and warmth in chilly climates, and for airiness in the tropics. The noble house was simply an enlargement and elaboration of the large house—more spacious, more elegant, more decorated. On the ground floor, shops faced the street, and carriages drove into the courtyard (where the fountain was) through the big portal. A monumental stairway led to the living quarters above, where drawing room and sitting rooms, dining room and bedrooms—and a chapel, if the house were noble enough—opened on the gallery around the same patio. In back were kitchens and bathroom and stables, often around a second patio. It is the trimming—the way windows are spaced and framed, the design of the portal, the character and kind of sculpture on fountains and stairways and rooflines—which gives clues to dating. Local character depends mostly on materials: the tile of Puebla, or the local stone that sets the tone of a city—green in Oaxaca, honey-colored in Querétaro—or the superb tezontle, ranging from rose color to deep maroon, softening the light in its velvety surface, which characterizes the colonial capital. Inventories from the past inform us that the furnishings have changed somewhat: in the olden times the effect was more Moorish, with less furniture, with ladies sitting on rugs or on divans, and clothes stored in chests rather than chests of drawers and wardrobes. But the basic house changed very little; the fact is that one can hardly find a better plan for a city dwelling. Privacy is enclosed, the garden is enclosed, the street is excluded by heavy doors and barred windows, and on the upper floors there are balconies and a roof garden offering light, air, and quiet.

Such a pattern for city living is not perfected overnight, and the Mexican house looks back to Andalusia—to the Roman house, to the Moorish house—and also, perhaps, to the palaces of Tenochtitlán. Nor was it quickly or whimsically changed: there is no reason to think that the houses of Spaniards anywhere in Mexico—once there was time to build them fine—were ever very different. In fact there are a number of sixteenth-century houses still in use, though it is usually only the outer walls, and especially the front, that we can be sure of. The rich Plateresque facade of the house of Francisco de Montejo the Younger is the finest of these relics; dated 1549, it was probably the work of Spanish stonecutters from the cathedral of San Ildefonso. Among half a dozen in Puebla, the "House of the Animal-Killer" has a beautiful portal, and inside "The Dean's House" (1580) some extraordinary Renaissance murals have been rescued.

And so the Mexican house lasted, from its beginning into the nineteenth century (Neoclassic columns of great purity appear on the facade). When Manuel Toussaint or Romero de Terreros y Vinent describe the rooms of a noble house and their use, one feels that they are drawing on personal memory, not research. The viceregal modes of life were not extinguished in 1810, nor even, entirely, in

HOUSES

1910. There is hardly a provincial city without its noble dwelling on the plaza, and its long streets lined with the sober one-story houses that may be as old as the colony. In the capital itself you can still see block after block of big stone houses in the old sections: their presence gives Mexico City a special character. They may be plastered with signs, no longer family dwellings but taken over as tenements or broken up into stores and offices—in disrepair and dirty, cracked by earthquakes, their splendor diminished—but the effect of each building (and even more, of the whole street) still speaks eloquently of the life in a viceregal town.

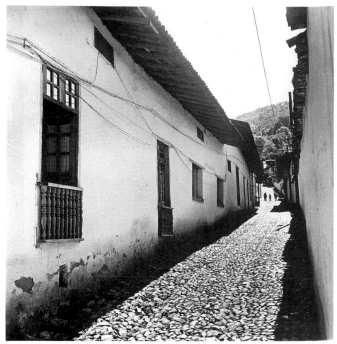

284. Street. Valle de Bravo, México.

285. House. Tancítaro, Michoacán.

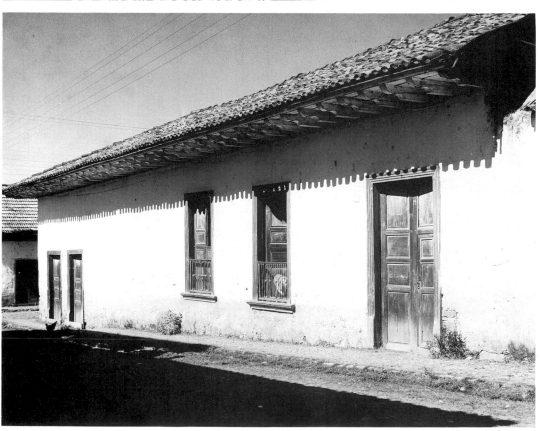

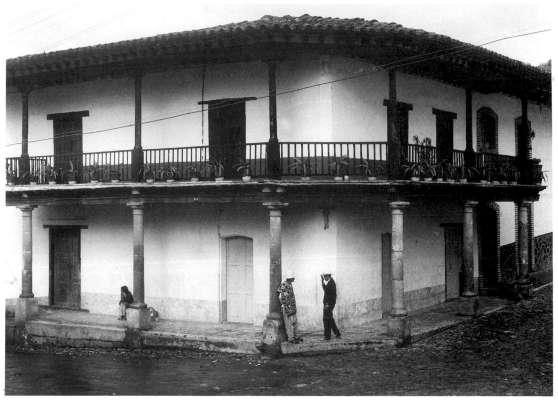

286. House. Valle de Bravo, México.

287. Portal of a house. Quecholac, Puebla.

288. Window. Salinas Victoria, Nuevo León.

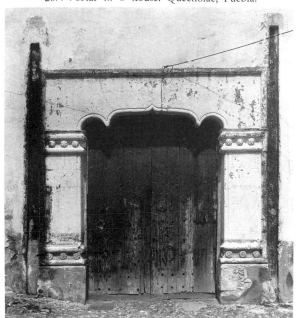

289. House on the plaza. Nochistlan, Zacatecas.

290. House. Pinos, Zacatecas.

291. House of Cortés. Tepeaca, Puebla.

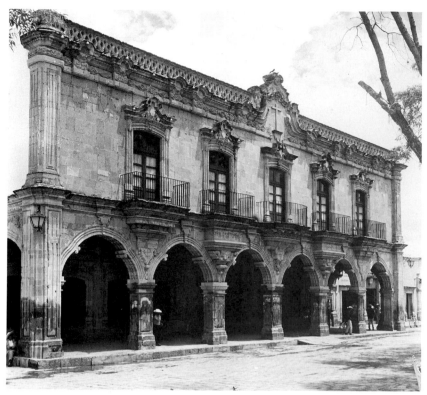

292. House on the plaza. Dolores Hidalgo, Guanajuato.

293. House. Guadalajara, Jalisco.

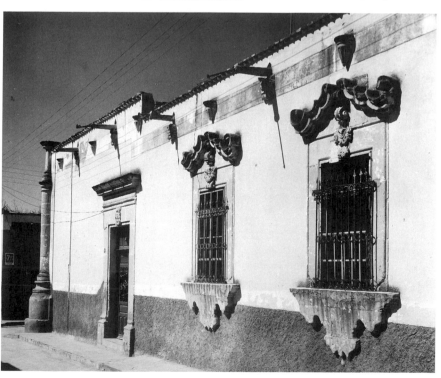

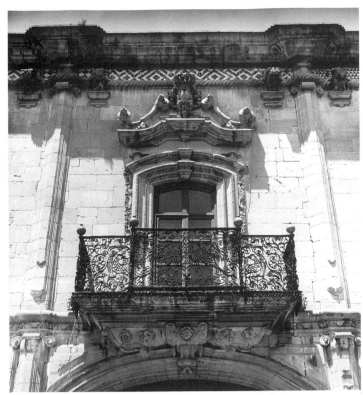

294. Window, house of the Marqués de la Villa del Villar del Águila. Querétaro, Querétaro.

295. Upper patio of a noble house (now Hosteria del Marqués). Querétaro, Querétaro.

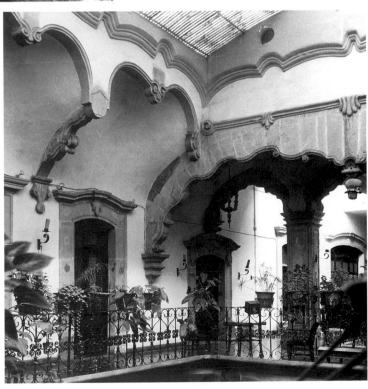

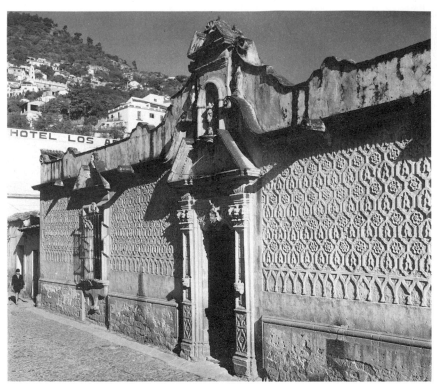

296. Humboldt House. Taxco, Guerrero.

297. Garden loggia, Humboldt House. Taxco, Guerrero.

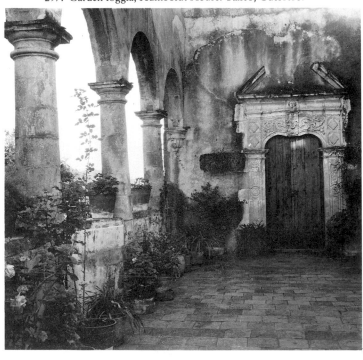

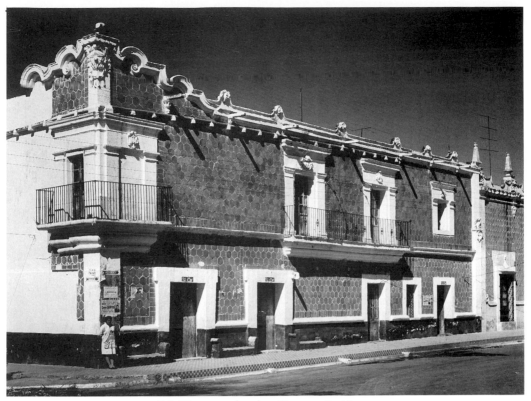

298. House on the plaza. Tepeaca, Puebla.

299. House at No. 31, 2nd Street of San Francisco.
San Miguel Allende, Guanajuato.

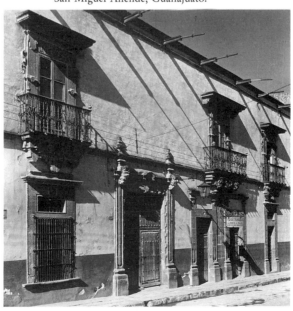

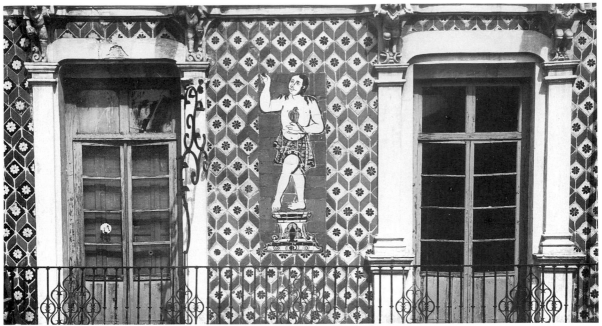

300. House of Los Muñecos. Puebla, Puebla.

301. Window, house of General San Martín. Puebla, Puebla.

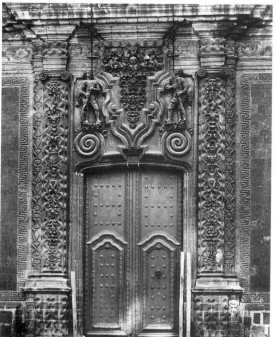

302. House of the Count of Santiago de Calimaya (Museum of the City of México). México, D.F.

303. Portal, house of the Marqués of Jaral de Berrio. México, D.F.

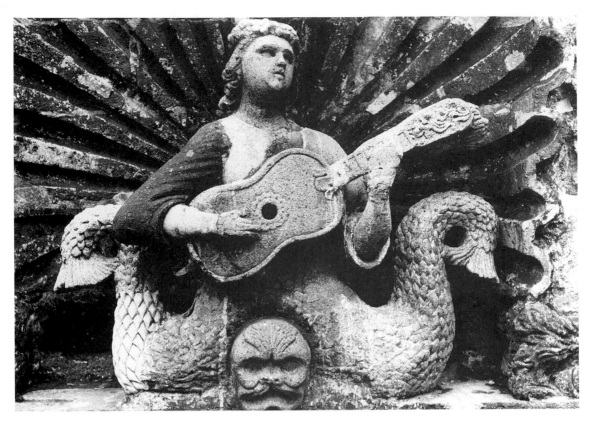

304. Fountain in the patio, house of the Count of Santiago de Calimaya (Museum of the City of Mexico). México, D.F.

305. Dog on the stairway, house of the Count of Santiago de Calimaya (Museum of the City of Mexico). México, D.F.

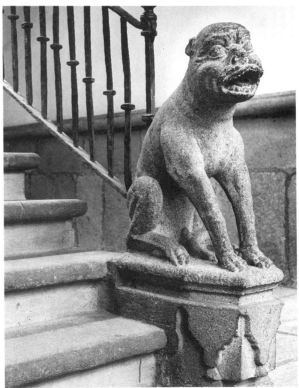

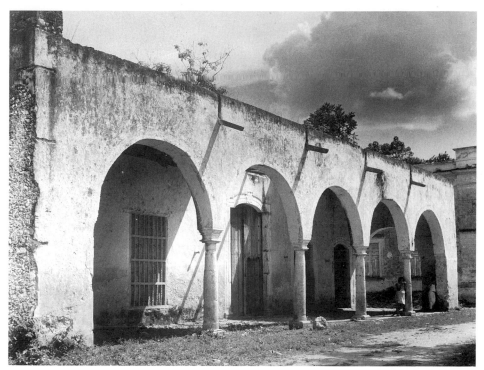

306. House on the plaza. Sotuta, Yucatán.

307. House of the Nachi Cocóm family. Sotuta, Yucatán.

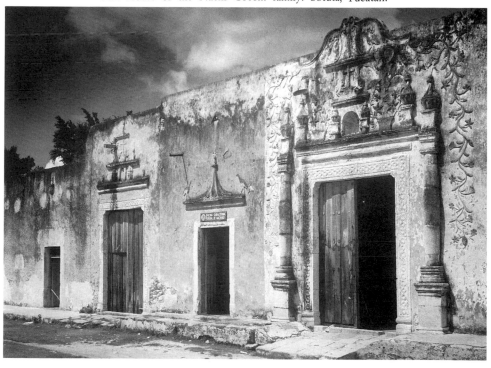

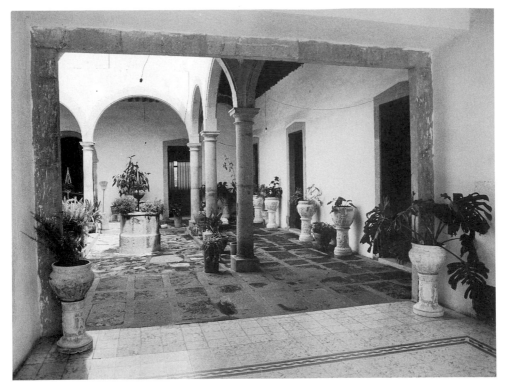

308. Entrance to patio of a house. Jeréz, Zacatecas.

309. Patio of a house. Jeréz, Zacatecas.

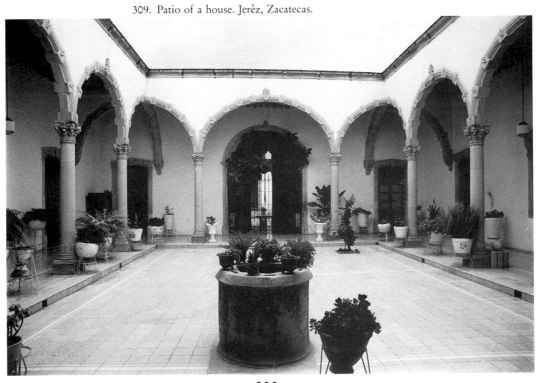

310. Patio, Chata House. Tlalpan, D.F.

XII

HACIENDAS

There were also country houses in Mexico from the beginning. No one appreciates the country retreat more ardently than the confirmed city dweller, and though even the cities of colonial Mexico had their gardens and open spaces, ladies liked to withdraw from formal society, friars from their austere monastery, and viceroys from the demands of office. Besides, practically all wealth and position in Mexico came from the land, and although a noble family might much prefer the capital— or Europe—it must, from time to time, visit its estates.

After 1600 the typical landed estate was the hacienda. Its nucleus was usually a small land grant from the Crown (often rewarding a conquistador and his descendants), augmented by purchase, consolidation, encroachment, and every form of intimidation and chicanery. It is difficult to explain the extent and dominion of the haciendas, for the Council of the Indies seems to have been aware of the dangers inherent in large holdings, and had set up formidable legal blocks. The original agricultural grants were seldom more than some two hundred acres; grants for ranching were no more than permits to graze stock, over three square miles at the most. Furthermore, land grants to Indian communities were inalienable. And yet, slowly, the hacienda owners bought up the smaller estates around them, absorbed the Indian lands, gobbled up the Indian towns, and ended by supporting the Indians in a peonage which was nearer to slavery than to employment. Haciendas were always Spanish, with a cluster of Indian population. The hacienda described the Indian as inferior, without land, wealth, or emancipating skills; it depended upon the availability of such Indians, and so helped to perpetuate the superior position of the Spaniards.

It was in the seventeenth century, with its economic breakdown, that the haciendas took on their character. Semi-feudal, they offered refuge and livelihood to Indians from the cities and Indians who had lost their land. For a while, with the mines in decline and trade disrupted, land was the only wealth and the only security. By the time things had picked up again, around 1700, the isolated hacienda had permanently affected the social organization of the viceroyalty. It was an island of civilization surrounded by desert, an all but self-sufficient operation where some money crop like sugar brought in revenue, herds and gardens supplied food, cloth was woven and clothes tailored, the forge, the carpenter shop, the kiln—and above all, aqueducts and wells—answered the needs of a simple social group. It was the inn for all travelers in the wilderness, the school of the young and the haven of the old. Through the neglect of the capital the hacienda owner had acquired a sort of civil authority, and was judge, policeman, and governor for the region. As a unit of production, and even more as a unit of society, the hacienda dominates the history of Mexico.

The haciendas easily survived the War of Independence (which indeed was fought for Mexican-born *hacendados*); their position was only improved when the Spanish protective legislation for Indians lapsed, and Spanish lands were forfeit. Indeed the hacienda again became a refuge and fortress in the turmoil of the nineteenth century, with an inevitability that made feudalism and peonage seem the natural way of life. Of all the buildings in Mexico, the hacienda buildings best illustrate the proposition that architecture is timeless and largely invariable. If it is often impossible to date a granary or a barn, it is even less important to try, since the building and the crop and the animals and the reason for housing them and the people who care for them are all but interchangeable for three centuries.

A wealth of travelers' accounts tell of life on the haciendas, after Independence had opened the country to foreigners. How pleasant it could be, a young man reports in 1828:

> ... Santa Inés, where we arrived at about 3 o'clock ... and the relics of the dinner brought forward for us ... We spent the afternoon in the shade on the terrace, chatting, smoking cigars, with the ladies ... the Marqués de Salvatierra, with his lady and family, the Marqués de Santiago, and his sister; miners, soldiers, lawyers—and priests, of course. Besides our worthy host, Don Antonio de Michaus, we made the number of his guests twenty-four, and for the most part they had come—like ourselves—*au hasard*, uninvited and unexpected, but sure of a hearty welcome and good fare.

But, as time passed, it was more and more likely to be, as Mme. Calderón de la

Barca describes, abandoned to the care of a steward, forgotten by the family who lived on its income in Madrid or Paris: "The house is merely used as an occasional retreat during the summer months and is generally a large empty building with innumerable lofty rooms, communicating with each other and containing the scantiest possible supply of furniture." Even so, it took the twentieth century to break up this last vestige of viceregal society; only 1910 brought Mexico to the threshold of modern times.

When the haciendas went, everything went. Among the fields and factories of modern agricultural Mexico lie scattered the ruins of the old country estates: sugar in Morelos, pulque in Hidalgo, mescal in Zacatecas, sisal in Yucatán, wheat and maize and cattle and horses. Some have been converted to modern methods, some deserted; some are now residences or hotels, or have been absorbed into towns and become tenements. Among the ruins lingers an authentic sense of life: the encircling walls, the great house with its amenities and its defenses, the attendant chapel, the work buildings, the barns and corncribs, the aqueduct, the cisterns and the wells, the cattle yards and corrals, the houses of the workers. Like Pompeii, the buildings often appear to have been abandoned in full swing; as in medieval Rome, people have crept back to camp in the ruins.

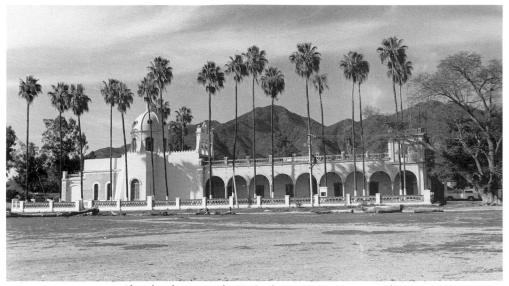

311. Chapel and casa grande. Hacienda San Antonio Matute, Jalisco.

312. Chapel. Hacienda San Juan Molino, Tlaxcala.

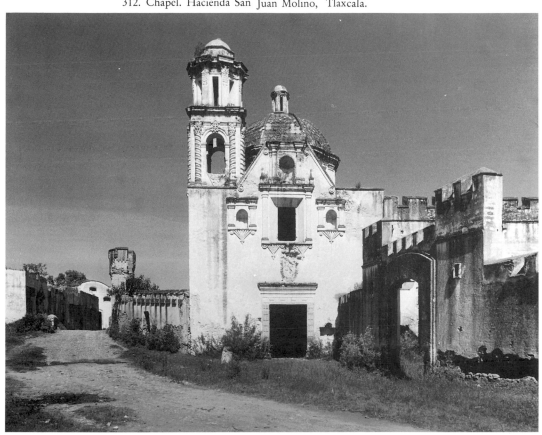

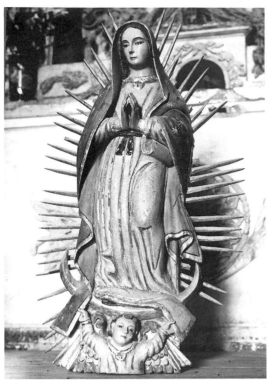

313. Virgin of Guadalupe on chapel altar. Hacienda
El Salto, Zacatecas. *256*

314. Chapel. Hacienda Molino de Flores, México.

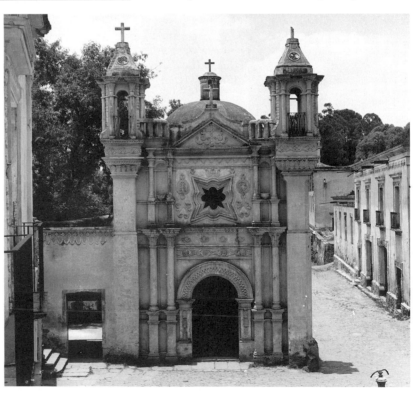

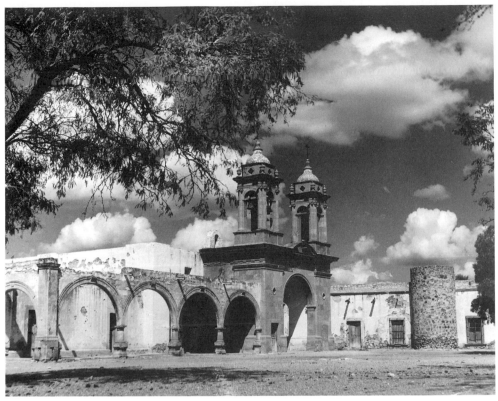

315. Chapel and casa grande. Hacienda El Mezquite, Zacatecas.

316. Plaza arcade. Hacienda El Mezquite, Zacatecas.

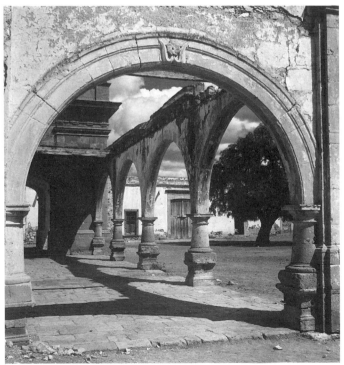

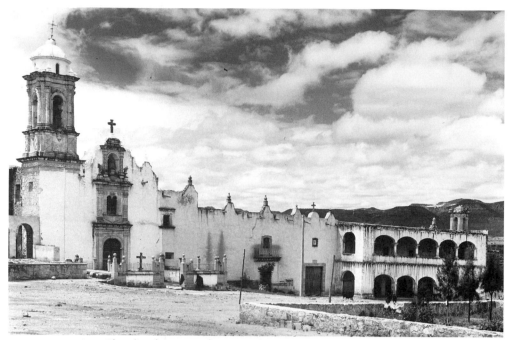

317. Chapel and casa grande. Hacienda San Mateo de Valparaíso, Zacatecas.

318. Casa grande. Hacienda Santa Ana, Zacatecas.

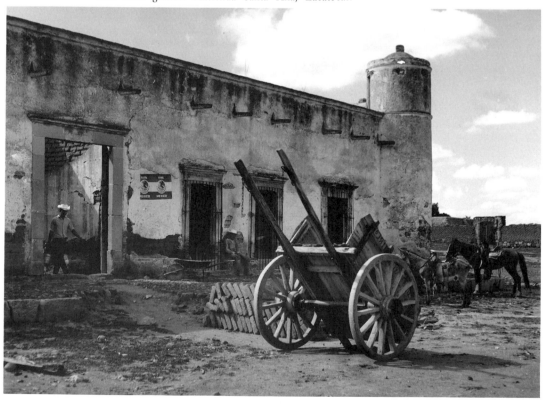

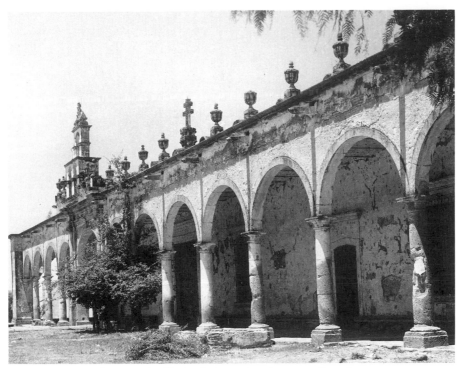

319. Casa grande. Hacienda Santa Ana Apacueco, Guanajuato.

320. Arcade on facade of casa grande. Hacienda El Carmen, Jalisco.

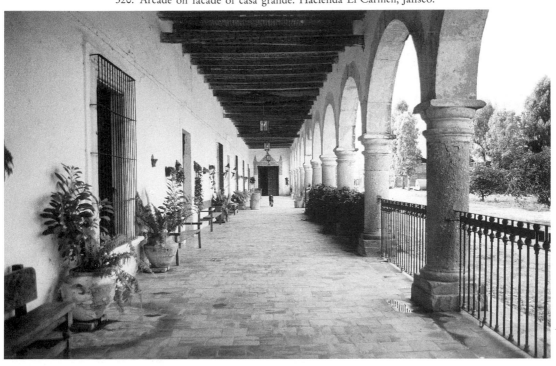

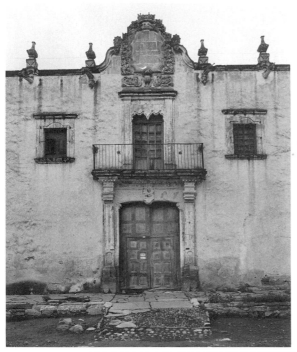

321. Entrance, casa grande. Hacienda El Mortero, Durango.

322. Gate. Hacienda Santa Rosa, Zacatecas.

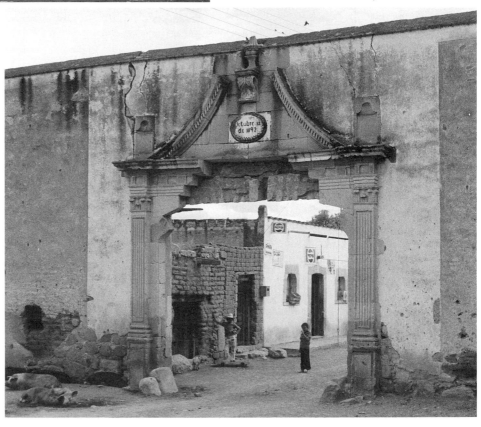

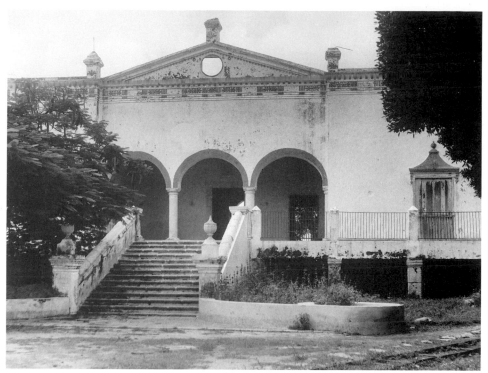

323. Casa grande. Hacienda San Pedro Chimáy, Yucatán.

324. Casa grande. Hacienda Tadzídz, Yucatán.

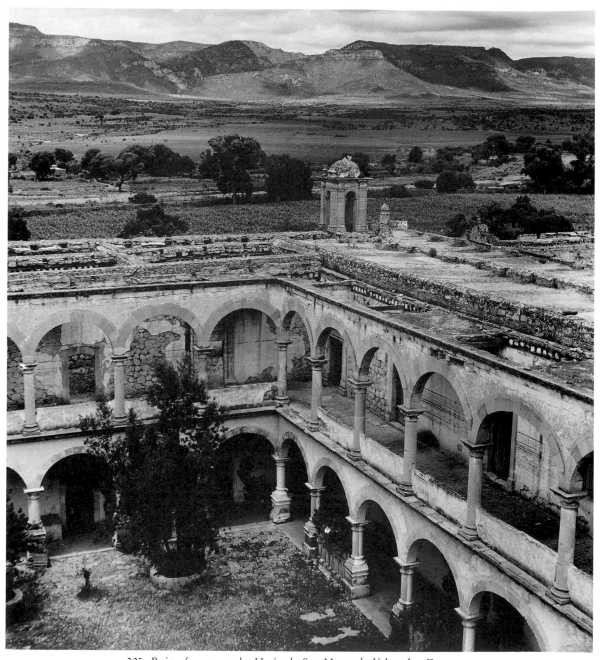

325. Patio of casa grande. Hacienda San Mateo de Valparaíso, Zacatecas.

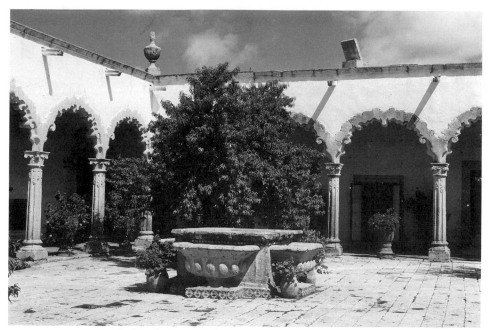

326. Patio of casa grande. Hacienda Ciénega de Mata, Jalisco.

327. Patio of casa grande. Hacienda El Mortero, Durango.

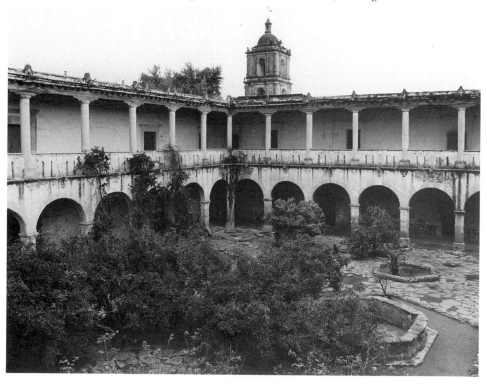

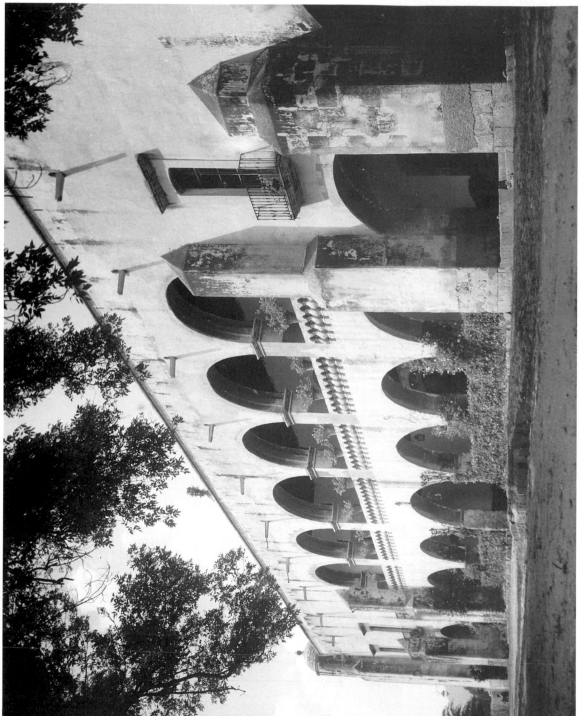

328. Casa grande. Hacienda Chichimequillas, Querétaro.

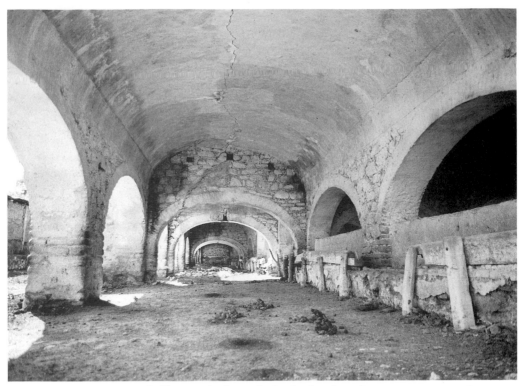

329. Stables. Hacienda Jaral de Berrio, Guanajuato.

330. Storage barn. Hacienda La Encarnación, Zacatecas.

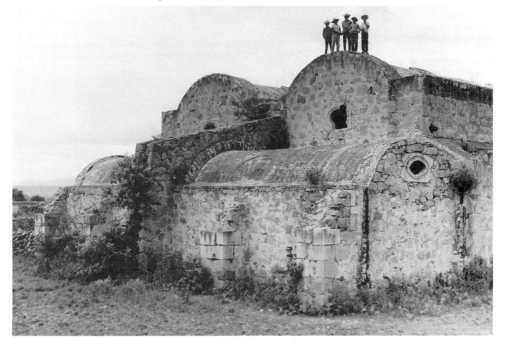

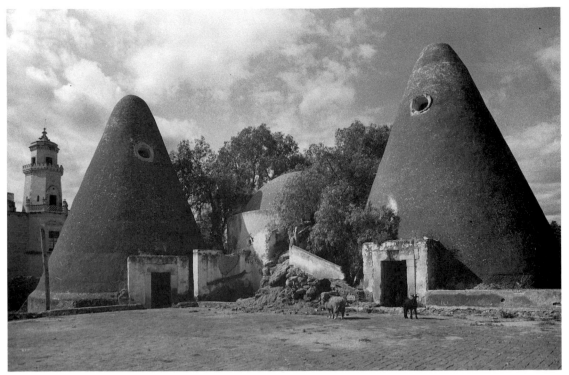

331. Granaries. Hacienda Jaral de Berrio, Guanajuato.

332. Mescal factory. Hacienda La Trinidad, Zacatecas.

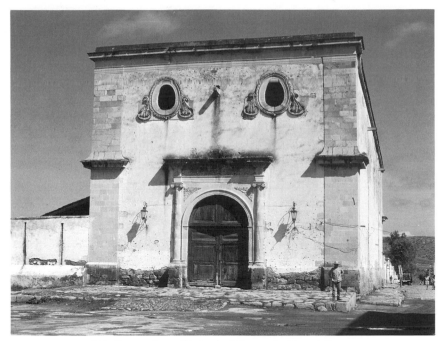

333. Storage barn. Hacienda Ciénega de Mata, Jalisco.

334. Worker's house. Hacienda Chenkú, Yucatán.

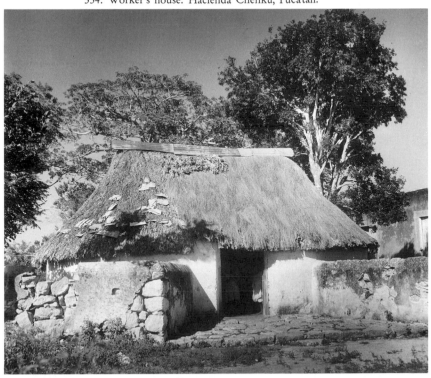

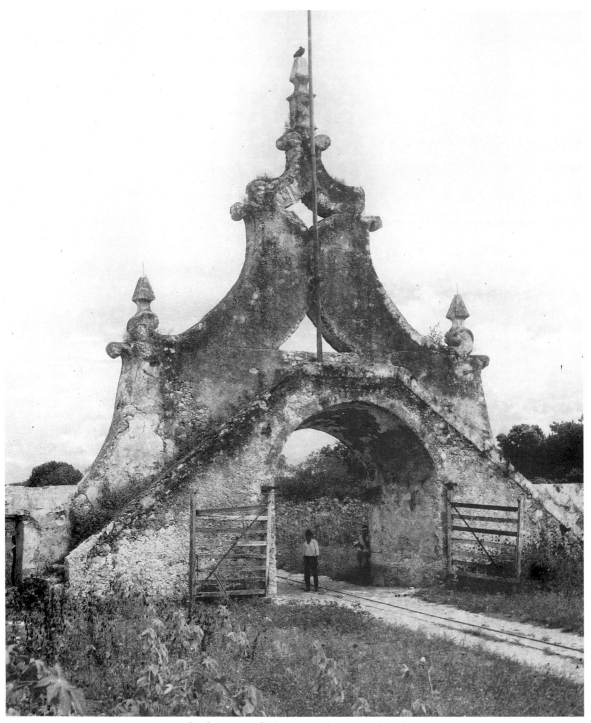

335. Gate to the henequen fields. Hacienda San Pedro Chimáy, Yucatán.

GLOSSARY

a lo romano
Classical or Renaissance borders, deriving from the Roman "grotesque" decoration.

altarpiece
A general term for any large, perpendicular, decorative treatment behind the altar. Here usually more specific in the *retable* (q.v.).

anástilo
Literally, "without style"; or unidentified in style.

artesonado ceiling
A wooden structure covering a building, its beams and/or panels decorated with painting and inlay. Moorish in origin.

atole
A preconquest drink (gruel), made of ground fresh corn kernels (maize) mixed with water or flavors; often prepared with chocolate or cinnamon.

atrio
In Mexico, the walled churchyard. Often includes four corner chapels (posas) and some provision for celebrating mass.

azulejos
Glazed tiles in the Moorish style, usually yellow, blue, white and black.

camarín
A small sacristy where a sacred image is cared for and dressed; literally, a dressing room.

cenote
A natural well, as in Yucatán, where rivers run underground through limestone; in due course, the surface rock breaks away and reveals the "well" below.

chiluca
A fine gray limestone available for building in the Valley of Mexico; often used for carved decoration framing walls of tezontle.

Churrigueresque
A form of Ultra-Baroque style popular in Mexico, characterized by the estípite (q.v.) and used both inside and outside the church. Not particularly related to the art of the Churriguera brothers.

conjunto
An aggregate of various parts; an entirety, functioning as more than the sum of its parts, a *Gestalt*.

encomienda
A grant to a Spaniard in the sixteenth century as a reward for services to the Crown, and carrying feudal responsibilities, consisting of 1. land and villages, 2. natives, 3. church and clergy.

ensamblador
A joiner (or cabinetmaker); the carpenter who puts together a retable.

entallador
A sculptor in wood as a worker on the retable, in any capacity from routine carving to making saints.

espadaña
A wall-belfry: a vertical wall over the roof, pierced to hold bells, used instead of a tower.

estípite
The vertical member of the Ultra-Baroque entablature, replacing the classical column of the Renaissance and the twisted helix of Bernini.

estofador
The craftsman who finished the painted clothing of a wooden image, when the face and hands had been finished by the encarnador. Brocade was simulated by painting over gold leaf.

faldoncito
A motif in relief sculpture which seems to drape the otherwise plain surface of a retable.

hacienda
A landed estate, variable in status and size, devoted to the production of livestock, agricultural goods and minerals. Haciendas developed in the late sixteenth century and were broken up after the Revolution of 1910.

Indian
A general term covering all native Americans.

merlons
Defensive or decorative construction, varying the skyline of a fort, church or mansion.

mestizo
A person of mixed race, as the result of the intermarriage of Indian and Spaniard; hence of mixed origins and quality.

metropolitan
Characteristic of a metropolis (strictly speaking, of the bishop's or archbishop's see), hence of a large city, a center of culture.

mudéjar
The culture of the Moors in Spain, or under Spanish rule.

naturales
Native-born Americans, Indians.

parroquia
The church of a parish, under its own priest, where the administrative records are kept.

portería
An arcaded open porch beside the west front of a church, usually the entrance where travelers are admitted to the church offices or convent buildings. Often doubled as an open chapel.

posa
One of the (usually four) shelters provided in the corners of the churchyard to receive the sacrament.

preconquest
The period in any area of the Western Hemisphere before Europeans arrived; in Mexico, pre-1520, when Cortés landed.

provincial
Local in style; from the provinces as distinct from the metropolis, typical of the country outside the capital.

ramada
A bower of branches, a shelter built against the sun, as in the trellis which roofed the churchyard naves in Yucatán.

retable
The Spanish altarpiece of the sixteenth to eighteenth centuries. Retable is the English form of the Spanish *retablo.*

Santiago Matamoros
Spanish vernacular form of Saint James Major (translated by Prescott as Sant'Iago), associated with his shrine at Santiago de Compostela. The battle-cry "Santiago Matamoros!" (the Moor-Killer) dates back to the Moorish wars, and is represented by the saint on horseback, riding over several prone and turbaned Moors. Indians were sometimes substituted for Moors, but in due time the saint became a great patron of baptized Indians.

sempasuchitl
Marigold: members of the North American *Tagetes* family, neither "French" nor "African," but always Mexican. Growing all over Europe before 1550. This flower was sacred to the dead in Aztec ritual, and is used to decorate graves for All Souls' Day.

tecali
A translucent, unmetamorphosed limestone, generally tan to creamy white in color, used

for window panes in the sixteenth century, as alabaster was used in the Near East and Europe.

Tenochtitlán

The largest island of the group on which the city of Mexico was built. Part of its Great Temple complex, the center of Aztec ritual, has recently been excavated and lies just east of the Cathedral.

tequitqui

A Nahuatl word meaning "tributary" to distinguish vestiges of preconquest style in colonial art. Coined in 1942 by José Moreno Villa, a Spanish art historian, on the model of the term *mudéjar:* evidence of Moorish style under Spanish domination.

tezontle

A porous volcanic stone used by builders, especially in the city of Mexico; color varies from deep red (even black) to rosy tan. Laid in plenty of mortar, it provides an all but monolithic wall, very light. In Baroque buildings often supplemented by gray chiluca limestone.

Tlatelolco

Second largest island of the group on which the city of Mexico was built, holding the Great Market of the Aztecs. It holds the second Franciscan house constructed in New Spain, Santiago Tlatelolco, and had an Indian college.

traza

Floor plan of a building, or the general layout of a city and its divisions.

Veronica

The miraculous print of Christ's features left on the cloth with which Saint Veronica had wiped his face; the reproduction of such a face.

visita

A church or chapel without resident clergy, under the care of a mission or parish church.

BIBLIOGRAPHY

This is a list of books in English which treat the colonial art of Mexico in a general way, for general readers. Reference to more specific, more detailed, exhaustive works will be found in the bibliographies of these books, especially in Spanish.

Baird, Joseph A. *The Churches of Mexico: 1530–1810.* Berkeley: University of California Press.

Baxter, Sylvester. *Spanish-Colonial Architecture in Mexico.* Boston: J. B. Millet, 1901.

Benítez, Fernando. *The Century After Cortes,* trans. J. Maclean. Chicago: University of Chicago Press, 1951.

Borah, Woodrow W. *New Spain's Century of Depression,* Berkeley: University of California Press, 1951.

Bottineau, Yves. *Iberian-American Baroque,* trans. K. M. Leake. London: Macdonald, 1971.

Calderón de la Barca, Frances. *Life in Mexico: The Letters of Fanny Calderón de la Barca (1843),* ed. and trans. Howard T. and Marion H. Fisher. Garden City, N.Y., Doubleday, 1966.

Cal'i, François. *The Art of the Conquistadors.* London: Thames and Hudson, 1961.

Castedo, Leopoldo. *A History of Latin American Art and Architecture,* ed. Phyllis Freeman. New York, Washington, D.C.: Frederick A. Praeger, 1969.

Chevalier, François. *Land and Society in Colonial Mexico: The Great Hacienda,* trans. Alvin Eustis. Berkeley, Los Angeles: University of California Press, 1963.

Cline, Howard F. "The Relaciones geograficas of the Spanish Indies: 1577–1586." *Hispanic American Historical Review,* 48:341–376.

Cook, Sherburne F., and W. W. Borah. *The Indian Population of Central Mexico, 1531–1610.* Berkeley, Los Angeles: University of California Press, 1960.

Cordry, Donald Bush, and Dorothy Cordry. *Mexican Indian Costumes.* Austin, London: University of Texas Press, 1968.

Dirección de Monumentos Coloniales. *Three Centuries of Mexican Colonial Architecture.* New York: D. Appleton-Century, 1933.

Edwards, Emily, and Manuel Álvarez Bravo. *Painted Walls of Mexico: from Prehistoric Times Until Today.* Austin, London: University of Texas Press, 1966.

Fernández, Justino. *A Guide to Mexican Art.* Chicago: University of Chicago Press, 1969.

Foster, George M. *Culture and Conquest: Amer-*

ica's Spanish Heritage. Chicago: Quadrangle Press, 1960.

Gage, Thomas. Travels in the New World. Norman: University of Oklahoma Press, 1958.

Gibson, Charles. The Aztecs Under Spanish Rule: a History of the Indians of the Valley of Mexico: 1519–1810. Stanford, Calif.: Stanford University Press, 1964.

Gibson, Charles. Tlaxcala in the Sixteenth Century. New Haven, Conn.: Yale University Press, 1949.

Gonzalez Obregon, Luis. The Streets of Mexico. San Francisco: George Fields. 1937.

Hanke, Lewis. The First Social Experiments in America. Cambridge, Mass.: Harvard University Press, 1935.

Hanke, Lewis. The Spanish Struggle for Justice in the Conquest of America. Philadelphia: University of Pennsylvania Press, 1949.

Hanke, Lewis, ed. The Colonial Experience. History of Latin American Civilization: Vol. 1. London: Methuen; Boston: Little, Brown, 1969.

Humboldt, Alexander von. Political Essay on the Kingdom of New Spain, trans. John Black. London: Longman, Hurst, Rees, Orme, and Brown, 1811.

Kelemen, Pál. Art of the Americas, Ancient and Hispanic. New York: Thomas Y. Crowell, 1969.

Kelemen, Pál. Baroque and Rococo in Latin America. New York: Macmillan, 1951.

Kubler, George. Mexican Architecture of the Sixteenth Century. New Haven, Conn.: Yale University Press, 1948.

Kubler, George, and Martin S. Soria. Art and Architecture in Spain and Portugal and Their American Dominions, 1500–1800. The Pelican History of Art, 17. Baltimore: Penguin, 1959.

Leonard, Irving. Baroque Times in Old Mexico. Ann Arbor: University of Michigan Press, 1959.

McAndrew, John. The Open-Air Churches of Sixteenth-Century Mexico. Cambridge, Mass.: Harvard University Press, 1965.

Motolinia (Toribio de Benevente). Motolinia's History of the Indians of New Spain, trans. Francis Borgia Steck. Washington, D.C.: Academy of Franciscan History, 1951.

Mullen, Robert J. Dominican Architecture in Sixteenth Century Oaxaca. Phoenix: Arizona State University, 1975.

Phelan, John Leddy. The Millennial Kingdom of the Franciscans in the New World: a Study of the Writings of Geronimo de Mendieta (1525–1614). Berkeley, Los Angeles: University of California Press, 1956.

Prescott, William H. History of the Conquest of Mexico. (1843).

Ricard, Robert. The Spiritual Conquest of Mexico, trans. Lesley B. Simpson. Berkeley: University of California Press, 1966.

Sitwell, Sacheverell. Southern Baroque Revisited. London: Weidenfeld and Nicolson, 1967.

Smith, Bradley. Mexico: a History in Art. New York & Mexico. 1968.

Smith, Robert C., and Elizabeth Wilder (Weismann). A Guide to the Art of Latin America. Washington, D.C.: Library of Congress, 1948.

Toussaint, Manuel. Colonial Art in Mexico, trans. and ed. Elizabeth Wilder Weismann. Austin, London: University of Texas Press, 1967.

Weismann, Elizabeth Wilder. Mexico in Sculpture: 1521–1821. Cambridge, Mass.: Harvard University Press, 1950. Reprint, Westport, Conn., 1971.

Weismann, Elizabeth Wilder. "The History of Art in Latin America, 1500–1800; Some Trends and Challenges in the Last Decade." Latin American Research Review, 8(1975):87.

Zavala, Silvio. Sir Thomas More in New Spain: a Utopian Adventure of the Renaissance. London: Hispanic and Luso-Brazilian Council, 1955.

ABBREVIATIONS OF STATE NAMES

Aguascalientes	Ags.
Campeche	Camp.
Chihuahua	Chih.
Chiapas	Chis.
Durango	Dgo.
Guanajuato	Gto.
Guerrero	Gro.
Hidalgo	Hgo.
México	Méx.
México, Distrito Federal	México, D.F.
Michoacán	Mich.
Morelos	Mor.
Nuevo León	N.L.
Oaxaca	Oax.
Querétaro	Que.
Quintana Roo	Q.R.
Tlaxcala	Tlax.
Veracruz	Ver.
Yucatán	Yuc.
Zacatecas	Zac.

INDEX

INDEX

INDEX

INDEX

INDEX